QUESTIONS, HYPOTHESES & CONJECTURES

DISCUSSIONS ON PROJECTS BY EARLY STAGE AND SENIOR DESIGN RESEARCHERS

iUniverse, Inc.
New York — Bloomington

iUniverse books may be ordered through booksellers or by contacting:

iUniverse
1663 Liberty Drive
Bloomington, IN 47403
www.iuniverse.com
1-800-Authors (1-800-288-4677)

Because of the dynamic nature of the Internet, any Web addresses or links contained in this book may have changed since publication and may no longer be valid. The views expressed in this work are solely those of the author and do not necessarily reflect the views of the publisher, and the publisher hereby disclaims any responsibility for them.

ISBN: 978-1-4502-5966-8 (pbk)
ISBN: 978-1-4502-5965-1 (ebk)

Library of Congress Control Number: 2010915447

Printed in the United States of America

iUniverse rev. date: 10/18/2010

CONTENTS

PART 3 — *EMERGING QUESTIONS*

SPECIAL ARTICLES

FOREWORD

Design Research is often self-conscious about its lack of systematic methods and theories in comparison to other academic disciplines. This self-consciousness, on the one hand, has to a certain degree advanced the quality of design discourse; on the other hand, it has resulted in much research that is methodologically rigorous but conceptually weak. "Here is the solution and what was the problem?" seems to describe the unfavorable character of much design research. It has been forgotten that it is questions and ideas that give meaning and value to meticulously executed research. To promote rigor in formulating research questions and conceiving new ideas, the Design Research Network organized the learning conference *Questions & Hypotheses* in 2008 in Berlin. The Design Research Network is a platform established in 2007 particularly to serve research students in Design. Students are encouraged to take an active role in raising questions and participating in discussions in order to inform and help each other.

The debates and discussions on the presentations at the conference were both critical and constructive. To preserve and disseminate these valuable discussions and to encourage continuous learning, this book *Questions, Hypotheses & Conjectures* was conceived. The contributing authors are mainly early stage design researchers who presented their projects at the conference. Authors were asked to capture and reflect on the comments, questions, and discussions during the conference. Based on these reflections, the authors rewrote their papers. There are therefore two contributions from each author: the original abstract or poster with comments and a final paper. The comments have originated mainly from our invited senior researchers and are particularly educative. They highlight the positive directions, ambitious goals and critical issues to explore. They also expose common oversights which must be addressed. Often overlooked tasks include reviewing major literature, adequately defining or articulating concepts and terms, generalizing based on sufficient evidence, clearly stating relevancy and values, arguing logically, examining assumptions, and building theoretical ground. If you compare the original posters or abstracts with the final papers, then you will not only appreciate how the authors succeed at synthesizing what they have learned into fruitful thoughts and ideas, but also the hidden process of refining questions, hypotheses and conjectures.

The papers are not arranged by theme here, rather, they are deliberately arranged in such a way as to reflect the mental journey that the authors have taken, to arrive at grounded questions, plausible hypotheses or informed conjectures. The papers have been arranged in this way to serve pedagogical purposes and the arrangement should not be interpreted as ranking the quality of the papers. It should also be mentioned that it is not straight-forward to sort the papers in this way. There are certainly debatable cases. However, when collected together, the papers give a sense of what is generally required or achieved at each step. As a whole, they show that arriving at research questions, hypotheses and conjectures is a significant achievement and requires a demanding process that is often unfamiliar to and underestimated

by junior researchers. Through this arrangement, we would like to encourage readers to take the important steps of conceptualizing research seriously.

PART 1 — INTENT OR INTEREST

The authors talk about the research topics that interest them and explain briefly their motivations and intents. Here DOAA EL AIDI shows her interest in contributing to alleviating poverty in Egypt through design and particularly by system thinking. She belongs to an emergent domain, namely social innovation, which is very much open for exploration. Whereas the development of methods and tools for design practice has a longer tradition, social innovation is relatively new in design research. In spite of this, DENNIS OSWALD believes that the design community must become better at presenting design methods and proposes developing a tool to support this. Furthermore, FAN XIA would like to bring visualization methods to Design Management in China through research focusing on innovative approaches to facilitating interdisciplinary creative teams.

PART 2 — WORK IN PROGRESS

The authors study, summarize and interpret existing literature in their fields. They also identify knowledge gaps and narrow their topics to more specific themes and research directions. Here the interests in social innovation and design methods are also represented. LESLEY MCKEE explores the concept of "craftsmen of democracy" from the political philosopher Hannah Arendt as a basis for developing design-led social innovation. Another related topic is Service Design, the management of which interests QIN HAN. She sees the opportunity to explore this new field of practice to develop much-needed theories about it. Similar to FAN XIA, MAREIKE GRAF and CARMEN MENZEL hope to identify the role of design method, particularly visualization, in aiding decision-making at the early stage of product development. Additionally, MITHRA ZAHEDI is working on the design model "environment for

reflective collaboration" to facilitate the works of multidisciplinary teams. These investigations reflect the continuous expansion of the subject matter of Design and the need for new knowledge to support it. Besides design methodology, design thinking has also been well studied but continues to excite interest. THIERRY LAGRANGE has practiced architecture for many years and plans to interpret his own photographs, architectural drawings, and words to understand design thinking. Another specific theme is also found here. ZDRAVKO TRIVIC sees the potential of the healing power of "seductive" consumption space and aims to explore this potential.

PART 3 — EMERGING QUESTIONS

The authors examine the literature of their fields in more depth and gain a good grasp on various interrelated issues. They also develop their own stand or perspective and are able to judge and identify knowledge gaps and formulate research questions to fill these gaps. Here again we find socially-oriented research: LISA CRESSWELL sheds light on the role of design in dealing with complex problems such as counter-terror communication. CARMELA CUCUZZELLA proposes and examines a new model for assessing sustainable design based on the concept of prudence. STELLA BOESS shows an ongoing action research project for understanding students' learning experiences. Besides the practical and normative, in this section we also encounter reflective and critical investigations. SARAH BELKHAMSA appraises three different perspectives in the domain of design semiotics. ANNINA SCHNELLER scrutinizes, compares, and contrasts different approaches in Visual Rhetoric. DAG BOUTSEN reflects on the production and reception of architecture with the aim to explore the issue of trust in participatory design. KATHARINA BREDIES challenges the common notion of "design-for-use" and proposes an unusual alternative. Finally, two contributions examine design research itself: MICHEL DE BLOIS touches on fundamental issues in conceiving design research and CHRISTIAN WÖLFEL discusses the issues involved in selecting design research methods.

It would be wrong to claim that these papers encompass all the major themes of current design research, but they do represent some important ones including service and socially oriented design, design thinking and method development, management of multidisciplinary design teams, and design as meaning construction. None of these is trivial: each carries implications for research, education and practice.

SPECIAL ARTICLES

There are also two special articles by the distinguished design thinkers ALAIN FINDELI and KEITH RUSSEL. Both texts are based on presentations given by the authors at the conference. They raise the fundamental and yet unresolved issues of the basis for and purposes of Design Research. In a subtle but authoritative voice, they invite us not to shy away from difficult questions and challenge us to be serious design researchers.

Questions, Hypotheses & Conjectures is published with research students in mind; however, it is of interest to the entire design community. It contains not only current design research projects but also the debates, dialogical thinking and intellectual struggles involved in arriving at research questions. We wish you a very enjoyable read! We also invite you to join the Design Research Network *(www.designresearchnetwork.org)* and raise questions and comments on *Questions, Hypotheses & Conjectures*.

Editors

Rosan Chow, Wolfgang Jonas, Gesche Joost

ACKNOWLEDGEMENTS

The conference and the publication would not have been possible without the support of the delegates at the conference and the following people. We would like to thank:

Special Guests
Prof. Alain Findeli, Prof. Mike Press, Prof. Keith Russell, Prof. Susann Vihma and Prof. Khaldoun Zreik

Conference Reviewers
Prof. Brigitte Borja, Prof. Uta Brandes, Prof. Eduardo Corte-Real, Prof. Clive Dilnot, Prof. Alain Findeli, Mr. Johann van der Merwe, Prof. Boris Müller, Dr. Harold Nelson, Prof. Silvia Pizzocaro, Prof. Mike Press, Dr. Keith Russell, Prof. Arne Scheuermann and Prof. Teal Triggs

Conference Team
Birgit Bauer, Tom Bieling, Katharina Bredies, Lea Brumsack, Sandra Buchmüller, Jana Ehlert, Jan Golke, Susann Hamann, Fabian Hemmert, Irene Hube, Jan Lindenberg, Mattias Löwe, Severin Neumann, Georg Reinecke, Sebastian Spittau, Lea Undi, Kathrin Vent and Anne Wohlauf

Publication Team
Joshua Marr and Katharina Bredies

Sponsor

Deutsche Telekom Laboratories

PART

1

INTENT
AND
INTEREST

ORIGINAL POSTER

Seeing the Future Through Aesthetics

Doaa El Aidi

Questions and Hypotheses,
October 25–26, 2008
Design Research Learning Conference,
Berlin, Germany

Background:

The world has become a global village, and more than ever we are aware of the gap between rich and poor. Moreover, people in developing countries are often focusing on the most fundamental needs, work hard to earn a living and have no money to spend.

Problem:

Many companies ignore them and focus on rich people as if the poor did not exist.

The aim:

To help poor people and improve their life's quality in the next 10 or 15 years through exploring desirable futures.

Research questions:

— How can design bridge the gap between poor people and companies in a sustainable context?

— How can design convince companies to fulfil their social responsibility towards these people?

— What kind of support does design need to solve problems effectively in the real world (to change the undesirable present, imagine the desirable future and improve societies)?

— What kind of strategy leads to comprehensive solutions in order to overcome the weakness of infrastructure in developing countries?

Research methods:

The focus will be on Egypt as a case study, to understand the people there and their needs in a socio-cultural context. A multiplicity of user-experience research methods will be used, such as observation and qualitative analysis using contextual inquiries and in-depth interviews as data gathering techniques. Moreover, scenarios will be used to explore a new vision for the future.

POSTER+
COMMENTS
—

The Future

01—You should first de-fine what you mean with Aesthetics, then apply this definition in order to solve the research problem.

Through
Aesthetics

[1] [2]

02—Aesthetics could be defined according to the Frankfurt School, Bauhaus, Paolo Freire or Karl Marx.

Doaa El Aidi

Questions and Hypotheses.
October 25–26. 2008
Design Research Learning Conference.
Berlin. Germany

— How can design bridge the gap between poor

04—There is a successful project in Egypt called Sekem, you should take a look at it.

change the undesirable present, imagine the desirable future and improve societies)?

— What kind of strategy leads to comprehensive solutions in order to overcome the weakness of infrastructure in developing countries?

Research methods: 5 6

The focus will be on Egypt as a case study, to understand the people there and their needs in

06—You may apply leapfrog technology in order to overcome the technology gap in a short time.

Moreover, scenarios will be used to explore a new vision for the future.

B

03—In order to write a good research plan you should first formulate the aim very well, then choose suitable methods which enable you to reach your aim in a short time.

rich people as if the poor did not exist.

The aim: 3

To help poor people and improve their life's quality in the next 10 or 15 years through exploring desirable futures.

05—Take a look at design projects that contribute to design policy. Manzini is famous in this context.

FINAL PAPER

—

Seeing the Future through Aesthetics: A Sustainable Approach to Solving Real-World Problems

Doaa El Aidi

Aesthetics as a theory of sensory recognition and experiences refers here to aesthetic experience in a social context as a dynamic reflection arising from a moral point of view. It also poses a potential for individual, social and cultural development, which in turn allows us to imagine the interrelatedness of being in our world.

Nowadays, the world is changing quickly and radically. As a result we have many new and particularly complex problems. Looking at these

problems, designers should adopt a new role in understanding, operating and solving problems by asking new questions in order to find new solutions. We can follow HEIDEGGER's path to help identify such a new role for designers: "being-a-designer-in-the-world" means that designers should and must experience the world through sustainable solutions. *This transition requires systematic change. It is not about doing what we already do better, but doing different things in a completely different way. This includes products and service systems that propose different ways of being and doing from those that currently dominate, are lighter in environmental terms and more favorable towards new forms of socialization.*[1] Moreover, we could interpret "understanding" here as *understanding the role and potential of design research in the transition towards sustainability* as presented in the Design Research Agenda for Sustainability.[2] This was also proposed by the Changing the Change conference, where it was pointed out that "sustainability must be the meta-objective of every possible design research activity."[3]

However, we can say that good design research is measured by satisfying the demands and needs of the society from which the problems arise. Or in other words, the research questions and problems must be closely connected to society. *Through the Millennium Development Goals the world is addressing the many dimensions of human development* to achieve sustainable development. *Developing countries are working to create their own national policies and strategies based on local human needs and priorities.*[4] Therefore, *the findings of technical and financial reports could be a reliable resource for addressing shortcomings, desires, and opinions.*[5]

Poverty reduction is one of the challenging problems facing developing countries. In Egypt, *poverty is a problem clearly recognized by policy makers. Poverty reduction remains a challenge for Egypt* as stated in the poverty assessment report 2007, which assesses the nature and dimension of

1 EZIO MANZINI, "New Design Knowledge," *Design Studies* 30, no. 1 (2009): 4–12.
2 EZIO MANZINI (2009), *Ibid.*, 4.
3 "Design Research Agenda for Sustainability." *Changing the Change, ICSID Torino*: 2008. *http://emma.polimi.it/emma/showEvent.do?page=645 &idEvent=23* (accessed March 19, 2009)

4 UNITED NATIONS DEVELOPMENT PROGRAM, "UNDP Egypt and Poverty Reduction." *http://www.undp.org.eg/Default.aspx?tabid=153* (accessed April 17, 2009)
5 VESTER, FREDERIC *The Art of Interconnected Thinking. Tools and Concepts for a New Approach to Tackling Complexity.* Germany: MCB Verlag, 2007.

poverty in Egypt.[6] Thus, *it would have been easy to get trapped in the enormity of the developmental challenge and end up with an unfocused wish list that had lost sight of the original purpose.*[7] To avoid this trap, we should be aware of the complex context in which we are working in order to choose an appropriate methodology that enables us to act in a sustainable manner.[8]

Research framework and methodology:

The intent here is to do *transdisciplinary*[9] research, based on different disciplines such as business and design management, complexity, future studies, philosophy and sociology. Most central are system thinking and scenario building; *systems-thinking describes the attempt to make the complexity of problem fields and contexts manageable without destroying their systemic character, while scenario building is the answer to the fact that design considerations reach into uncertain futures.*[10]

Aims, hypotheses and research questions:

The broader aim of my research is to link design research activities directly to social needs. The meta-hypothesis is that, by applying system thinking and scenario building from a design perspective, we can gain a better understanding of real-world problems and develop more flexible guidelines for the development of undetermined future solutions. I argue that design could play a powerful role in contributing to the ongoing efforts of many institutions and organizations in Egypt that are trying to tackle poverty in order to achieve sustainable development. This research puts forward a particular perspective on design, which

6 AL-SHAWARBY, SHERINE *et al.* "Arab Republic of Egypt. Poverty Assessment Update." The World Bank: 2007. *http://mop.gov.eg/PDF/povert_report.pdf* (accessed March 15, 2009).

7 DU PLESSIS, CHRISNA "Agenda 21 for Sustainable Construction in Developing Countries" UNEP-IETC and CIB: 2002. *http://www.sustainable-design.ie/sustain/CIBsustainConstruct_DevelopingCountries.pdf* (accessed March 19, 2009).

8 VESTER, FREDERIC (2007), *Ibid.*, 19–20.

9 FINDELI, ALAIN *et al.* "Research Through Design and Transdisciplinarity: A Tentative Contribution to the Methodology of Design Research" *FOCUSED – Current Design Research Projects and Methods* (2008): 67–91. *http://5-10-20.ch/~sdn/SDN08_pdf_conference%20papers/04_Findeli.pdf* (accessed February 2, 2009)

10 JONAS, WOLFGANG "Communication Futures. Systems Thinking and Scenario Building in Design." *Conference good / bad / irrelevant,* September 3–5, 2003, UIAH Helsinki, *http://www.conspect.de/jonas/PDF/HEL9_2003.pdf* (accessed April 12, 2009)

is not only restricted to form-giving activity but it *is more about courses of action aimed at changing existing situations into preferred ones*" in order to prepare people and society for desirable change.

In doing so, the research will try to answer these questions:

— What role should the designer play in supporting national policy for sustainable development in developing countries?

— What kind of support does design need to solve problems effectively in the real world (to change the undesirable present, imagine the desirable future and improve societies)?

— How much can design link real-world problems with uncertain future solutions?

— To what extent can design research aimed at poverty alleviation contribute to sustainability?

Research methods:

The research will consist of three phases:[10]

1. *Analysis Phase:* What is the problem and how does the system in which it is embedded look?[12]

 — Internal variables using the VESTER approach (sensitivity model) based on the ecological principles of living systems.

 — External variables using the PESTE+ model, which refers to politics, economy, society, technology and ecology, as well as values and lifestyles, as guidelines for environmental scanning.

2. *Projection Phase:* Aim at different contextual scenarios for uncertain future conditions by using possible future frames: "Quattro Stagioni."[10]

3. *Synthesis Phase:* What do we need for synthesis? Using SWOT analysis and a matrix of decision options to ask "what if?"

These methods should contribute to seeing the future through a new lens in order to gain a better understanding of how to tackle real-world problems. This is very much needed to provide innovative and creative visions and solutions in a sustainable way.

—

11 SIMON, HERBERT *The Sciences of the Artificial,* 3.ed., Mass.: MIT Press, 1996.

12 VESTER, FREDERIC (2007), *Ibid.,* 198.

ORIGINAL POSTER

Why do I, as a design researcher, always have to explain myself?

Dennis Oswald, (M.A.) | Email: info@designmethods.de | Blog: http://www.designmethods.de

01. Questions

Why do I, as a designer in general, and as a design researcher specifically, have to repeatedly explain my work and motives?

Why isn't there a general, well-known reference book, encyclopedia or catalog about the discipline of "design research" with its own explicit design methods, its unique understanding of design, its standards, and its most popular respresentatives and theories?

Do I, as an image-creating designer and as a problem-solving design researcher, have an "image problem"?

If we were to build one, how would it look and work?

If there is one, why is it not taught at the (German) design schools and universities?

02. Hypothesis

While the design research community does not have such a standard-setting "encyclopedia of design methods," our work will be underestimated by the public/clients, and we will not get the interesting jobs, projects and the large budgets we want.

to unite and share the knowledge and skills of different design and research communities

to set standards by specific terms and processes to sharpen our internal and external communication

to make the design process itself more efficient and comprehensible for other scientific disciplines

03. Synthesis

a.) **Collect:** Collective or archive database *about* design methods.

b.) **Discuss:** Discussion platform *through* which the design research community debates.

c.) **Assign:** Application tool *for* designers and researchers supporting their work.

DRAFT DRAFT

Prototype (Work-a-Like): Visualization-Tool with Hypergrid running on **MedioVis** Software from the Human Interaction AG, Uniseversity of Constance (Master's Thesis 2006)

Draft (Look-a-Like): Layout Interface-Design for the Visualization-Tool **MedioVis** Software from the Human Interaction AG, Unisversity of Constance (Master's Thesis 2006)

After the methods are discussed, defined and accepted by the community as initial standards, they could be taken from the pool of "approved" methods and assigned to different visualization- and selection-tools.

DESIGN & METHODS

Reminder: Questions & Hypotheses, October 25th–26th, Berlin

Quote: Peter Metholz: Business & Design

Screenshot: Weblog: http://blog.designmethods.de relized with Wordpress.com (D. Oswald, since 2007)

Category: Design Methods

Screenshot: Prototype Wikipedia http://wiki.designmethods.de, realized with MediaWiki (starts end of Oktober 2009)

Once the investigation is done, the collected methods have to be discussed, selected and checked by a wider community through an application platform.

The shown examples illustrate that there are a lot of existing and free software-tools that could be used to realize a discussion platform for the whole research and design community, e. g. Ning.com, Liferay.com

Screenshot: Database on 200 design methods and 90 layout principles, realized with Excel (Master's Thesis, 2006)

Submit Entry

Screenshot: Draft for a CMS-based database

Research all the existing databases of methods, lists and tools, to get standardised data. Collect this data in an easily bound format (e.g. Excel) and enter it into a CMS system (e.g. Drupal) so that the data can be exported to other discussion platforms or visualisation tools.

POSTER+COMMENTS

Why do I, as a design researcher, always

Dennis Oswald, (M.A.) | Email: info@designmethods.de | Blog: http://www.designmethods.de

01. Q

Why

design researcher specifically have to repeat
tedly explain my work and motives?

[1]

[2]

01—No, there is no such thing as a "standard-setting encyclopedia of design methods" – that has been tried and failed, because it results in "full control" (i.e. design guarantees) of the design solution/outcome.

02—Interactive, open source and public, online

02. Hypothesis

While the design research community does not have such a standard-setting "encyclopedia of design methods," our work will be underestimated by the public/clients, and we will not get the interesting jobs, projects and the large budgets we want.

[3]

03. Synthesis

a.) **Collect:** Collective or archive database *about* design methods.

b.) **Discuss:** Discussion platform *through* which the design research community debates.

c.) **Assign:** Application tool for designers and researchers supporting their work.

to unite and share the knowledge and skills of different design and research communities

to set standards by specific terms and processes to sharpen our internal and external communication

to make the design process itself more efficient and comprehensible for other scientific circles

03— Is the trio of applications necessary, or can one tool combine all?

04— Weblog is nice for news and updates, but I would prefer Wikipedia as a more structured tool for empirical work.

05— How can other design process models be integrated?

06— Looks like iTunes, which could be an interesting interface for a method-tool.

07— This is an iterative process that will never end.

After the methods are discussed, defined and accepted by the community as initial standards, they could take... from the pool of "approved" methods and... signed to different visualization and selected tool...

...one, the collected meth... selected and checked by... h an application platform.

The shown examples illustrate that there are a lot of existing and free software-tools that could be used to realize a discussion platform for the whole research and design community. e.g. Ning.com, Liferay.com

FINAL PAPER

—

"Why do I, as a Design Researcher, Always Have to Explain Myself?"

Dennis Oswald

Abstract

During my master's thesis I collected approximately 300 design methods from various sources. I implemented this database in a special "hyper grid" information visualization application.[1] Each method is characterized by attributes (e.g. procedure, aim, costs, material), so that the "method-tool" supports designers in finding an adequate method or set of methods for their problems or questions.

—

1 MedioVis, "Product of Human-Computer Interaction." (Germany: *University of Constance*, 2006), *http://hci.uni-konstanz.de*

Poster (description)

The poster is divided into three segments: *questions, hypothesis and synthesis.* I open with provocative questions to initiate the discussion about the self and public perception of design and the design research community, specifically the gap between these two images:

> *"Do I, as an image-creating designer and as a problem-solving design researcher, have an image problem?"*

My *hypothesis* points out that design and the design research community have not yet found a way to communicate their instruments and methods as reliable, innovative and promotional sales tools to the public (i.e. future clients), and in this way contrast with other disciplines (e.g. marketing, consulting). As a result, they are often underestimated. To change this, I suggest establishing a method database platform (method-tool):

> *"While the design research community does not have such a standard-setting 'encyclopedia of design methods', our work will be underestimated by the public/clients, and we will not get the interesting jobs, projects and the large budgets we want."*

In the main segment *synthesis,* I present three steps *(collect, discuss and assign)* to develop a "method-tool" for designers, design researchers, students and teachers, based on existing applications and software:

1. "Collective or archive" – database about design methods
2. "Discussion" – platform through which the design research community debates
3. "Application" – tool for the design researchers

Some of my statements were confirmed by the feedback on the poster and the input during and after the conference. In other areas I was obliged to re-think and to revise them:

Revised: Questions & Hypotheses

In my opinion, designers and design researchers still struggle with their public perception. For most people (including designers), design is still

linked with beauty, aesthetics, typography and visual layouts. It is not yet established as a scientific discipline with its own methods, or as an innovation-driven process for solving complex problems. The public, designers and design students have often never heard of "wicked problems"[2] or "design methods"[3] as explicit terms, or "research for, through and about design,"[4,5] nor seen a compendium of these topics.

Therefore, designers and the design research community have to think about how to communicate the advantages of their working methods in a transparent way to the collaborating disciplines and to their clients.

Referring to the poster comment, "No, there is no such thing as a 'standard-setting encyclopedia of design methods' – that has been tried and failed, because it results in 'full control' (aka design guarantees) of design solution/outcome," I wish to point out that, in my understanding, an "encyclopedia" is not exactly a single framework or process model that promises "full control" for all future tasks. Rather, it will be a learning tool where designers will find a wide pool of methods and may select those that fit their current problem.

I am persuaded that such an "encyclopedia" of design methods will support the awareness of design as a "major strategy for competitive success"[6] towards the community itself, and the public/clients. This "encyclopedia" will:

— be a point of reference for the design community

— sharpen internal and external communication by standardizing terms and processes

— make the design process itself more efficient and predictable for all involved parties

2 RITTEL, H. and M. WEBBER, "Dilemmas in a General Theory of Planning, Policy Sciences," Vol. 4 (Amsterdam: Elsevier Scientific Publishing Company, Inc., 1973): 155–169. *http://www.uctc.net/mwebber/Rittel+Webber+Dilemmas+General_Theory_of_Planning.pdf* (accessed 9 May 2009)

3 JONES, JOHN CHRISTOPHER, *Design Methods,* (John Wiley & Sons, 1970), 2nd ed. 1992.

4 FRAYLING, C. "Research in Art and Design," in *Royal College of Art Research Papers*, Vol. 1, No. 1, 1–5 (1993/1994).

5 FINDELI, ALAIN "Research through Design and Transdisciplinarity: A Tentative Contribution to the Methodology of Design Research," in *Proceedings of Focused – SDN Symposium 2008*. Berne, Switzerland (2008): 67–91.

6 OWEN, CHARLES L. "Design, Advanced Planning and Product Development." 1998. *http://www.id.iit.edu/141/getdocument.php?id=128* (accessed Feb., 2008).

— enable a scientific approach because of its transparency, traceability and discipline

— support design education by teaching a less restrictive conception of design and training students to handle complex tasks

Revised: Project task and approach

The feedback from the conference had the most impact on the synthesis section. I found out that there are already diverse applications that list and arrange methods ranging from a simple matrix[3] to paper cards,[7] websites,[8] and complex applications.[9]

Primarily, these tools or interfaces are closed systems. Furthermore, these tools themselves are often purchasable goods, which makes them somewhat biased. As a user, one can only take and use them as they are. For the most part, they work only if connected to their own design process model, or have a limited set of methods and use their own visualization. In most cases, there is no feedback or discussion function implemented, which makes them inflexible for rearrangements by users according to their upcoming tasks.

Yet as JOHN C. JONES mentioned in the early 1970's, there is not and will never be a general or final solution for adopting design methods in the design process:

> "Is there any general theory, or set of principles, to which one can refer in selecting and combining design methods? The plain answer is 'no'."[3]

In view of the complexity of problems and the unpredictability of future tasks, this is certainly still true.

Thus, my new project's task will not be to create just another interface or framework in addition to the existing ones. Instead, the focus of my tool is to return to the "encyclopedia" approach and the design methods themselves. Therefore, the new tool must:

7 IDEO Method Cards: Product of IDEO, Palo Alto, California, USA.
8 "Design & Emotion." *http://designandemotion. org/society/knowledge_base/tools_methods.html* (accessed March 9, 2009).

9 CHOW, ROSAN and WOLFGANG JONAS, "Beyond Dualisms in Methodology." 2008. Paper presented at the DRS 2008 conference *Undisciplined*, Shefield, UK.

— be unbiased

— be free to share and to participate in

— provide a collection of existing information

— be open for new content/feedback (e.g. methods, case studies, user experience)

— enable discussions through a wider research community (e.g. blog, forum)

— be flexible for rearrangements (method filtering and clustering).

So, after considering all this and the conference input, I will change and adjust my "method-tool" project.

Among other things, it was mentioned that the division into three tools is unnecessary; I agree. In the future application, the former tri-section *(collect, discuss and assign)* will be reduced and unified to one single application. The future application will be an independent **"Design Methods Encyclopedia"** based on the free software WikiMedia.

Why? Because all relevant functions of the "collective or archive data-base" *(Excel or CMS)*, as well as important functions from the "Application-tool" *(MedioVis)*, can easily be integrated into this Wikipedia application. So, collect, discuss and assign will go hand in hand:

1. Wikipedia enables the community to collect existing and emerging design methods, as well as to assign attributes to them for later classification from different perspectives.

2. The platform allows feedback from the community and discussions about the listed design methods by reflecting users' experiences during projects. It also provides further information on the topic of design research, such as literature, weblinks, theories, institutions and representatives.

3. The tool enables designers to select an adequate set of methods by sorting and filtering data according to their problem and project circumstances.

Outlook

By opening the database of design methods, I expect to reach a wider research community and to integrate their different perspectives and experiences into each method. I also intend to collaborate with international design institutions in order to establish my "method-tool" as a well-known and reliable standard.

Fan Xia: PhD Student

First supervisor: Prof. Mike Press
Second supervisor: Prof. Thomas Inns

Duncan of Jordanstone College of Art & Design
University of Dundee

THE HITCHHIKER TO THE DESIGN

The Hitchhiker's Guide to the Galaxy (h2g2) is a science fiction comedy written by Douglas Adams (1979). In this novel, a hapless British man Arthur Dent, travelling with his friend Ford Prefect, an alien from a small planet somewhere in the vicinity of Betelgeuse, escapes the Earth's destruction, brought about by a bureaucratic alien race called Vogons. Accidently picked up by a starship, the Golden Heart, they escape from certain death. Joining the crew (Zaphod Beeblebrox, the fugitive Galactic President, who steals the spaceship; Marvin, the Paranoid Android, a depressed robot with Genuine People Personalities; and Trillian, the only other survivor of Earth's destruction) they embark on the quest to find the legendary planet Magrathea and the Question to the Ultimate Answer.

The Hitchhiker's Note to the Design Management Galaxy refers to the novel described above. But it will soon diverge, with lots of new material and different twists. I, Fan Xia, am the hitchhiker, an earth girl from the mysteriously oriental country China. I have launched my research study from the UK on the western hemisphere of the Earth. I am going to explore the vast, huge, mind-bogglingly big galaxy of Design Management. Hitchhike with different spaceships with the towels (research methods), and embark on a series of adventures to find the planet of Question and the orbiting moons of Hypotheses!

 The hitchhiker: Miss Fan Xia, a Chinese girl, completed her Master of Design Degree and is beginning her PhD in the UK.

 The towel: "Know where the towel is" is a catchphrase from H2G2. In my tour, towel refers to the design research methods.

 Babel fish: In H2G2, the fish feeds on brainwave energy, absorbing unconscious frequencies and excreting a matrix of conscious frequencies. Stick one in your ear and you can understand everything in your language. But in my story, the fish is a metaphor for the confidence and all kinds of abilities to absorb multi-disciplinary information and knowledge for my research.

 The spaceship: Named the Golden Heart in the book, the most coveted ship in the universe represents all the technical equipment I use in my exploration, for example: computers.

 Zaphod Beeblebrox: The Galactic President represents my supervisors in the reality, simply because he has two heads in the book.

 Ford Prefect, Trillian and Marvin: The hitchhiker's friends are also known as other design researchers; they give me their domain expertise during my tour.

 Planet of Question: The broad research theme has been developed through a series of design methods; consequently there are significant distinctive research questions that may be considered, such as 'how neo-Confucian educated designers could exert their creative thinking skills and talents as competitive players in the international environment.

 Moons of Hypotheses: The research aims to examine which design management approaches developed in Europe and North America can be imported to the Chinese context and further to test how it can be adopted to equip Chinese design companies to more successfully meet the challenges and opportunities of the global commercial environment. There will also be a distinctive experience for the Western countries to learn from. Eventually, a holistic knowledge exchange can be made rather than a unilateral knowledge transfer.

Case Study 1: Crystal Digital Technology Co. Ltd (Shanghai)

Case Study 2: Woodhead Shanghai

Case Study 3: AliveWorld Advertising Co., LTD

ORIGINAL POSTER

+ Observation

+ Requirement

1
Have the team members learn by visualizing.
Reinforce that the visualizing method is a progressive process.
Provide positive reinforcement to team members to prove that they can visualize their own ideas.

2
Apply visualization to real-life situations whenever possible.
Use materials and equipment that are easily attainable and economical.
Apply the techniques to a variety of scenarios

3
Structure the information from simple to complex, from concrete to abstract, from general to specific.
Emphasize speed in mastering actions and concepts, reducing time, effort, and cost of working.

4
Help the team develop their own unique style of visual expression
Become a visual thinker and communicator.
Develop the method in a style that is comfortable and can work for them.

5
Help design teams defer judgment. One of the most dangerous pitfalls of learning visual skills is the tendency to judge your work too soon.
Set tight parameters. The workshops are attempted to restrict the team freedom temporarily. Because too many choices breed confusion and non-performance, one needs to decide specifically what to do and do it.

6
Maintain a joyful working environment.

MANAGEMENT GALAXY

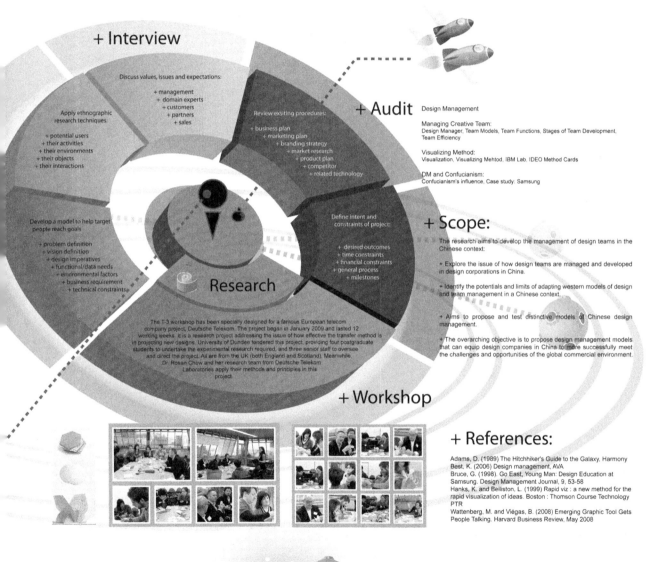

+ Interview

Discuss values, issues and expectations:

+ management
+ domain experts
+ customers
+ partners
+ sales

Apply ethnographic research techniques:

+ potential users
+ their activities
+ their environments
+ their objects
+ their interactions

Review exsiting procedures:

+ business plan
+ marketing plan
+ branding strategy
+ market research
+ product plan
+ competitor
+ related technology

Develop a model to help target people reach goals

+ problem definition
+ vision definition
+ design imperatives
+ functional/data needs
+ environmental factors
+ business requirement
+ technical constraints

Define intent and constraints of project:

+ desired outcomes
+ time constraints
+ financial constraints
+ general process
+ milestones

Research

The T-3 workshop has been specially designed for a famous European telecom company project, Deutsche Telekom. The project began in January 2009 and lasted 12 working weeks. It is a research project addressing the issue of how effective the transfer method is in projecting new designs. University of Dundee tendered this project, providing four postgraduate students to undertake the experimental research required, and three senior staff to oversee and direct the project. All are from the UK (both England and Scotland). Meanwhile, Dr. Rosan Chow and her research team from Deutsche Telekom Laboratories apply their methods and principles in this project

+ Audit

Design Management

Managing Creative Team:
Design Manager, Team Models, Team Functions, Stages of Team Development, Team Efficiency

Visualizing Method:
Visualization, Visualizing Mehtod, IBM Lab, IDEO Method Cards

DM and Confucianism:
Confucianism's influence, Case study: Samsung

+ Scope:

The research aims to develop the management of design teams in the Chinese context:

+ Explore the issue of how design teams are managed and developed in design corporations in China.

+ Identify the potentials and limits of adapting western models of design and team management in a Chinese context.

+ Aims to propose and test distinctive models of Chinese design management.

+ The overarching objective is to propose design management models that can equip design companies in China to more successfully meet the challenges and opportunities of the global commercial environment.

+ Workshop

+ References:

Adams, D. (1989) The Hitchhiker's Guide to the Galaxy, Harmony
Best, K. (2006) Design management, AVA
Bruce, G. (1998). Go East, Young Man: Design Education at Samsung. Design Management Journal, 9, 53-58
Hanks, K. and Belliston, L. (1999) Rapid viz : a new method for the rapid visualization of ideas. Boston : Thomson Course Technology PTR
Wattenberg, M. and Viégas, B. (2008) Emerging Graphic Tool Gets People Talking. Harvard Business Review, May 2008

Planet of Question

Moon of Hypotheses

CONTACT:
Miss. Fan XIA
f.xia@dundee.ac.uk
0044 01382 385295
Duncan of Jordanstone College of Art & Design
University of Dundee, Scotland, UK DD1 4HY

Questions and Hypotheses: When **Design Management** Embraces **Visualization** in the **Chinese Context**

Fan Xia
PhD Research Student
Supervisors: Prof. Mike Press & Prof. Tom Inns
University of Dundee, UK
fxia@dundee.ac.uk

Demographics

User Diary

Competitor Analysis

Observation

Psychographics

Individual survey

Pilot Research

Original Poster

Released in 10.2008

Progress 1
10.2008-05.2009

Formative

Define and Solve Problems

What are the problems?
How can the problems be solved?

Cultural Probes

Iterative Design

Visualization

Personas

Workshop

Questionnaire

Co-Design

Focus Group

Conclusion

Photo-Ethnography

Surveys

Shadowing

Analysis

Research

Progress 2
05.2009-10.2009

Summative Research

Evaluate Solution
Do the solutions fit the problems?
How effective are the solutions?

FINAL PAPER

Questions and Hypotheses: When Design Management Embraces Visualization in the Chinese Context

Fan Xia

This paper outlines a project that focuses on design management, which aims to identify the potentials and limits of adapting visual models of design and team management to a Chinese context. Additionally, it aims to propose and test distinctive models of Chinese design management. The research involves a combination of ethnographic and action research methods as a means of studying processes of design team management in Chinese design firms. The overarching objective is to propose visual models that can equip design companies in China to more successfully meet the challenges and opportunities of the global commercial environment.

The Chinese Context

China has a history that goes back over 5000 years and is known for its cultural richness and ancient civilization. Central to this history is Confucianism, which as an ethical and philosophical system has been fundamental to Chinese culture irrespective of the social formation which has changed from feudal to semi-feudal and semi-colonial to socialist. Confucianism has deeply influenced the moral, social, political and philosophical values in East Asia including China, Japan, Korea, Singapore and Vietnam. In principle, Confucianism is enlightening and uplifting; however, the neo-Confucian mode of thought has evolved philosophies of quick-fix solutions and slipcover mentalities, often based on top-down processes (BRUCE 1998). In the design context, this manifests itself as companies rushing to meet the deadlines of so-called important design projects rather than spending valuable time and money in longterm solution development. Little priority is given to lower-positioned designers' opinions. Therefore, Confucianism, which is often now seen in terms of submissiveness, obedience and conventionality, gotten in the way of the Chinese design industry achieving good design strategies and policy. The *Question* is: What kind of methods and methodologies are appropriate to tackle these problems?

Visualization

Thinking and concepts normally exist in a pictorial form in people's minds. The mind sees things when the brain is activated, including pictures, patterns, still images or even a series of motion pictures. Common phenomena suggest that people remember pictures, diagrams and illustrations more easily than words when reading an article or a book. That is because visual forms can naturally draw people's attention and make the information much easier to be understood. The use of visualization to present creativity, demonstrate opinions and sort information in terms of (mind) maps, scientific drawings, statistic illustration and 3D models has spread all over the world. An example is the well-known schematic diagram of the London underground map designed by HARRY BECK in 1931.

Because our mind thinks in pictures, thinking does not have to involve words. Nor are concepts limited by the availability of words to describe them. Thinking can be in images and can express feelings which are quite definite but too amorphous to be expressed in words. People often have to think in practical, messy ways in order to solve problems and bring things about (BEST 2006). The more efficiently we use our visualizing method, the more freedom and ease we will have in expressing ourselves. HANKS and BELLISTON (1999) stated visualizing functions in three ways:

1. A great way to communicate clear, concise messages
2. A tool to aid learning and remembering
3. A method of expanding the mind to inspire creative thinking and realize creative potentials

Therefore, my *Hypothesis* is that if people could use visual thinking, they would be able to work more effectively and efficiently.

DM embraces Visualization

Design management can be seen from two perspectives. From the internal side, design management is applied in the brand communication, corporation visual identity, products, services, and the advertising of each design or non-design organization. TOPALIAN (1990) stated that within an organization, design management consists of managing all aspects of design at two different levels: the corporate level and the project level. From the external side, design management can respond to handle competition in the marketplace, address government legislation regulations and policies, and accommodate the rapidly changing environment in the world for the management of local and global resources. Therefore, both the internal and external aspects need to be taken into account in the management of design to maximize time, money and costs and to more successfully achieve business goals.

Design companies nowadays face the unique situation that people who work in design firms are from very different backgrounds and

corporations are becoming more complex. As a result, they have difficulty progressing in communication, collaboration and innovation. However, visualization, which is now becoming an increasingly useful business tool, can help to determine suitable solutions in different scenarios. A report from *Harvard Business Review* in 2008 stated that visualization not only helps highlight the firms' problems, but also to promote better collaboration, employee engagement, and company-wide understanding of the organization's challenges.

Series of field research have been completed in the China-based animation design company *Artist Media* to examine the hypothesis. *The aims are to:*
— Provide positive reinforcement to team members to prove that they can visualize their own ideas
— Have the team members learn by visualizing, thus reinforcing that the visualizing method is a progressive process
— Apply the techniques to a variety of scenarios
— Help the team develop their own unique style of visual expression and then become visual thinkers and communicators
— Develop the method in a style that is comfortable for team members and can work for them

Various ethnographic methods and tools combined with visualization are used to address the issue. *Approaches:*

— Literature Review — Demographics
— Surveys and Questionnaires — Psychographics
— Focus Groups — Personas
— Observation — Iterative design
— Photo Ethnography — Visualization
— Visual Anthropology

Seeing the world through *Artist Media's* eyes, I gained insights and understood their problems. Subsequently, I completed analysis and synthesis through the lenses of my multidisciplinary specialties. I then facilitated customized workshops for their creative team using dynamic visualizing approaches. Some lessons for *Effectiveness* have emerged:

— Structure the information from simple to complex, from concrete to abstract, from general to specific.

— Emphasize the importance of speed when mastering actions and concepts, reducing time, effort, and the cost of working.

— Help design teams defer judgment. One of the most dangerous pitfalls of learning visual skills is the tendency to judge your work too soon.

— Set tight parameters.

— Maintain a joyful working environment.

More similar action research will be carried out in the future and I strongly believe that by using visual thinking and involving stakeholders to co-design solutions, we can improve motivation, commutation and collaboration among team members in an interactive and joyful environment.

References

BEST, K. *Design Management*. AVA: 2006.

BRUCE, G. "Go East, Young Man: Design Education at Samsung." *Design Management Journal* 9 (1998): 53–58.

HANKS, K. and BELLISTON, L. *Rapid Viz: A New Method for the Rapid Visualization of Ideas*. Boston: Thomson Course Technology PTR, 1999.

WATTENBERG, M. and VIÉGAS, B. "Emerging Graphic Tool Gets People Talking." *Harvard Business Review* (May 2008).

PART

2

WORK
IN
PROGRESS

ABSTRACT+
COMMENTS

**Phenotype and Genotype
The Subject Always
Changes, but the
Structure Remains
the Same**

**Mareike Graf &
Carmen Hartmann-Menzel**

Hypothesis

The designer is like a black box to most disciplines. The process of generating and creating something new is fuzzy; only results and solutions are measurable. Describing our results and "the way we got to the solution" is the only way we can communicate and confirm the idea of design today; the process itself is not transparent. Having a nontransparent design process also makes the result untrustworthy.

Even though more and more designers show representations of their processes (e.g. IDEO) in order to convince potential clients of what they should pay for, the design discipline still lacks a scientific base compared to technical professions such as engineering.

The specialty of design does not come to the foreground in a convincing way to be taken seriously. Designers do not work in designated laboratories or focus on particular problems but rather complex situations of use considering humans, interaction, cultural diversity, perception and so on. Because of this, the design discipline needs to use its inherent strengths, namely observing, comparing and visualizing, to contribute to

01—What is the status of design compared to the status of other disciplines? **02**—What happens if the designer is first in the process? What would change regarding the product? **03**—Why is the topic of your paper "phenotype and genotype?" I am confused. I think your question needs to be defined. **04**—The question should be more about the goals of each profession, not the methods.

the scientific community in another way.[1] Therefore, in the process of designing, in order to get to a solution, it is key to define the role and potential of design.

Since the designer is a communicator between many disciplines, he should have certain standardized tools to communicate ideas and approaches. We do not doubt the designer's ability to gather different disciplines and contextual information and to create something out of the knowledge in between. But if the communicator is not able to control and communicate his ideas, these ideas will die.

Questions

We would like to research the design process in two different ways. One is at a meta level, looking for structures and parameters that repeat themselves in evaluated projects. Here we start with the design process itself. As we have access to plenty of existing methods and numerous unique projects, we have to gather and screen the information contained.[2]

Our particular approach involves revealing parts of the conceptual phases of the design process which are similar, though the item being designed might be

* With these really helpful questions in mind, we focussed on discussing the goal of our question in our revised paper. Research on methods used by other disciplines, plus a mapping for the professions included in the process, would be nice to have but are simply not manageable. Things are in a state of flux, and every project is unique. For this reason we decided to concentrate on one discipline, the discipline we know best: design. Our experiences with product development showed us that other team members didn't know about the quality that designers could add to a project. Because they didn't know, they couldn't take advantage of the designers' skills. For us, the role of a designer in interdisciplinary projects is to be the communicator as:

a) the one who visualises

b) the advocate for people

c) the out-of-the-box-thinker

So our question now is:

How can we capture the value designers add to the development process?

47

In regard to content, the paper can be structured in the following way:
— Frameset: Starting from an organisational platform
— Developing a communication platform
— Combining views for the future
— Visualization and User Centered Development
— Design Processes
— Transformation of the organizational platform
— Summary

different because of the design discipline or the aim of a project. We ask in the process: What might be "standard," what might change and what is unique?[3]

On the other hand, we would like to research existing representative methods in scientific disciplines in order to compare them with methods and tools used in design.[4] Even though disciplines like engineering do work creatively as well, their way of working, focus and solutions are different. It may be that "design is invisible," but it is sensible. Therefore, the role of design in contributing to development and creation processes increases the quality of results. That is what we wish to highlight.[5]

FINAL PAPER

—

Improving Communication in Development Processes through Design

Mareike Graf & Carmen Hartmann-Menzel

Introduction

Corporations feel a particular need for new product development processes. Saturated markets, technological developments, changing human demands and behavior are some reasons for driving product and service innovation, while competitors, suppliers and their behavior in the market are others (KUMAR 2004, PORTER 1979).

From the beginning of the Nineties on, that competitors distinguished themselves from one another changed. Having previously competed on the basis of the product's functionality, companies began to focus on the creation of an entire experience of a brand or company for the user. The emotional underpinning of product experience became one of the core goals of using design in development processes (VALTONEN 2006). At the same time, design changed from market-led to consumer-led (WHITELEY 1993) and the emphasis on user-centered approaches in design increased in terms of human-machine interaction and usability (BEYER and HOLTZBLATT 1998). Ethnographic methods for understanding user needs have become important tools of the different design fields beyond the usability of digital technology (e.g. IDEO method cards). Although matching user demands appears to be the main goal within development processes, the best performing companies that are also developing new products (the top 25 %) have a success rate of 78 %. The success rate of the poor performers is only 38 % (COOPER 1998), while other statistics show even worse results. Due to the investment drive that takes place before a product is launched, this means a great financial loss.

Design is still seen in many cases – especially in the technical disciplines – as "cosmetics" coming into play at the end of development processes even though approaches like design thinking and innovation through design already seem quite popular in the economics field.

Research Context
Design Management

Design in the Design Management field is described as improving teamwork and business processes in terms of new product development (PRESS and COOPER 1995, BORJA DE MOZOTA 2003). That also means that design is able to contribute to product innovation in different areas (like ergonomics, usability, emotional user experience, cognitive and cultural aspects), as well as process-driven innovation (BORJA DE MOZOTA 2003).

Proper communication is important between designers and the different corporate functions such as marketing, finance, R&D and production. The different backgrounds, ways of working and foci of

those participating in development processes can lead to communicative difficulties in cooperation: "to a marketing manager, a quality design may mean a distinctive package; to a mechanical engineer it may signify ease of fabrication; to an industrial designer it may translate into ease of use" (WALTON 1991).

The definition of the development direction is a sensitive and important starting point for creating a product or service solution. A crucial point is the transfer from collected data into insights, due to the amount and complexity that needs to be handled. For better cooperation and narrowing down the complexity of a topic, overview visualizations showing connections and relations of users, products, information, services, etc. are very valuable (KUMAR 2004).

It does not make sense to involve designers in the early stages. (ENGELN 2006). Designers can contribute to a sharper, user-centered definition of a design problem. The impact in defining the design problem through developing possible solutions (with sketching, creating visual scenarios) starts the iterative design process.

In contrast, the design direction is usually defined by company-driven demands such as distribution, product, price, politics and promotion, rather than actual user demands (KUMAR and WHITNEY 2007). This can be considered as one of the gaps in developing sensible innovation.

Design Thinking

The positive impact that design has on development processes is a result of the way that the designer works and thinks, as comprehensively defined by "Design Thinking" (e.g. BROWN 2008; OWEN 2005). Building up ideas and solutions is one of the core competencies of design, in addition to being working across disciplinary boundaries, and being context-sensitive in terms of user-product surroundings and emotional user experience. The representation of ideas, concepts and solution statements through visualization (for example, KUMAR's Innovation Toolkit represents a wide range of methods and tools for visualization of different kinds) is an important way to integrate people of different backgrounds who are participating in development processes.

Anticipation and empathy are characteristic of the designer's way of working. Verbal communication leaves more space for interpretation than visual representation does, especially in complex questions. The competence of transforming the invisible into something visible (in terms of models, graphics, diagrams, etc.) promotes communication in the team in the early stages of development processes.

Design in Development Processes

The role of design and design consultancy in development processes is different when working in idea development and idea execution. An important turning point during a development process is when a particular idea goes from planning to execution and realization. After that "go" decision, the amount of people and resources committed to the process increases dramatically and with that, as do the costs.

Before the turning point when plans begin to be realised, it is very valuable to have the opportunity to select from a wide range of different visualized ideas. By arguing and comparing different product concepts, people learn to articulate and to recognize what is important, beneficial and reasonable for the desired solution.

However, "one of the main concerns in companies is to know the most suitable ideas to which to commit. All forms of criteria or services that help (...) to make decisions are highly appreciated" (HYTÖNEN, *et al.* 2004). Furthermore, "trying to change an already selected product specification or suggesting alternative product specifications after the hurdle often leads to dissatisfaction, missed deadlines, increased costs etc." (SOMMERLATTE 1990, COOPER and PRESS 1995, HYTÖNEN *et al.* 2004)

Design can reduce risks in development processes by improving communication through the means of visual representations. In order to assure a common understanding of the product and its direction, possible versions of solutions need to be validated in the team.

Research Direction

Today, factors that drive innovation do not only come in the form of technical achievements or user experience of products and brands;

intangible solutions like access to information or the improvement of processes also help provide what users really need.

Therefore, the evaluation of a wide range of product ideas needs to take place at a very early stage of the development process in order to save costs for changing requirements later on or even bearing failure in the market. We would like to highlight how design methods and tools can improve the quality of ideas and the communication between different participating disciplines. This is an argument for the earlier involvement of designers, especially in small and medium-sized companies.

References

ARTHUR D. LITTLE Int., ed., and T. SOMMERLATTE. *Praxis des Design-Management.* Frankfurt am Main: Campus Verlag GmbH, 1990.

BEYER, HUGH and KAREN HOLTZBLATT. *Contextual Design: Defining Customer-Centered Systems.* San Francisco: Morgan Kaufmann Publishers, 1998.

BORJA DE MOZOTA, BRIGITTE. *Design Management: Using Design to Build Brand Value and Corporate Innovation.* New York: Allworth Press, 2003.

BROWN, TIM. "Design Thinking." *Harvard Business Review* (June 2008).

COOPER, RACHEL and MICHAEL PRESS. *The Design Agenda – A Guide to Successful Design Management.* Chichester: John Wiley & Sons Ltd., 1995.

CORSTEN, HANS, ed. *Die Gestaltung von Innovationsprozessen.* Berlin: Erich Schmidt Verlag GmbH & Co., 1989.

ENGELN, WERNER. *Methoden der Produktentwicklung.* München: Oldenbourg Industrieverlag, 2006.

HYTÖNEN, J., J. JÄRVINEN, and A. TUULENMÄKI. *Designium: The New Centre of Innovation in Design,* University of Art and Design Helsinki. Helsinki: Graficolor Ky, 2004.

KUMAR, VIJAY. "Innovation Planning Toolkit," Illinois Institute of Technology – Institute of Design, 2004. *http://www.id.iit.edu/.*

KUMAR, VIJAY and PATRICK WHITNEY: "Daily Life, Not Markets: Customer-Centered Design." *Journal of Business Strategy* 28.4 (2007). *http://www.id.iit.edu/*

OWEN, CHARLES L. "Design Thinking. What It Is. Why It Is Different. Where It Has New Value." Illinois Institute of Technology – Institute of Design, 2005. *http://www.id.iit.edu/*

PORTER, MICHAEL E. "How Competitive Forces Shape Strategy." *Harvard Business Review* (March–April 1979).

THACKARA, JOHN. *In the Bubble. Designing in a Complex World.* Cambridge, Mass.: MIT Press, 2005.

VALTONEN, ANNA. "Back and Forth with Ethics in Product Development: A History of Ethical Responsibility as a Design Driver in Europe." 2006. *http://www.taik.fi/designresearch/.*

ORIGINAL POSTER

Mind the Gap:

Theories and Practices in Managing Service Design

Qin HAN
q.z.han@dundee.ac.uk
School of Design,
University of Dundee,
DD1 4HT

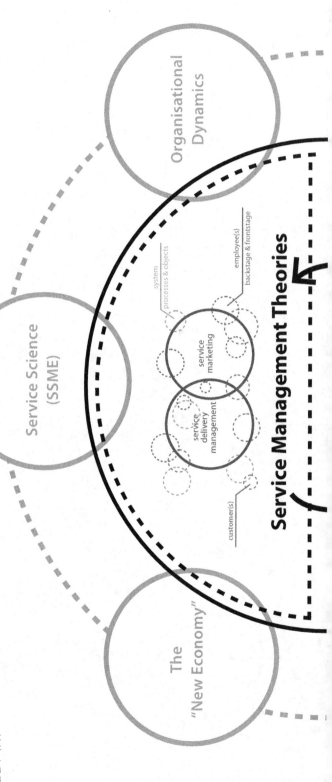

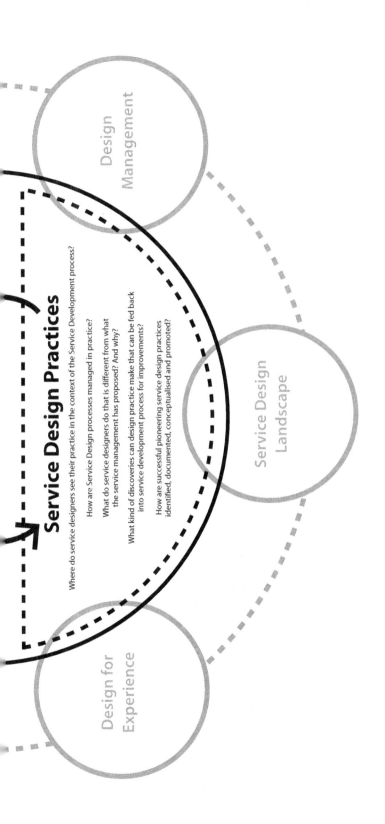

This research explores an emerging design discipline, Service Design, where designers within service organisations, either from the public or private sector, design service systems that create value for customers at different levels. The management of Service Design is particularly focused. Although Design Management is not a new topic, most research in the field studies collaborations between design and business, when the focus is largely upon branding, product innovation, communication and spatial design.

The literature describing collaboration between business and service designers is less well established, and this lack of knowledge has already attracted some attention from scholars around the world.

For example, Brigit Mager from the Köln International School of Design runs projects on a number of topics, ranging from using various art and performance methods in service modelling, to solving problems associated with street prostitution in the Tippelzone of Eindhoven. Bill Hollins, in his recent publications, has explored the definition of Service Design with the British Design Council and developed a Service Design process based on the New Product Design methodology.

In addition, a number of design consultants from different backgrounds have begun working with both public and private organisations to design complex service systems, such as Live|work and Engine in the UK and IDEO in the US.

Service Design, as a young but developing design discipline, urgently requires further in-depth research that involves both theory development and design practice in the real world.

UNIVERSITY OF DUNDEE

POSTER+COMMENTS

Mind the Gap:

Qin H
Q.2.ho
Schoo
Unive
DD1 4

01—What is Service Design?

To be honest, I still don't quite have the answer to the first question, even after almost two years of research. Simply from a New Service Development (NSD) perspective, design is one of the many parallel processes that run through the organisation. For a researcher like me, it provides exciting opportunities to study how Design Thinking could be adopted to solve problems in a totally new field and at a new level in both practice and theoretical development. To designers, it's their day-to-day practice. By using certain tools, methodologies and approaches, designers manage to balance the needs of different stakeholders and help to deliver the design of service system as an outcome. *What is Service Design* is still an evolving debate, but it's also important to appreciate the diversity and creativity it allows for the development of new types of practice and academic research.

[1]

[2]

Service Management Theories

Service Design Practices

Where do service designers see their practice in the context of the Service Development process?

How are Service Design proce...
What do service designers do...
the service management h...

What kind of discoveries can design ...
into service development pr...

How are successful pioneerin...
identified, documented, con...

02— This topic is really broad. What exactly is your focus in this area?

I believe that I have now developed a more focused area of investigation. Back then, the poster presented a very initial and exploratory journey of making sense of the literature and the practices at the time. To be honest, the design practices in the field have developed so much since the poster was presented six months ago. Some of the literature had gradually appeared to be more relevant than others. However, most literature suggests that the stakeholder inputs are essential to the quality of the NSD outcomes. Therefore, the main research question became: "How can designers manage the complex stakeholder involvements in the Service Design process?"

In terms of collecting empirical data, I decided to focus my attention on the project level design process, because the feedbacks from the practitioners suggested that, at the moments in most practices, this is the level where design specialists are operating most effectively within a service business model.

Interestingly, after a series of empirical studies in the second year, a knowledge management perspective started to emerge along with the process management perspective, which made me go back and extend my literature basis.

...ve begun working with both public and private organisations to design complex service systems, such as Livelwork and Engine in the UK and IDEO in the US.

Service Design, as a young but developing design discipline, urgently requires further in-depth research that involves both theory development and design practice in the real world.

This research explores an emerging design discipline, Service Design, where designers within service organisations, either from the public or private sector, design service systems that create value for customers at different levels. The management of Service Design is particularly focused. Although Design Management is not a new topic, most research in the field studies collaborations between design and business, when the focus is largely upon branding, product innovation, communication and spatial design.

The literature describing collaboration between business and service designers is less well established, and this lack of knowledge has already attracted some attention from scholars around the world.

For example, Brigt Mager from the Köln International School of Design runs projects on a number of topics, ranging from using various art and performance methods in service modelling, to solving problems

DUNDEE

FINAL PAPER

—

Mind the Gap: Theories and Practices in Managing Service Design

Qin Han

Introduction

This paper describes the early stage of research conducted as part of a PhD dissertation. It presents the context of the literature and discusses the research directions to be taken.

The research project explores an emerging design discipline, Service Design, where designers with service organizations, either in the public or private sector, design service systems that create value for customers

at different levels. The focus is on how designers manage their practice in the New Service Design (NSD) process while working with a group of stakeholders from different backgrounds. Although the managing of design processes is not a new topic, most research in the field studies collaborations between design and business where the focus is largely upon branding, product innovation, communication and spatial design. The lack of knowledge about managing Service Design has already attracted some attention from scholars around the world. For example, WOLFGANG JONAS explores new methodological approaches for Service Design research (JONAS, *et. al* 2009); BIRGIT MAGER from the *Köln International School of Design* and SHELLEY EVENSON from *Carnegie Mellon University's School of Design* are looking at Service Design from an artistic perspective (MAGER 2009 and EVENSON 2008); and LUCY KIMBELL (KIMBELL and SEIDEL 2008) from the *Said Business School* in Oxford studies the impacts of Service Design for high-tech businesses.

At the same time, a number of design consultants from different backgrounds have begun to work with both public and private organizations in designing complex service systems, such as *Live|work, Engine, Plot, Options* and *Think Public* in the UK, *IDEO* in the US, and *DesignThinkers* in The Netherlands. However, compared with the diverse types of practices in Service Design, the research seems to be limited to the study of design tools, methods and processes. The reflections from a management perspective are occasionally captured by practitioners in their personal blogs and project websites.

These reflections, however, have never been collected and synthesized in a generalizable manner which would inform the future development of Service Design as a discipline and enable other disciplines to recognize the contributions of Service Design in NSD process. Furthermore, the implicit knowledge embedded in the various practices could potentially provide a rich base for the continuing study of service development and innovation in all disciplines. A systematic investigation of how the Service Design process is managed and how the service designers constantly redefine their roles in the rapidly changing economic and social environments is also noticeably absent.

Research Context

The "New Economy"

The shift to a service economy is no longer a new phenomenon. In the UK, the service sector has grown at the expense of manufacturing. Data from the *British National Statistics* (2000) showed that "the services account for around 70% of the Gross Domestic Product (GDP). Private sector services alone account for over 50% of GDP." Organizations in virtually every industrial sector are facing both challenges and opportunities brought about by the increasingly dynamic economic, social, political, technological, legal and ecological changes globally. Increasingly, organizations realize that value creation has shifted from producing tangible goods to organizing intangible service, experience and even relationships (OXTON 2008).

Service Science, Management and Engineering (SSME)

Traditionally, service is defined by its non-material nature, which distinguishes it from tangible products (also called tangible goods). Some widely accepted characteristics of service involve intangibility, inseparability, variability, perishability and non-ownership. This way of understanding service, as being a special kind of "intangible product," is now challenged by a new concept called service-dominant logic, where service is recognized as a process of co-creation of value which then feeds back into this continuing process (VARGO and LUSCH 2008). Service is no longer presented as a series of isolated activities within any organization, rather, it becomes an architecture/platform inhabited by interactions, experience, emotions, value creation, relationships and networking.

In order to study all aspects of such a platform, Service Science, Management and Engineering (SSME) was formed as a multidisciplinary research field which encourages researchers and practitioners from various specialties to cooperate in developing new concepts, methods and practices in order to explore service in not only an organizational, but also a social context (HEFLEY and WENDY 2008). In practice, professionals from science, policy making, business development, marketing, operation, engineering, technology and design get together in creating new

product and service offerings, which presents challenges as well as opportunities for creating new types of collaborations on various projects in different contexts.

Organizational dynamics

The core activities of an organization can be considered to be an important perspective from which to understand the operations of services. The aforementioned activities are Design and Development (or Research and Development in some cases), Marketing and Sales, Accounting and Finance and Manufacturing and Assembly (in a service organization, this is replaced by Delivery Management, as most of the Manufacturing and Assembly activities are outsourced). All of these activities are interdependent and have an impact on various organization-customer interactions. This way of viewing an organization as comprised of complicated machines with different processes is challenged by new theories on organizational dynamics. Such recognition of organizational dynamics acknowledges the nature of emergence in any organization. It also emphasizes a social aspect to organizational activities, where managers (or designers) are participants who actively engage in ongoing conversations.

Design management

As with all core business activities, design needs to be managed. Whether working with or within an organization, the design activities should contribute to fulfilling the long-term strategy of the business development of the company. Design managers have to balance resources at different levels of the company in order to produce the best possible solutions from the efforts of the design team. At the same time, they communicate and negotiate with other functional units in the company so as to achieve a shared recognition of the value created by design (BORJA DE MOZOTA 2003; BEST 2007).

Service is full of human interactions; thus, the design process itself becomes a part of the management of these interactions. Apart from working with user groups to understand their experiences in using service systems, service designers often find themselves playing the role of

design manager at the same time – collaborating with managers, using management language and even providing suggestions for business development.

Design for experience

User experience is complex and can be influenced in many ways. As a group, users' attitudes and behavior are influenced by their political, economic, social, technological, legal and ecological environments. As individuals, their personality, age, gender and geographic location all have an impact on their decision-making processes. Their needs, expectations, profitability and value can differ sufficiently to justify focus strategies that require tailored design solutions for experiential dynamics. In service systems, the user groups include not only the consumers, but also the providers. Therefore, while designing for experience, understanding the complex situation within the organization is just as important as understanding dynamic customer needs and the environment that stimulates them.

Service Design Landscape

In the UK, a number of pioneering design practitioners have joined the rapidly developing business of Service Design. An investigation conducted in the early stage of this research determined some general factors shared by some or all of these consultancies:
— Small group format for design practitioners
— Establishing loose networks with wide ranges of specialists
— Employing multiple channels of design solutions
— User-centered approach
— Close involvement with branding and marketing strategies
— Encouraging cross-functional cooperation within the organization
— Aiming at a long-term impact on the organization

Research Direction

The research contexts show a dynamic yet evolving socio-economic environment that places multiple demands on all aspects of the outcomes of

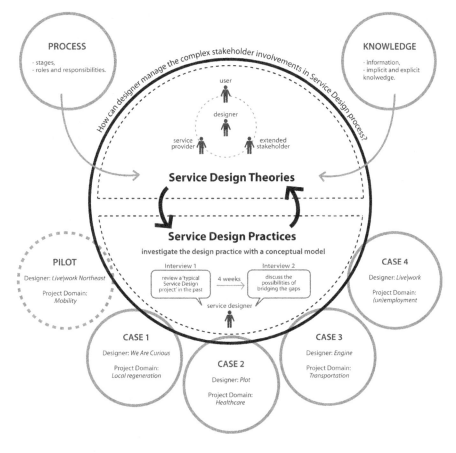

The Research Approach: details of case study methodology employed in this research.

a NSD process. To achieve the best solution, NSD requires inputs from all stakeholders, which include internal stakeholders from the organizational dynamics, as well as external stakeholders such as user groups and supplier teams (WALKER and MARR 2001).

When design specialists are involved in a NSD process, they tend to bring in skills and approaches that not only balance various stakeholders' requests but also create embodied solutions to meet these needs. Therefore, how designers manage multiple stakeholder involvements in the Service Design process became the main research question of this project.

The literature also provides a rich base of possible theoretical models and tools for managing the Service Design process, especially from Service Marketing, Service Management and NPD Management. Established NSD management literature in process management, knowledge management, and stakeholder relationships could provide a conceptual model that links the contribution of design to existing principles of NSD and service innovation. However, we must be cautious with the attempt to adopt models and methods from other disciplines to explain or examine what is happening in Service Design. As an emerging design area, Service Design is still relatively immature in theoretical development and generalizable best practices. Nonetheless, its fast development in the past decade has shown a potential to give birth to new tools, approaches, even hypotheses that inspire theoretical development. Therefore, rather than building a model to be used as a form of best practice or to examine existing Service Design projects, this research becomes a method of exploring the field of practice and locating further research inquiries.

This research, by its nature, is exploratory. A conceptual model based on Service Management theories is developed to shape the investigation of Service Design practice. At the same time, it also collects the contributions of pioneering practices with the aim of improving existing theories. The rapidly growing Service Design practices in the UK provide a rich empirical base for a more deductive approach to this research. Thus, a case study approach is employed to explore the empirical field, to locate further research inquires and to search for answers to the research question.

Acknowledgements

The author wishes to thank PROFESSOR TOM INNS and PROFESSOR BILL NIXON for their suggestions and guidance on this research. She would also like to acknowledge the inspiring conversations and feedback she had during the Design Research Network conference in Berlin in 2008.

References

BRITISH NATIONAL STATISTICS. *The UK Service Sector.* London: National Statistics, 2000. *http://www.statistics.gov.uk/statbase/*

BEST, K. *Design Management.* Lausanne: AVA, 2006.

BORJA DE MOZOTA, B. *Design Management: Using Design to Build Brand Value and Corporate Innovation.* New York: Allworth Press, 2003.

GILLHAM, B. *Case Study Research Methods.* London and New York: Continuum, 2000.

GOULDING, C. *Grounded Theory: A Practical Guide for Management, Business and Market Researchers.* London: SAGE, 2005.

JONAS, W., R. CHOW and N. SCHAEFFER. "Service Design Descriptors: A Step Towards Rigorous Discourse," in *Design Connexity: 8th International Conference of the European Academy of Design, Conference Proceedings,* edited by J. MALINS. 2009.

KIMBELL, L. and V. SEIDEL, ed. *Designing for Service – Multidisciplinary Perspectives.* Oxford: Saïd Business School, 2008.

MAGER, B. and S. EVENSON. "Art of Service: Drawing the Arts to Inform Service Design and Specification," in *Service Science, Management and Engineering,* edited by B. HEFLEY and W. MURPHY. New York: Springer, 2008.

OXTON, G. "An Integrated Approach to Service Innovation," in *Service Science, Management and Engineering,* edited by B. HELFLEY and W. MURPHY. Pittsburgh, PA: Springer, 2008: 97–105.

STRAUSS, A. and J. CORBIN. *Grounded Theory in Practice,* London: SAGE, 1997.

VARGO, S. and R. LUSCH. "A Service Logic for Service Science," in *Service Science, Management and Engineering,* edited by B. HELFLEY and W. MURPHY. Pittsburgh, PA: Springer, 2008: 83–88.

WALKER, S. and J. MARR. *Stakeholder Power.* Cambridge, Mass.: Perseus, 2001.

YIN, R. *Case Study Research: Design and Methods.* 3rd ed. London: Sage Publications, Inc., 2003.

ORIGINAL POSTER

MATRICES & EXPERIENCES
in pursuit of looking and communication

title

goal — this research project aims to achieve an ordering of experiences, a strategy for self-reflexivity and to generate a grammar worthwhile to read and possible to use

sculpture	strategy	subversion	intensity
indistinctness	materiality	texture	image
commomplace	typology	layering	x
facts	puzzles	splinters	old masters

material

matrix (I), ca 10000 images = 15 years of conscious looking matrix (T), ca 15 terms = 10 years of formulating a language matrix (W), ca 20 key projects = 15 years of architectural practice

matrix (I) ⟺ matrix (T) ⟺ matrix (W) ⟺ matrix (I)

these connections lead to: formulating experiences + creating insights on own architecture and related mechanisms + communication to others + testing and modifying output

strategy 1 matrix (I) ⟺ matrix (T)

refining my look at the environment by labeling all images (I) with the terms (T) is a reflection on looking. by doing this the reader may improve his own way of looking

output:
classifications,
video and
textual
comment

first series of videos on architecture. in these videos some terms are far more present than others.

strategy 2

matrix (T) ⟷ matrix (W)

positioning the series of terms (T), already reflections, in front of the architectural work (W) generates interpretations for myself and for an audience. the audience gets a view on how architecture *functions*

fragments of a documentary on my own house, after it was built. working in particular with the terms sculpture. materiality: indistinctness

output:
new
photography,
video and
textual
comment

strategy 3

matrix (I) ⟷ matrix (W)

by juxtaposing images (I) and architecture (W) my *look* becomes sharper. it might bring the creative process and the way of looking closer to an audience

selection of collages (key-projects + images)

output:
collages and
textual
comment

research — all strategies aim for a refinement of the terms. at the end they should function as small containers of knowledge

keywords — analogous spaces, architecture, grammar, look, matrix, photography, terms (architecture, sculpture, strategy, subversion, intensity, indistinctness, materiality, texture, image, commonplace, typology, layering, x facts, puzzles, splinters, old masters)

who — ir. arch. Thierry Lagrange, thierry.lagrange@architectuur.sintlucas.wenk.be, www.alt-architectuur.be + prof. Rolf Hughes (Sint Lucas) + prof. Paul Cruysberghs (KUL), supervisors
Sint Lucas, Department of Architecture, Ghent-Brussels, Belgium

POSTER+ COMMENTS
—

01—Alain Findeli discusses the research question and how the design question and answer are related to it. In this area there is still work to be done. The goal must be re-interpreted with Findeli's thoughts in mind.

[1]

[2]

02—The outcome of testing and modifying has to be defined more precisely. It must be an evaluation process that involves students and the audience.

title

goal this research project aims to achieve an ordering of experiences in pursu

mat

sculpture

indistinctness

commonplace

typology layering

puzzles splinters old masters

matrix (W) matrix (t)

matrix (W) matrix (t)

output
classifications,
video and
textual
comment

first series of videos on architecture, in these videos some terms are far more present than others.

strategy 2

matrix (T) matrix (W)

positioning the series of terms (T), allegede reflections, in front of the architectural work (W) generates interpretations for myself and for an audience. the audience gazes over on how architecture functions / terms

03—What are the possible meanings of a literal interpretation of all these lines drawn on the poster? Is it a plan for a mental construction? Is it a transformation of a matrix?

matrix (I)

by juxtaposing images (I) and architecture

04—In addition to the research, a consistent introduction that reflects on multiple elements (the matrix, the look, the allegory, the analogous space, etc.) is needed.

[3]

output
new
photography,
video and
textual
comment

[4]

strategy 3

output
collages and
textual

at the end they should function as small containers of knowledge

biography, terms (architecture, sculpture, strategy, subversion, intensity, indistinctness, ...ture, image, commonplace, typology, layering, x facts, puzzles, splinters, old masters)

thierry Lagrange, thierry lagrange @architectuur.seduca.web.be, www.dearchitectuur.be
...olf Hughes (Sint Lucas) + prof. Paul Craysberghs (KUL), supervisors
Sint Lucas, Department of Architecture, Ghent-Brussels, Belgium

FINAL PAPER

—

Matrices & Experiences, a Pursuit of Looking and Communicating

Thierry Lagrange

Introduction

After fifteen years of working as an architect and photographing the environment, the time has come for a more in-depth reflection on these activities. My first thoughts and ideas have resulted in a more structured research project set up with some handy tools such as matrices, tables and maps, with photographs linked to a number of experiences and with text fragments contextualizing the project on the one hand and experimenting with the creative output on the other.

Goal

Matrices & Experiences, a quest of looking and communicating is a PhD project that starts with a preliminary ordering of experiences (photographic, architectural and linguistic) in so-called matrices. By implementing several actions on the potential relations between such matrices, the aim is to elucidate a personal grammar and thereby identify the basis for an evaluation phase. The research question can be put as follows: Can one identify and represent the purportedly "ineffable" qualities of experiential knowledge in design practice? The research answer comprises a series of actions that express a designer's way of thinking.[1]

The matrices, each with a specific content, are juxtaposed next to each other so that relations and conflicts can be traced. By selecting these connections, reflection becomes possible and new artistic output, such as text, photography and video, can be created. This continuous working process, with the matrices and their juxtaposition as central elements, generates a routine. Individual cases can then be worked out and a so called personal grammar for self reflexivity can be written down. Nevertheless, the final goal is not limited to a self-reflexive approach. The approach embeds certain aspects that are useful for others. To make this concrete it is necessary to establish a phase of communication, evaluation, correction and fine-tuning with an audience (a public, students ...).

The project must lead to a better understanding of some of the patterns in design thinking that I have developed as an architect and a photographer. Through this knowledge it should be possible to improve my work as well as that of others.[2] In other words, this project will investigate the relationship of experiences in such situations as:

1 It is ALAIN FINDELI's contribution to the conference that lead to this explicit formulation.
2 The actual contextualization of this research project resulted in a close reading of a series of publications in the field of photography (BERND & HILLA BECHER, DIRK BRAECKMAN, ROBERT FRANK, FRANÇOIS HERS, GERD SANDER, ETC.), art (HONORÉ D'O, JAN DE COCK, GERHARD RICHTER, MARCEL DUCHAMP, ETC.) and architecture (RENÉ HEYVAERT, HERZOG & DE MEURON, STEVEN HOLL, ROGER BOLTSHAUSER, ETC.).

Moreover, it is particularly important to mention the academic work of: KORMOSS, B. and P. EISENMAN. *Theories End Practices.* T.U. Eindhoven, 2007 and RUNBERGER, J. *Architectural Prototypes.* Licentiate thesis (part of PhD) KTH School of Architecture and the Built Environment, Stockholm, 2008. These dissertations are of great interest, the first one for the interpretation of the matrix, the latter for its way of organizing his whole study.

— What do I see in my environment, on specific locations, by coincidence?

— How do I use concepts to respond to specific design questions and problems?

— How do I construct procedures relating to my architecture to anticipate complex problems (financial, juridical, legal, etc.)?[3]

The element of time is a crucial factor when thinking about these experiences and forming a vision of a design, a problem, an architecture itself, etc. It may be helpful to ask the question before, during and after the design process. Each time span can result in a different reflection or a different answer. The research partly aims to investigate how this complex notion of timing really functions.

Material-matrix

The type of material used in this research problem is a given. My experiences as an architect and photographer are mainly materialized in projects, images and words. So the material used in a first stage consists of the following:

— Architectural work over a period of more than 10 years. There may be a difference between key works (ca. 8) and works of interest (ca. 20).

— A collection of images (ca. 5000), photographs taken by myself and other photographers. This is the result of 15 years of consciously looking at the world – call it the explicit materialization of an architect's gaze.[4] There is a direct, but complex relation between the architect's gaze and the architectural work.

— A series of key words (ca. 18: sculpture, strategy, subversion, structure, intensity, indistinctness, materiality, texture, image, commonplace, typology, layering, x, facts, puzzles, splinters, old masters, new masters, etc.). These key words have emerged during those years of designing and are not always explicit, but rather sometimes latent and implicit. Over time my design attitude has involved handling those key words without

3 These situations are some elementary examples symptomatic of an architectural design process.

4 LAGRANGE, T. "An Architect's Eye, Looking as an Essential Act in a Design Process." *Procs. Interrogations: AHRC Postgraduate Conference,* 2009: 127–137

a fundamental theoretical background. Next to the architecture and the photography these key words constitute a language.

All three collections are dynamic. The architectural work does not end. New projects are in progress. The collection of images is becoming larger every day. And the language can, after every new experience, change little by little. By including them in this research project , I am exposing all three collections to new actions (elimination, variation, selection, change, etc.). This type of continued change will permit me to evaluate and update any interpretation that is developed.

The tool that is used to organize the answers to these questions is the matrix.[5] Although situated in mathematical discourse, it is also seen as a pragmatic tool in the present context. The matrix can position data in a structured way and allows for the analysis of their relations. But because the matrix also implies systematic changes of perspective, it becomes a dynamic tool. It is clear that the matrix should not determine the analysis – a distinct risk of any kind of tool. Additional tools may have to be developed or used, including extensions of the language, which I have been developing some key words for.

The use of the matrix tool may be exemplified as follows. The work, the images and the key words are referred to as #W, #I, #K, respectively. How can we explore the relationship between those matrices? The aim is to find links or similarities between their content. In other words, the matrices should serve as catalysts that trigger interesting experiences and insights which could indicate the intended interpretation.

5 LAGRANGE, T. "Self-Reflexivity as a Tool for a More Relevant Design-Process. Mapping Strategies and Creative Outputs by Using Matrices." *Procs. IASDR Conference*, 2009: 160

Action

By constructing a chain of actions, this project is now finally initiated. This chain starts with a creative phase and ends with a phase of evaluation and reorientation.[6] The first phase starts with selecting cells in these matrices, goes further with producing videos, images and texts and ends with edited video, portfolios of images and text cycles. The second phase starts with communicating to an audience, goes further with an active participation and ends with an evaluation.

In the meantime, the matrix is also used as a tool for reflection. It transforms into a more elaborate form, such as the poster presented on the *Questions & Hypotheses* conference. This tool functions as an analogous space, similar to a conceivable architectural space and possible to visit.[7] Walls become lines, rooms become smaller matrices, etc.

Once this chain of actions is set in motion, it becomes clear that there is a crucial underlying element that leads to a certain representation of the ineffable qualities of experiential knowledge. This element is the allegory. The allegory, introduced by handling images, videos[8] and matrices in a way that generates analogous spaces, leads to new interpretations beyond the ones initiated by the architect and the photographer. Thanks to the mental action of an audience, elements of the ineffable qualities become apparent.

6 Through the discussion with ALAIN FINDELI it became clear that the evaluation phase must be defined in a more rigorous way.

7 LAGRANGE, T. "Mental Spaces, a Design Tool Seen in a Historical Perspective" *Procs. Analogous Spaces Conference,* 2008

8 The videos (such as the triptych *Old Masters*) are the main artistic output of this research project. Reinterpreting the matrices and their mutual relations have given rise to a series of videos. These videos will function as key elements in an exhibition which has experiential knowledge as one of its main themes.

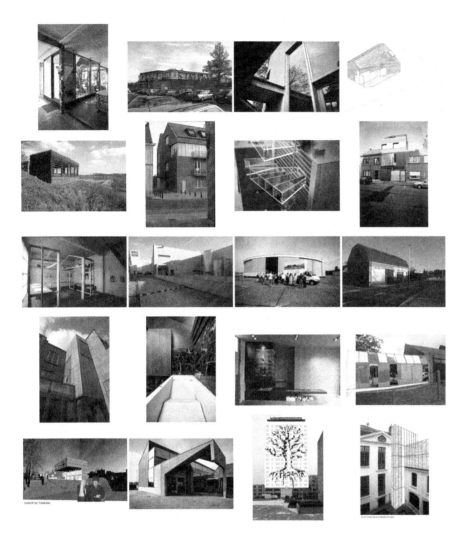

VANOP DE FABRIEK

ZICHT VANOP DE WILFRIEDE STRAAT

#W

#I

sculpture	strategy	subversion	intensity
indistinctness	materiality	texture	image
commonplace	typology	layering	x
facts	puzzles	splinters	old masters

#K

Stills of the video "Old masters"

ORIGINAL POSTER

COMPLEX CONNECTIONS

CONTEXT

Action on increasing socio-cultural economic and environmental instability will require contribution and participation from all levels of society.. Complex interrelations of organizational structures and networks of communication make comprehension of contemporary culture an impossible task to achieve from any single perspective, if at all.

In response design objectives are now centering less on development of individual ideas and more so on processes and frameworks of collaboration. Ezio Manzini (1998) explains that we are a society moving from a focus on material goods to one of information. A paradigm shift from a perception of product-based well-being to one of context describes a need for decentralised forms of organization.

METHODS AND METHODOLOGY

To date:
Structured discussion with key thinkers
Literature review
Contextual review
Field case studies

Proposed - Ethnographic research in urban environments:
Field case studies
Prototyping
Empirical Observation

RESEARCH QUESTIONS

What is required for the creation of autonomous platforms of reflective space and time in urban communities?

What "visioning" methods are appropriate for designers to employ?

HYPOTHESIS

This research considers a potential role for design working primarily with soft assets of community. The objectives are to explore what is required in creating platforms for the autonomous flow of conversations within urban communities. The nature of this research differs from conventional design perspectives. It asserts that meaning is not a definable entity but one that flows from individual to collective as a result of experience. It is interaction through these contextual experiences that create what Joseph Lyons (1973) describes as the "over-life" of a place.

A design objective in a changing paradigm may be to provide platforms for open conversation. Through the provision of these platforms, the opportunity to come together, understand and reunite ourselves with reality, may begin to move us towards more sustainable scenarios of living. This will require practice that does not look to interpret cultural meaning, but provide space for conversation and meaning to flow.

Key objectives are to understand the value of reflective space and time, so that opportunities for critical engagement and orientation are increased, thereby allowing local groups to navigate and direct new future action in a distributed and decentralised manner.

6 KEY THEMES

CONTEXT

COMPLEX CONNECTIONS

1. COMPLEXITY

"The present escapes us when we escape to thoughts of what was yesterday or what may be tomorrow. So if there is no time like the present then we are in this sense out of time much out of time."
(Gault, R. 1995. P.152)

KAIROLOGICAL TIME
- QUALITATIVE
- TIME OF OPPORTUNITY

- INCREASING INSTABILITY

- SOCIO-CULTURAL
- ENVIRONMENTAL
- ECONOMIC

A DIAGRAMMATIC INTERPRETATION OF COMPLEXITY BY TRANSFORMATION DESIGNER COLIN BURNS.

2. UNDERSTANDING

"Understanding as distinguished from correct information and scientific knowledge, is a complicated process which never produces unequivocal results. It is an unending activity by which, in constant change and variation, we come to terms with, reconcile ourselves to reality, that is to be at home in the world."
(Arendt, H. 1953)

COMPLEX INTERRELATIONS

RE-FRAME
- INDIVIDUAL IDEAS → PROCESSES OF COLLABORATION
- MATERIAL GOODS → INFORMATION/CONVERSATION
- PRODUCT BASED WELL-BEING → CONTEXT BASED WELL-BEING

"The language of the official future inhabits a separate world, which is not the same world as the people of the city..."

While Glasgow's future might be insulated from the everyday lives and aspirations of the city its people and it's costs are not.
(Hassan, G. Mean, M. Tims, C. 2007)

OFFICIAL FUTURES VS SELF-STRUCTURED FUTURES AND COMMUNITY STRUCTURED FUTURES

3. RECONCILIATION

"SOFT ASSETS"

CENTRALISED ASSETS WHEN NECESSARY

HARD ASSETS / SOFT ASSETS

SUBSIDIARITY

- FREEDOM TO EXPRESS
- FREEDOM TO ACT

4. NESTING

URBAN ENVIRONMENTS
- COMPLEX
- PERMEABLE
- OVERLAPPING

NEED! STRENGTHEN CONNECTIONS:
"To respond with speed and effectiveness, people need access to the intelligence of the whole system. Who is available, what do they know and how can they reach each other."
(Wheatley, M. 2005)

5. LANGUAGE

THE BASIS OF HUMAN EXISTENCE → HUMBERTO MATURANA

LANGUAGE + EMOTION = CONVERSATION
- CONTINUOUS INTERPLAY
- THAN GODANELDIE

"...consensual braiding of emotions and co ordinations of consensual behaviours."
(Maturana, H. 1997)

REFERENCES:

ABENDT, A. (1953) The difficulties of understanding. [online] Unpublished. Available at: http://www.aando.online/ Accessed 3a.08.30

BALZDGLU, Z. (1998) The role of product design in post-industrial society. Ankara: METU Faculty of Architecture.

BURNS, C. (2004) On dialogue. London: Routledge

GAULT, R. (1995) In and out of time. Ecommonsense Values X. Cambridge: White Horse Press

HASSAN, G. MEAN, M. TIMS, C. (2007) The dreaming city and the power of mass imagination. London: DEMOS

LYDALL, I. (1973) Approach: an introduction to a personal psychology. New York: Harper & Row

MASEINI, E. BION, T. (2002) Sustainable everyday: scenarios of urban life. Milan: Edizioni Ambiente

MATURANA, H. K. (1997) Metta design [online]. Chile: Instituto de Terapia Cognitiva Chile. Available at: http://www.inteco.cl/metta/

MATURANA, H. J. (1980) Autopoiesis and Cognition: the realisation of the living. Boston: Reidel Publishers, inc.

WHEATLEY, M. (2005) Finding our way: leadership for an uncertain time. San Francisco: Berrett-Koehler Publishers, inc.

LESLEY McKEE
l.j.mckee@dundee.ac.uk

POSTER+COMMENTS

COMPLEX CONNECTIONS

"Complex Connections" represents an early stage in this doctoral research. The reflections seen here come through further contextual review, experiences and conversations since.

CONTEXT

Action on increasing socio-cultural economic and environmental instability will require contribution and participation from all levels of society. Complex interrelations of organizational structures and networks of communication make comprehension of contemporary culture an impossible task to achieve from any single perspective, if at all.

In response design objectives are now centering less on development of individual ideas and more so on processes and frameworks of collaboration. Ezio Manzini (1998) explains that we are a society moving from a focus on material goods to one of information. A paradigm shift from a perception of product-based well-being to one of context describes a need for decentralised forms of organization.

METHODS AND METHODOLOGY

To date:
Structured discussion with key thinkers
Literature review
Contextual review
Field case studies

Proposed - Ethnographic research in urban environments:
Field case studies
Prototyping
Empirical Observation

RESEARCH QUESTIONS

What is required for the creation of autonomous platforms of reflective space and time in urban communities?

What "visioning" methods are appropriate for designers to employ?

HYPOTHESIS

This research considers a potential role for design working primarily with soft assets of community. The objectives are to explore what is required in creating platforms for the autonomous flow of conversations within urban communities. The nature of this research differs from conventional design perspectives. It asserts that meaning is not a definable entity but one that flows from individual to collective as a result of experience. It is interaction through these contextual experiences that create what Joseph Lyons (1973) describes as the "over-life" of a place.

A design objective in a changing paradigm may be to provide platforms for open conversation. Through the provision of these platforms, the opportunity to come together, understand and reunite ourselves with reality, may begin to move us towards more sustainable scenarios of living. This will require practice that does not look to interpret cultural meaning, but provide space for conversation and meaning to flow.

Key objectives are to understand the value of reflective space and time, so that opportunities for critical engagement and orientation are increased, thereby allowing local groups to navigate and direct new future action in a distributed and decentralised manner.

CONTEXT

COMPLEX CONNECTIONS

6 KEY THEMES

1. COMPLEXITY

INCREASING INSTABILITY
• SOCIO-CULTURAL
• ENVIRONMENTAL
• ECONOMIC

A DIAGRAMATIC INTERPRETATION OF COMPLEXITY BY TRANSFORMATION DESIGNS' COLIN BURNS.

OUR ABILITY TO COMPREHEND

SOCIAL COMPLEXITY

SOMEWHERE AROUND 1870's

TIME

COMPLEXITY

"The present escapes us when we escape to thoughts of what was yesterday or what may be tomorrow. So if there is no time like the present then we are in this sense out of time much out of time."
(Gaut, R. 1995. P.152)

KAIROLOGICAL TIME
• QUALITATIVE
• TIME OF OPPORTUNITY

2. UNDERSTANDING

COMPLEX INTERRELATIONS

"Understanding as distinguished from correct information and scientific knowledge, is a complicated process which never produces unequivocal results. It is an unending activity by which, in constant change and variation, we come to terms with, reconcile ourselves to reality, that is to be at home in the world."
(Arendt, H. 1953)

Are convergent user-centered, co-design processes adequate in dealing with the constant flow of meaning in real world contexts. As design steps beyond it's conventional boundaries what are the transferable attributes of the designer?

OFFICIAL FUTURES v.s SELF-STRUCTURED FUTURES AND COMMUNITY STRUCTURED FUTURES

"The language of the official future inhabits a separate world, which is not the same world as the people of the city...

While Glasgow's future might be insulated from the everyday lives and aspirations of the city its people and it's costs are not.
(Hassan, G. Mean, M. Tims, C. 2007)

RE-FRAME
• INDIVIDUAL IDEAS → PROCESSES OF COLLABORATION
• MATERIAL GOODS → INFORMATION, CONVERSATION
• PRODUCT BASED WELL-BEING → CONTEXT BASED WELL-BEING

3. RECONCILIATION

SPACE = the opportunity of people to come together in conversation. A future objective of this research is to explore the relationship between physical and abstract space.

SOFT ASSETS are a set of intangibles such as skills, culture, ideals, and common situations, settings and such as; environment, local be, principals, commerce and the capacity to deliver personal.... (Freuler, C. 2006)

CENTRALISED ASSETS WHEN NECESSARY

HARD ASSETS
COMMUNITY RESOURCES
SOFT ASSETS

SUBSIDIARITY

Soft assets such as culture, skills, social ties and memories already permeate everyday life. The challenge is not to aquire them, but to increase capacity for people to act on them

• FREEDOM TO EXPRESS
• FREEDOM TO ACT

4. NESTING

URBAN SUBDOMAINS
• COMPLEX
• PERMEABLE
• OVERLAPPING

STRENGTHEN CONNECTIONS:
"To respond with speed and effectiveness, people need access to the intelligence of the whole system. Who is available, what do they know and how can they reach each other."
(Wheatley, M. 2005)

NEED!

5. LANGUAGE

THE BASIS OF HUMAN EXISTANCE →HUMBERTO MATURANA

LANGUAGE + EMOTION = CONVERSATION
• CONTINUOUS
• DURRETABLE
• TRANSGENERATIONAL

"...consensual braiding of emotions and co ordinations of consensual behaviours."
(Maturana, H. 1997)

REFERENCES
ARENDT, H (1953) The attributes of understanding [essay] Unpublished, Available at: http://www.dac.neu.edu/ Accessed 24.08.08

BALCIOGLU, T. (1998) The role of product design in post-industrial society. Ankara: METU Faculty of Architecture Press

GAULT, R. (1995) In and out of time. Environmental Values 4, Cambridge: White Horse Press

HASSAN, G. MEAN, M. TIMS, C. (2007) The dreaming city and the power of mass imagination, London: DEMOS

LOWE, J. (1973) Experience: an introduction to a personal psychology. New York: Harper & Row

MAGING, E. ASDIL, F. (2000) Sustainable everyday: scenarios of urban life. Milan: Edizioni Ambiente
http://www.edizioniambiente.it/Formats/0006/lancio_ing.htm

MATURANA, H. R., (1997) Metadesign [online], Chile: Instituto de Terapia Cognitiva Chile, Available at:
http://www.oikos.org/metadesign.htm Accessed Vol 42, 4:1-173

MATURANA, H. & VARELA, F. J., (1998) Autopoiesis and cognition: the realization of the living. Boston:
Studies in the Philosophy of Science Vol. 42, 4:61-173

WHEATLEY, M. (2005) Finding our way: leadership for an uncertain time. San Francisco: Berrett-Koehler Publishers, Inc.

LESLEY McKEE
l.j.mckee@dundee.ac.uk

FINAL PAPER

—

Crafting the Space for Change: Towards a New Perspective on Design's Contribution to Community Development and Democracy

Lesley McKee

"We must examine what each of us can contribute from our own specific role in society. We must ask the question: What can I do as a professor, construction worker, taxi-driver, school teacher, prostitute, lawyer, pianist, housewife, student, manager, politician or farmer?" (PAPANEK 2001, 17)

As social, economic and environmental instability increase, there is a growing realization that changes to our patterns of living will require contribution from everyone. This paper explores the challenges facing design as it pushes beyond conventional boundaries into real world contexts. It discusses a greater provision of space within everyday urban environments for people to better navigate and direct their own future action. It concludes by questioning if HANNAH ARENDT's concept of "craftsmen of democracy," rather than design, may provide a more useful theoretical framework for affecting social transformation.

EZIO MANZINI believes that significant and sustained change will require scenarios of living that are judged by everyone to be preferable to current conditions (BALCIOGLU 1998). *The Sustainable Everyday Project* catalogs examples of community-driven service development at a local level and asks how design can support social innovation (MANZINI and JEGOU 2003). This is a theme currently being explored by *Designs of the Time* (DOTT), a ten-year rolling initiative taking place across different regions of the UK and advocating a design application's potential to engage with to social issues (THACKARA 2007). The emphasis thus far has been on "design-led community engagement projects ... to drive the development of new solutions to social and economic challenges and involve communities in designing new local services" (DESIGN COUNCIL 2009).

BURNS *et al.* (2006) assert that transformation and service objectives are built on methods and processes established in the 1960's through the Scandinavian Participatory Design Movement. Over recent decades user-centered design and co-design have sought to incorporate user feedback into varying stages of the design process. Democratization of process therefore, is not a new concept. What makes new social service objectives interesting is that they push beyond conventional design boundaries into everyday life and behavior.

In these new contexts user-centered, co-design tools have been adopted, inviting parallels to be drawn with early incentives for greater public participation in policy and planning initiatives. SMITH (1981) explains that within the UK, "By the late 1960's government realised it was better to consult people on some issues before decisions

were finalised, rather than giving them the right of objection after the event." It appears logical to assess the capacity of collaborative methods and processes for affecting social transformation. However, the notion of collaborative community (MANZINI and JEGOU 2003) represents very different scenarios of living than how we live today. The realization of such scenarios will require radical transformation of the public sphere. Once we move beyond the creation of products to social transformation through the public sphere, is democratization of the process adequate? (PRESS 2006).

> "There are varying degrees of participation and co-design, but co-design work-shops (such as experience prototyping and user-led design reviews) all point to more designers making the design process accessible to non-designers." (BURNS *et al*. 2006)

THACKARA (2007) has presented the perspective that providing the tools and frameworks for greater social connectivity is a form of innovation, or design-led social innovation. If design has a role to play in support-ing social transformation, it appears crucial that we assess the limits of a "design-led" application to economic and social development. SHERRY ARNSTEIN (1969) asserted that true citizen participation "is the redistri-bution of power that enables the have-not citizens, presently excluded from the political and economic processes, to be deliberately included in the future."

ARNSTEIN's *Ladder of Citizen Participation* (1969), contains eight rungs of participation, each moving closer to citizen power. Consultation and placation are at rungs four and five on the ladder, and both are attrib-uted to tokenism. This appears to suggest that expansion on the notion of social regeneration fundamentally requires space for people-led action. In laying the foundations for social transformation, what can design contribute to established areas of public policy and planning? Can design contribute to the provision of space for people-led action?

Glasgow 2020, an 18-month project run by London think-tank *DEMOS*, sought to uncover the "non-institutional" picture of the city through the medium of storytelling. The project highlighted the negative

effects of centralized, top-down, closed systems of organization and decision-making: "the language of the official future inhabits a separate world, which is not the same world as the people of the city." (HASSAN, *et al.* 2007). If change must come through everyone, bridging disparities between official objectives and the everyday realities of people is crucial.

German political theorist HANNAH ARENDT considered problems of understanding, such as those highlighted by *Glasgow 2020*, to be the result of a loss of the public sphere and thus, a common world (ARENDT 1953). The consideration she gave to craft in conjunction with human action as a means of enabling socio-political transformation provides insights useful to design in a time of "structural crisis" (MANZINI 1994).

If we apply the concept of "craftsmen of democracy" as developed by ARENDT (LEADBEATER 2008) to an analysis of community-centered and -driven design practice, the focus shifts beyond democratization of the process to democracy and social freedom arising from the conditions that have been created. It is in the provision of space, ARENDT asserted, that the capacity for action manifests itself. In action we are free to see new ways of being. It is this combination of speech and action that "predates and precedes all formal constitution of the public realm and the various forms of government, that is the various forms in which the public realm can be organised" (ARENDT 1958).

Space in this context can be taken to constitute any situation in which people have the opportunity to come together in free and open conversation. Action lays the foundations for work. It is in work that we build the walls, both physical and meta-physical, which constitute the human world. It is in work that we are the craftsmen, crafting the conditions of our lived environment. Action therefore has a reciprocal, iterative relationship with work; as we craft the conditions for action, action must precede further work (ARENDT 1958). This research looks to the provision of active space within urban environments as a constant state, not as a stage contained within processes. An exploration of the relationship between physical and abstract space is a key future objective of this research.

References

ARENDT, H. "The Difficulties of Understanding." 1953. *http://www.loc.gov/* (accessed August 26, 2008).

ARENDT, H. *The Human Condition.* Chicago: University of Chicago Press, 1958.

ARNSTEIN, R. S. "A Ladder of Citizen Participation." *Journal of the American Institute of Planners* 35, no. 4 (1969).

BALCIOGLU, T., ed. *The Role of Product Design in a Post-Industrial Society.* Ankara: METU Faculty of Architecture Press, 1998.

BURNS, C., H. COTTAM, C. VANSTONE, and J. WINHALL. *The Red Paper 02: Transformation Design.* London: Design Council, 2006. *http://www.design council.info/mt/RED/transformationdesign/TransformationDesignFinalDraft.pdf* (accessed November 3, 2006).

DESIGN COUNCIL. "Dott Cornwall Tenders." 2009. *http://www.designcouncil. org.uk/en/Design-Council/1/What-we-do/Our-activities/Dott-Cornwall-tenders/* (accessed May 20, 2009).

HASSAN, G., M. MEAN, and C. TIMS. *The Dreaming City and the Power of Mass Imagination.* London: DEMOS, 2007.

LEADBEATER, C. *We-Think: Mass Innovation Not Mass Production.* London: Profile Books Limited, 2008.

MANZINI, E. "Design Environment and Social Quality," in *Design Renaissance '93 Selected Papers from the International Design Congress,* edited by J. MYERSON. Horsham, West Sussex: Open Eye Publishing, 1994.

MANZINI, E., and F. JEGOU. *Sustainable Everyday: Scenarios of Urban Life.* Milan: Edizioni Ambiante, 2003.

PAPANEK, V. *The Green Imperative.* London: Thames and Hudson, 2001.

PRESS, M. "Review." *The Design Journal* 9, no. 3 (2006): 59–62.

SMITH, L., and D. JONES, D., ed., *Deprivation, Participation and Community Action.* London: Routledge & Kegan Paul LTD, 1981.

THACKARA, J. *In the Bubble: Designing in a Complex World.* London: MIT Press, 2005.

THACKARA, J. *Wouldn't It be Great if...We Could Live Sustainably – by Design?* London: Design Council, 2007.

ABSTRACT+
COMMENTS

Seduction and Healing in Architectural Design – Can Consumption Spaces Heal?[1]

Zdravko Trivic

Dr Ruzica Bozovic-Stamenovic and Dr Limin Hee

01—It is a very unusual topic, and therefore quite experimental in terms of the approach, but is it relevant? 02—What do you mean by contemporary consumption space?

Designs of contemporary consumption spaces[2] have been recently criticised both for their lack of multi-sensorial stimuli and over-stimulation, for lack of identity and over-production of artificial identities – both for their ugliness and over-beautification.

Furthermore, prevalent in existing literature is a belief that people's behavioral, emotional and bodily reactions are manipulated by these places in such a way that people's well-being is threatened. This paper argues that such a manipulation should not be understood as a necessarily negative phenomenon, since the role of design is the deliberate manipulation of sensual

I describe *contemporary consumption spaces* as recently built complex and hybrid spaces that slowly abandoned unified architectural schemes of common shopping environments, where the traditional distinctions between private and public, leisure and consumption, culture and economy, etc. have been broken down. They have less and less to do with the exchange of goods, but rather with the pursuit of pleasure that comes from spacial experience.

03—The concepts *seductive experience, ambiental power* and *multi-sensorial pleasure* need to be clarified. Once refined, these concepts need to be related to *healing potentials*, and *well-being* in the context of consumption spaces. Without these, it is hard to see the value and implications of answering the proposed questions. The context can be made clearer if the author explains or describes the reasons or imports for the hypothesis that consumptions spaces may have certain healing potentials. And here more reference to

stimuli in order to achieve certain outcomes. The paper hypothesises that consumption places may have certain healing potentials resulting from the seductive experience of a places themselves, their ambient power, seductive design and multi-sensorial pleasure arising from the experience.[3]

While the negative effects are easier to observe, much less is known about the positive influences of contemporary consumption places on people's well-being. Similarly, whilst the effects of polluted and physically impoverished environments are somewhat more obvious, the influences of good design and aesthetically pleasing surroundings are arguably uncertain and difficult to measure. Although empirical evidence of such effects is hard to come by, there is plenty of anecdotal evidence as to the pleasure and happiness that better design may bring (PARKER 1990). It is a challenge (and responsibility) for architects to uncover the healing effects of their designs, regardless of the immense difficulty that such an attempt may pose.

existing knowledge and research will help. It is an interesting assumption, very catchy as it connects the concepts we usually do not. It may seem unsafe, but this is exactly what the research in design should be about.

This paper challenges predominant narrow understanding of health in public spaces, which is often linked to mere hygiene and safety, the absence of disease, functionalism and comfort. Our everyday urban experiences keep showing the limitations of such approaches as too rational and fashionable. The *World Health Organization* defines health as "a state of complete physical, mental and social well-being and not merely an absence of disease and infirmity" *(www.who.int/en)*. Thus, this paper addresses health and well-being as dynamic phenomena, in that people generally feel them not in measurable terms but in more subjective ways. Well-designed and aesthetically pleasing spaces make people happy and satisfied, give them high self-esteem and thus may positively affect their mood and health (KOLSTAD, in COLD 2001; LONSWAY, in LUKAS 2007). In fact, various studies show that "the psychological state of happiness" is a better predictor of coronary risks than any other clinical variable (LINTON, in MARBERRY 1995). However, such a subjective understanding of health still appears to be highly problematic and is difficult to test and apply in the design process.[4,5,6]

04—How do you measure happiness?

Interesting question. I don't know, but it is worth trying. Read for example: Jane Wernick, ed. *Building happiness: architecture to make you smile*, RIBA Building Futures. London: Black Dog Publishing, 2008.

05—How can the imposition of any kind of power be positive? The pleasure and short-term happiness possibly arising from it are still unreal. The ultimate goal is negative.

There is an intention in every design. Historically, spaces have had innate seductive properties. Once seduction was abused, it stood out as a problem. But that does not mean that experience itself is a priori unpleasant or unreal. Its immense continuous effectiveness, in fact, proves the contrary.

06—Indeed, health is about being in a good mood. Over-beautified places do not always make us happy. What about ugly and unhealthy spaces and actions that make us happy!?

Furthermore, "theming," "mallification" and "Disneyfication" are criticised as dominant models for all types of public spaces today, which usually result in homogenous and monotonous designs often described as clinical, sterile or sanitising. The predomination of aesthetic values of such designs leads to the privileging of vision over other human senses which further weakens people's sensations and critical awareness. Therefore, the process of aestheticization is seen as a source of anaestheticization as it tends to erase any unpleasant association, to reduce any pain and to induce a form of numbness (LEACH 1999).[7] However, such a limited understanding of aesthetics only creates so called "cannons of beauty" – static social conventions that suppress people's intuitive feelings of both beauty and health. In fact, the employment of theming in hospital environments has been proven to be highly successful in the treatment of some neurological diseases, such as Alzheimer's and Parkinson's diseases. Thematic design with carefully orchestrated environmental cues can stimulate senses and improve memory loss, disorientation and language deterioration, as well as decrease recovery time. However, it is more than controversial and slippery to approach both public spaces and their users in the same manner as we approach hospital environments and their patients – however traumatic, stressful or neurotic our cities might be.

Architecture is fully involved in this condition and aestheticization has become an unavoidable consequence for the architectural profession. However, all this suggests that aesthetic experience still plays

The *total healing* concept in healthcare research advocates an individual yet holistic approach. It states that positive distractions trigger positive emotions, which have positive impacts on human health and recovery time. This surely opens the discussion on things that we generally understand as unhealthy, but which in fact affect people positively. This also creates new design possibilities.

07—The hypotheses are experimental, against the mainstream and daring: for instance, to state the places and spaces of consumption as possibly *healing* instead of a moralistic disaffirmation of *Disneyfication*. Convincingly argued and reasoned.

My thesis does not try to dismiss these critiques, but rather challenges them. It assumes that consumption spaces are changing, both in terms of structure and program, as well as people's appreciation of them, creating a new form of arguably more interactive and transparent *publicness*.

o8—The hypotheses are not interesting enough. Despite the fact that I could feel the good intentions behind the author's questions, I feel that the research questions and the hypotheses are on the beaten path. (Sorry). It is surely not new to say that there are relations between design objects, aesthetics, experience, and emotion, although there perhaps is something more to learn in the context of consumption spaces and healing. In other words, the hypotheses are perhaps reasonable, but are not surprisingly interesting.

an important (if not critical) role in both architectural design and people's well-being. The most common initial response to the environment is emotional and multi-sensorial. Architecture is, indeed, an art form that engages the immediacy of people's multi-sensory and emotional experience more fully than other art forms (HOLL 2006). It needs to re-discover its potential to upgrade and become a healing tool instead of generating further problems.[8]

Additionally, this paper questions ordinary architectural research proposing a multi-disciplinary approach and advocating breaking the existent boundaries of individual disciplines and conventional formulas. It develops a theoretical concept that brings together the knowledge on seduction, multi-sensorial pleasure and well-being in contemporary consumption spaces.

The intention of my research is not necessary to learn about manipulative strategies *in* contemporary consumption spaces, but rather to learn *from* it. In order to go beyond the usual and constrained understanding of health and well-being and how it can be affected by (in)appropriate architectural design, I rather prefer to explore the hypotheses which are not safe and predictable.

93

Such knowledge comes mostly from discourses other than architecture, such as environmental psychology (psychoanalysis and atmospherics), philosophy (phenomenology and aesthetics) and sociology.

The questions that this paper poses may seem vague and somewhat "esoteric": What makes seductive architectural design? What is the role of multi-sensorial experience in consumption spaces? What kind of pleasure does it engender? Can consumption spaces heal?[9]

In order to answer these questions, a more subjective approach and emphasis on users' experiences are seen as relevant and needed.[10,11]

Finally, this paper will present the major results obtained through a pilot study conducted on new consumption spaces in Singapore and Belgrade, Serbia.[12] This preliminary research saw consumption spaces as sites of multi-sensorial journeys. The research aimed to identify how rich in sensorial stimuli and how seductive chosen places were from the users' perspective and to examine possible relations between the intensity and variety of sensorial stimuli and people's subjective evaluation of pleasantness and seductive power. Preliminary results[13] showed a certain correlation between the intensity of positive sensorial stimuli, the level of people's satisfaction with the place and the level of seduction. This paper will also discuss new investigations that will be conducted during August and September 2008 in Belgrade, Serbia.

09—**The research questions are clearly, and (self-)critically defined and promising. But are the research questions significant? They are quite vague in the sense that they require further formulation.** Indeed, the research questions may not be formulated well enough here. The intention was to make them look more unconventional and controversial, as the theme of the conference seemed to encourage. "Brown cows produce chocolate milk…" – remember? However their importance seems to be neglected here. Our hospitals are over-crowded; people will spend less and less time there; our cities and lifestyles are enormously stressful; etc. Architects and planners are responsible for creating places instead of spaces that will affect people positively, on both bodily and mental level, and in such a way contribute to healing. The power of seduction can direct people's conscious and subconscious attentions towards positive distractions that would otherwise not be noticed.

10—**This paper is particularly interesting because of the inter-disciplinary approach and evaluation. It will be helpful to know more about the applied methods. It is unclear what the author means by the**

subjective approach and it is also unclear which methods are used or planed to be used. I suggest that the author review existing approaches and methods in architectural and design research. More subjective approach refers both to: (a) the subjective and active role of the researcher in the research process, re-introducing and questioning his subjective experience and interpretations as valid for rigorous design research; and (b) collecting data from users' subjective experiences and evaluations. The approach is phenomenological, user-oriented and self-investigative. It includes indicative Post-Occupancy Evaluation (POE) based on first-person participatory observation, participatory surveys/photo-journeys, interviews, sensory mapping and spatial/typological analysis. 11—Working in healthcare design I have not come across a similar method, which aims to indirectly gather people's positive and negative subconscious preferences towards one space. It can be well applied in hospitals, particularly because it would make patients and staff active in the whole process. Hospitals do not need to look like shopping malls (although some resemblance would not hurt, I guess), but they can learn from the attention-grabbing tactic. It can also contribute to building more positive awareness about hospitals, as opposed to strong fear and hostility. Bringing elements of everyday life to patients can also alleviate the stress and loneliness coming from a feeling of confinement and isolation from the outside world. 12—Particularly interesting because of the team approach between researchers (and

ZDRAVKO TRIVIC — ABSTRACT

their spaces to be investigated) of very different cultures and from different parts of the world. Why Belgrade and Singapore? They seem incomparable. This research does not actually include a team approach in terms of having more than one researcher in different cultural contexts. In fact, one researcher conducts both field works. This allows the researcher to always gather primary data. The reasons for choosing different cities for investigation include: (a) seduction is assumed to be a global phenomenon; different contexts may be important for modifying its mediation and representation through design; (b) shopping malls are new concepts for city of Belgrade, compared to such development in Singapore; and (c) the researcher is familiar with both contexts, which makes the field work easier to conduct; he is also considerably distanced from both contexts (being a foreigner, and being away) which gives necessary balance and a level of "objectivity" to research. 13—Promising and exciting if carefully researched. The research results seem not to be significant.

FINAL PAPER

—

Seduction[1] and Healing in Architectural Design: Can Contemporary Consumption Spaces[2] Heal?

Zdravko Trivic

Dr Ruzica Bozovic-Stamenovic and Dr Limin Hee

—

1 *Seduction* in consumption spaces usually refers to a hypocritical power strategy, which manifests itself through prescribed architectural designs in order to manipulate the amount of time and money people spend and how much pleasure they gain. (DOVEY 1999). We define seduction as a subtle and sophisticated form of interactive power exchange, which unlike *manipulation* relies on an acknowledgement of both real and unreal, pleasure and pain, limit and limitless, etc. While manipulation keeps the subject ignorant, seduction acquires both physical and mental action. It is an interactive game, in which rules are not hidden from the seduced. "Seduction is never linear, and does not wear a mask" (BAUDRILLARD 1990, 106). "It is seductive to be seduced, and consequently, it is being seduced that is seductive" (BAUDRILLARD 1990, 68).

2 We describe *contemporary consumption spaces* as complex and hybrid spaces (in terms of both structure and program/function) that have slowly abandoned unified schemes of common shopping environments such as of typical shopping malls. They oppose the rules of manipulation and make more diverse multi-sensory experiences and space-user interactions possible. They have less to do with the exchange of goods and more to do with the pursuit of pleasure that comes from spacial experience.

The most common initial response to spaces is emotional (PÉREZ-GÓMEZ 2006) and multi-sensory (PALLASMAA 1996; MERLEAU-PONTY 1962). Architecture has immense potential to engage the immediacy of people's multi-sensory and emotional experiences more fully and effectively than other art forms (HOLL *et al.* 2006). However, architectural design practice often either neglects or manipulates this fact, creating formulas and design strategies that have been uncritically implemented globally.

In recent research, the design of contemporary consumption spaces has been criticized both for its monotony and over-stimulation, for ugliness and over-beautification. Furthermore, a belief is prevalent that formulas and design strategies, as used in these spaces to ultimately fulfill their higher consumption goals, manipulate people's emotional and bodily reactions in such a way that their behavior and subjective well-being is threatened (CRAWFORD, in SOROKIN 1992). *Theming, mallification, commodification* and *Disneyfication* are some of the terms coined to criticize commercialized strategies as predominant models for designing and re-shaping all types of public spaces today. It is often argued that the predominance of aesthetic values has led to the privileging of vision over other senses, which further weakens people's sensations and critical awareness. In such a way, the process of aestheticization becomes a source of intoxication and anaestheticization, as it tends to erase any unpleasant association and induce a form of numbness (LEACH 1999). However, such a limited understanding of aesthetics only creates so called "cannons of beauty" – static social conventions that suppress people's intuitive feelings of both beauty and health (COLD 2001).

We challenge these often nostalgic and quasi-moral critiques, arguing that such manipulative design strategies should not be understood as necessarily negative phenomena, as imposing certain experiences in order to achieve certain outcomes is the essential goal of each design. Focusing on the phenomenon of seduction and the power of ambiance, we trace positive facets of these more sophisticated and less obtrusive power strategies. Moreover, we hypothesize that seduction in

contemporary consumption places may have certain healing potentials resulting from the seductive experience of a place itself – from pleasant sensual and symbolic interactions with space.

Our main research questions are:
1. What is the nature and manifestation of seduction in contemporary consumption spaces?
2. What are the implications of seduction on architectural design of contemporary consumption spaces, and *vice versa*?
3. What are possible ways to rigorously explore and evaluate phenomenon of seduction in architectural design?
4. What are the potential implications of seduction and seductive design on people's subjective well-being?

While the negative effects are easier to perceive, much less is known about positive influences of consumption places on people's well-being. Similarly, while the effects of polluted and physically impoverished environments are somewhat more obvious, the influences of good design and aesthetically pleasing surroundings are more uncertain and difficult to measure. Consequently, the concepts of seduction, subjectivity and healing are still stigmatized and neglected in scientific research as too elusive and unreliable, and too difficult to measure, evaluate and incorporate into the design process.

In order to trace evidence for the healing potential of the seduction phenomenon, we also challenge the predominant narrow understanding of health and well-being. Such an understanding is often linked to hospital environments, hygiene, safety and the absence of diseases. Healing is, however, not restricted solely to healthcare environments, and our everyday urban experiences keep showing the limitations of such reasoning. The *World Health Organization* defines health as "a state of complete physical, mental and social well-being and not merely an absence of disease and infirmity" *(http://www.who.int/en/)*. Thus, health and well-being are dynamic phenomena, and people generally feel them not in measurable terms, but in more subjective ways.

The "total healing" concept and theory of positive distractions in healthcare research advocates for more a subjective, individual and holistic approach to healing. Positive distractions trigger positive emotions and pleasure, which have positive impacts on human subjective health, and reduce stress and recovery time. Well-designed spaces make people happy and satisfied, give them higher self-esteem and thus may positively affect their mood and health (KOLSTAD, in COLD 2001; LONSWAY, in LUKAS 2007). In fact, various studies show that "the psychological state of happiness" is a better predictor of coronary risks than any other clinical variable (LINTON, in MARBERRY 1995). Moreover, happiness and positive emotions (coming from appreciation of the built environment) have received more prominent attention in more recent architectural design research (WERNICK 2008).

We have developed a new form of research instrument which we want to use to investigate seduction as a subjective and elusive phenomenon and its possible implications on people's subjective well-being. We will also use the research tool to re-introduce and re-explore the relevance and validity of subjectivity in rigorous design research. It is mainly phenomenological, interdisciplinary, user-oriented and self-investigative, and includes two main phases. The first phase employs critical review, interpretation and an interconnecting of relevant theories, design practices and available research methods, while the second phase includes the original on-site research, which was conducted in four recently built shopping malls in Singapore and Belgrade, Serbia. On-site investigation was based on indicative post-occupancy evaluation (POE) that includes: descriptive experiential phenomenological method (first-person observation), participatory task journeys (photo-walks, interviews and short questionnaires), sensory mapping and spatial/typological analysis. The approach reinforced users' active participation through performing certain tasks (making photographs in this case) in order to gather indirect evidence for investigated phenomenon. The intention was to trace participants' first affective, emotional and sensory subjective readings of space, their mood and pleasure triggered by space, as well as their sense of subjective well-being.

Our preliminary results show that seduction operates primarily on subconscious physical and emotional levels, and that it considerably depends on the number, intensity and diversity of the positive/pleasant sensory stimuli provided. Seductive design triggers and subtly directs people's bodily and mental attention towards positive multi-sensory distractions that otherwise would not be seen, and thus contribute to their subjective well-being. As such, the logic of seduction may play an important role and possesses potential for creative application in architecture, particularly in healthcare design.

Initial results also seem to suggest that more complex, hybrid and organic spaces have considerable seductive and sensory qualities as opposed to early generation shopping malls. Furthermore, people seem to resonate better to such spaces, and to establish more positive physical and mental dialogues with them. This correlation between mediation / representation of power and space structure/atmosphere, as well as their mutual influences and transformations, call for further investigation. Concepts such as fractal theory, Gestalt theory, body-space continuum and biophilia (WILSON 1984) are seen as possibly fruitful for further analysis.

References

BAUDRILLARD, JEAN. *Seduction.* Translated by BRIAN SINGER. Basingstoke: Macmillan, 1999.

COLD, BIRGIT. "Introduction," in *Aesthetics, Well-Being, and Health: Essays within Architecture and Environmental Aesthetics,* edited by BIRGIT COLD. Aldershot, Hants, England; Burlington, VT: Ashgate, 2001.

CRAWFORD, MARGARET. "The World in a Shopping Mall," in *Variations on a Theme Park: The New American City and the End of Public Space,* edited by M. SOROKIN. New York: Hill and Wang, 1992.

DOVEY, KIM. *Framing Places: Mediating Power in Built Environment.* London; New York: Routledge, 1999.

HOLL, STEVEN, JUHANI PALLASMAA, and ALBERTO PEREZ-GOMEZ. *Questions of Perception: Phenomenology of Architecture.* San Francisco, CA: William Stout Publishers, 2006.

KOLSTAD, ARNULF. "What Happens if Zeleste Becomes an Architect?" in *Aesthetics, Well-Being, and Health: Essays within Architecture and Environmental Aesthetics,* edited by BIRGIT COLD. Aldershot, Hants, England; Burlington, VT: Ashgate, 2001.

LEACH, NEIL. *The Anaesthetics of Architecture.* Cambridge, Mass.: MIT Press, 1999.

LINTON, PATRICE. "Creating a Total Healing Environment." *Fifth Symposium on Healthcare Design, San Diego, CA, 1992,* in *Innovations in Healthcare Design : Selected Presentations from the First Five Symposia on Healthcare Design,* edited by SARA O. MARBERRY. New York: Van Nostrand Reinhold, 1995.

LONSWAY, BRIAN. "The Experience of a Lifestyle," in *The Themed Space: Locating Culture, Nation and Self,* edited by SCOTT A. LUKAS. Lanham: Lexington Books, 2007.

MERLEAU-PONTY, MAURICE. *Phenomenology of Perception.* London; New York: Routledge & K. Paul; The Humanities Press, 1962.

PALLASMAA, JUHANI. *The Eyes of the Skin: Architecture and the Senses.* London: Academy Editions, 1996.

PÉREZ-GÓMEZ, ALBERTO. *Built Upon Love: Architectural Longing After Ethics and Aesthetics.* Cambridge, Mass.: MIT Press, 2006.

WERNICK, JANE. "Introduction," in *Building Happiness: Architecture to Make You Smile,* edited by JANE WERNICK. RIBA Building Futures, London: Black Dog Publishing, 2008.

WILSON, EDWARD O. *Biophilia.* Cambridge, Mass.: Harvard University Press, 1984.

Designer as mediator: an innovative model for designing interactive devices within the user-centered approach

Mithra Zahedi, Université de Montréal

Abstract: This study aims to explore interface design in its early stages. It also seeks to explain how the designer can actively modify the vision of a multidisciplinary project team in order to promote the transfer of knowledge. This is to ensure that the design activity is focused on users. This reflection is supported by case studies from which we propose a new design model geared to facilitate collaboration and exchange of information amongst contributors. The model enables knowledge acquisition while positioning the user at the center of the design process.

As users: Technology is transforming our lives; we have some dissatisfaction with our experiences.

As designers: We encounter difficulties between collaborators when dealing with a project.

Questions:
How can we help a project team:
1. Focus on the way interactive devices are going to be used and design them accordingly?
2. Go beyond solving problems to seeing the bigger picture?
What will be the role of the designer in that context?

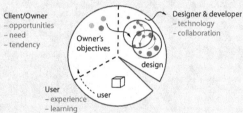

Client/Owner
– opportunities
– need
– tendency

Owner's objectives

Designer & developer
– technology
– collaboration

design

User
– experience
– learning

user

Focus is on:
– questioning the design process
– finding methods for creating dialogue and exchange of knowledge among stakeholders

Research framework

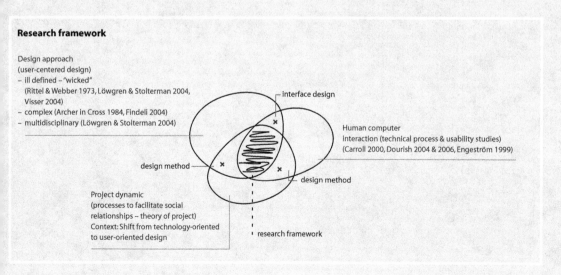

Design approach
(user-centered design)
– ill defined – "wicked"
 (Rittel & Webber 1973, Löwgren & Stolterman 2004, Visser 2004)
– complex (Archer in Cross 1984, Findeli 2004)
– multidisciplinary (Löwgren & Stolterman 2004)

interface design

Human computer interaction (technical process & usability studies)
(Carroll 2000, Dourish 2004 & 2006, Engeström 1999)

design method

design method

Project dynamic
(processes to facilitate social relationships – theory of project)
Context: Shift from technology-oriented to user-oriented design

research framework

Two case studies in the context of web design projects for a university institution

Methodological approach: Follows the "Recherche-projet" (Findeli 1998, 2004). Findeli explains that as the researcher engages more with the subject, new questions arise and modify the research throughout the project. Phenomenological and ethnographic approaches to HCI and action-research support the process.

Objectives:
– to get a better understanding of team dynamics in a multidisciplinary activity
– to identify the conditions that help support collaborative reflection

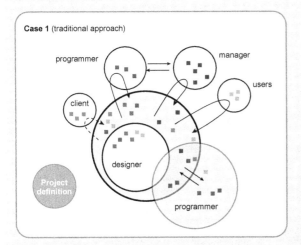

Case 1 (traditional approach)

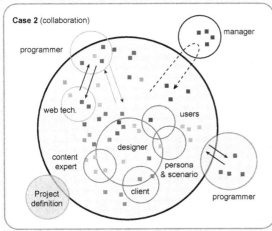

Case 2 (collaboration)

ORIGINAL POSTER
—

HCI, a multidisciplinary activity:
For a user-centered design approach, design must lean towards interdisciplinary methods. The interdisciplinary approach supports a dialogue and exchange of knowledge, analysis, and methods between two or more disciplines. It also implies mutually beneficial interaction between specialists (Morin 1994).

The model
We call it "environment for reflective collaboration." It supports the multidisciplinary team in a user-centered design approach from the very beginning of the project, with the following objectives:
– to encourage contact between contributors
– to increase knowledge exchange, and to develop a holistic vision
– at the early-stage of design process, to set aside immediate technical and conflicting constraints in order to generate new ideas
– to encourage critical thinking and direct feedback
– to reach consensus
– to make resources readily accessible to all as and when they need them
– to ensure the project advances in an efficient manner, on time, while respecting the development process

This model enables collaborative learning opportunities that combine theoretical and practical aspects based on a reflective approach and on collaboration. With this model in place, we aim to change the perceptions of the contributors and create conditions that help them to reflect collectively on a user-centered solution.

The proposed model has three principal elements:
– an intensive workshop for reflection and collaboration composed of a series of activities organized at the onset of the project
– mediation (to facilitate the activities of the workshop)
– tools to aid performance (i.e. visual representation of processes, games, systems for contribution and access to information, etc.)

We suggest a new role for the designer to act as a mediator of the environment for reflective collaboration.

Environment for reflective collaboration

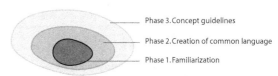

Intensive workshop

Université de Montréal

Mithra Zahedi
Université de Montréal, Faculté de l'aménagement
mithra.zahedi@umontreal.ca

This paper is based on a current PhD research directed by Giovanni de Paoli and co-directed by Manon Guité, both from Université de Montréal. 22.10.2008

Designer as mediator: an innovative model for designing interactive devices within ... approach

...ntréal

01—The title needs revision to better reflect the content.

1

Abstract: This study aims to explore interface design in its early stages. It also seeks to explain how the designer can actively modify the vision of a multidisciplinary project team in order to promote the transfer of knowledge. This is to ensure that the design activity is focused on users. This reflection is supported by case studies from which we propose a new design model geared to facilitate collaboration and exchange of information

Client/Owner
– opportunities
– need
– tendency

Owner's objectives

Designer & developer
– technology
– collaboration

design

User
– experience
– learning

user

03— The move from multidisciplinary to interdisciplinary collaboration in HCI and UCD should have been explained by the case studies.

Focus is on:
– questioning the design process
– finding methods for creating dialogue and exchange of knowledge among stakeholders

Research framework

Design approach
(user-centered design)
– ill defined – "wicked"
(Rittel & Webber 1973, Löwg... & Stol... an 2004, Visser 2004)
– complex (Archer in Cross 1984, Fin... 2004)
– multidisciplinary (Löwgren... St... an 2004)

2

design method

Project dynamic
(processes to facilitate social relationships – theory of project)
Context: Shift from technology-oriented to user-oriented design

02— Too much information is presented on the poster; the poster should have focussed on one aspect of the research rather than presenting the whole project.

Two case studies in the context of web design projects for
a university institution

Methodological approach: Follows the "Recherche-projet"
(Findeli 1998, 2004). Findeli explains that as the researcher engages
more with the subject, new questions arise and modify the research
throughout the project. Phenomenological and ethnographic
approaches to HCI and action-research support the process.

Objectives:
– to ge...
 mult...
– to id...

Case ...

client

designer

programmer

3

Case 2 (collaboration)

programmer

manager

POSTER+
COMMENTS

04—You should describe this model with more details. At the moment it is rather vague.

4

...disciplinary activ...
...ntered design a...ch, design must lean towards
...ary methods. The i...erdisciplinary approach supports a
...d exchange of knowledge, analysis, and methods between two
...plines. It also implies mutually beneficial interaction between
...orin 1994).

The model
We call it "environment for reflective collaboration." It supports the
multidisciplinary team in a user-centered design approach from the very
beginning of the project, with the following objectives:
– to encourage contact between contributors
– to increase knowledge exchange, and to develop a holistic vision
– at the early-stage of design process, to set aside immediate technical and
 conflicting constraints in order to generate new ideas
– to encourage critical thinking and direct feedback
– to reach consensus
– to make resources readily accessible to all as and when they need them
– to ensure the project advances in an efficient manner, on time, while
 respecting the development process

This model enables collaborative learning opportunities that combine
theoretical and practical aspects based on a reflective approach and on
collaboration. With this model in place, we aim to change the perceptions
of the contributors and create conditions that help them to reflect
collectively on a user-centered solution.

...ed model has three principal elements:
...ve workshop for reflection and collaboration composed of a
...tivities organized...the onset of the project
...(to facilitate the a...ties of the workshop)
...d performance i.e. visual representation of processes, games,
...r contribution and access to information, etc.)

5

...a new role for the designer to act as a mediator of the
...t for reflective collaboration.

05—The role of designer in an interdisciplinary team is an important issue of this research. This point should have been highlighted by explaining the results of case studies.

Mediation

...workshop

Tools

...for reflective collaboration

Mithra Zahedi
Université de Montréal, Faculté de l'aménagement
mithra.zahedi@umontreal.ca

Unive...
de Montreal

This paper is based on a current PhD research directed by Giovanni de Paoli and
co-directed by Manon Guite, both from Université de Montréal. 22.10.2008

Phase 3. Concept guidelines

Phase 2. Creation of common language

Phase 1. Familiarization

Intensive workshop

FINAL PAPER

Designer as Mediator in HCI Design Practice

Mithra Zahedi

Context and question

We are all users of interactive devices. Today we are witnessing the on-going development of digital technology and an increasing number and variety of people using digital devices. While these technologies are transforming lives, each one of us can recall occasional dissatisfaction. This situation motivated the present research, which looks closely at the role of the designer in bringing new insights into the field. Traditionally,

interactive devices were mostly developed with a technology-centered approach (CARROLL 2000; LINARD 2001; DOURISH 2004); however, in the past decade, the user-centered design approach and usability have been thoroughly researched in the area of human-computer interaction (HCI) (DOURISH and BUTTON 1998; PREECE *et al.* 2002; DOURISH 2004; LÖWGREN and STOLTERMAN 2004). We also know that in addition to the user-centered approach, it is crucial to develop HCI within a multidisciplinary team. Yet as design practitioners, we encounter conflicting situations; team members often have difficulty creating shared understanding and agreeing on the needs and motivations of the user. In practice we witnessed that at the beginning of a project, among HCI collaborators, different specialists have different understandings of users' interests and needs which make it difficult to reach common ground for the development of the project. In addition, the meaning of some concepts (for example "usability") is not the same for all team members. In this context, how can we as designers help a variety of contributing experts collaborate within a user-centered approach?

Hypotheses

User-centered design requires fluid communication within an interdisciplinary team. This means that a change of paradigm is needed in order to move from a multidisciplinary to an interdisciplinary approach. As BOYARSKI (1998) points out, a distinction should be made between the two terms. He refers to BUCHANAN and VOGEL (1994) for whom multidisciplinary means "a collection of disciplines brought together to solve a problem," whereas interdisciplinary is "a collection of disciplines on a team with a shared commitment to solving a problem." The interdisciplinary approach supports dialogue and exchange of knowledge, analysis, and methods between two or more disciplines (MORIN 1994). It also implies mutually beneficial interaction between specialists. We propose a design model that we named "environment for reflective collaboration" (ERC), which is geared towards facilitating collaboration and knowledge sharing among contributors while positioning the users' needs and motivations at the center of the design process (we create this

by producing personas and scenarios (CARROLL 2000)). The model allows for the construction of collective knowledge, which will be achieved through collaborative learning opportunities that combine theoretical and practical aspects. The model is based on a reflective approach (SCHÖN 1983) and on collaboration. With this model in place, we aim to change the perceptions of the contributors and create conditions which tend toward a user-centered approach.

Research Approach

We privileged "research through design" for this study (FINDELI 1998, 2001, 2004). This approach allows the development of our project towards the two poles "research through design" and "design through research" as JONAS mentions (2006, 2007). In recent years, this type of research has become a method also privileged among some researchers in HCI (for example, for ZIMMERMAN and FORLIZZI 2008; LÖWGREN 2004; and FALLMAN 2008). FALLMAN (2008) also brings up two concepts: "research-oriented design" to describe the user-centered design approach generally applied in HCI practice, and "design-oriented research," "where research is the area and design the means." In other words, by involving design activities in the research process, new knowledge is produced. LÖWGREN (2008) talks about practice-based research and asks if we can construct knowledge about a phenomenon by designing for it. For ZIMMERMAN and FORLIZZI (2008), the research through design approach offers several benefits that compliment HCI research such as addressing wicked problems and allowing an "ongoing dialogue on what a preferred state should be." Learning from FINDELI (1998, 2001, 2004, 2008), we used the Project-grounded approach *recherche-projet* supported by case studies in order to find out how the multidisciplinary team could achieve a shared understanding, early in the design process, about users' needs and motivations.

The case studies for our research are related to the design of three complex website projects for an educational institution. In all projects, as designer-researchers we were engaged with the project team during the early design phase. We looked at how the designer can actively modify the contributor's visions in order to promote the exchange of knowledge,

while ensuring that the design activity remains concentrated on the user. During the research (and the project) new questions arose and modified the research; the research enabled us to recognize the emergence of new parameters. We noted a continual back and forth between research and project, between theory and practice. We recognize this process as being reflective, promoting a clearer perspective on the project, and allowing for modification of our approach.

Research results

During the investigation, the design project and the research project unfolded in parallel. It became clear that the designer-researcher fits within a dynamic that requires him to act as a group facilitator for the project, thus directly influencing practice. The designer in this new role is a "designer-mediator." He will use the model we suggest (ERC), which helps the multidisciplinary team to adopt a user-centered design approach from the beginning of the project, with the following objectives:

— To encourage focusing on users' needs among all contributors
— To initiate knowledge exchange and to develop a holistic vision
— To encourage critical thinking and direct feedback
— To reach consensus
— To make resources readily accessible to all as and when they are needed
— To ensure the project advances in an efficient manner, on time, and while respecting the development process.

The ERC's process starts with an intensive workshop for reflection and collaboration, which is designed to achieve the aforementioned objectives. In this workshop, all multidisciplinary team members gather for a significant amount of time and engage in activities. Based on previous knowledge of the team and the project, the designer also designs the activities at the onset of the project and facilitates the workshop. During the workshop, the team starts using tools to aid performance (i.e. visual representation of processes, systems for contribution and access to information (such as wikis), as well as tools for project coordinating (such as *Basecamp*)). These tools are essential to give access to the

ongoing and growing information and knowledge of the project and its management. The workshop, the tools and the designer in the role of mediator are strongly related.

Through this model, we seek to build the particular knowledge and the know-how for the given project, to enrich and harmonize the understanding of the users' needs and motivations, and to create conditions for interdisciplinary exchange. With our case studies, we noticed that the dynamism and productivity of ERC depends on how the workshop plays out, but also upon the effectiveness of the mediator when facilitating the events and preparing and adjusting the tools.

Acknowledgements

This paper is based on my current Ph.D research at the *University of Montreal*, Faculty of Environmental Design. The author wishes to thank her director, PROFESSOR GIOVANNI DE PAOLI and co-director PROFESSOR MANON GUITÉ, both from University de Montreal.

References

BOYARSKI, D. *Designing Design Education.* SIGCHI 30, 1998: 7–10.

BUCHANAN, R. & VOGEL, C. M. *Design in the Learning Organization: Educating for the New Culture of Product Development.* DMI, 1994:5.

CARROLL, J. M. *Making Use: Scenario-Based Design of Human-Computer Interactions.* Cambridge, Mass.: MIT Press, 2000.

DOURISH, P. *Where the Action is: The Foundations of Embodied Interaction.* Cambridge, Mass.: MIT Press, 2004.

DOURISH, P., and G. BUTTON. "On 'Technomethodology': Foundational Relationships Between Ethnomethodology and System Design." *Human-Computer Interaction* 13 (1998): 395–432.

FALLMAN, D. "The Interaction Design Research: Triangle of Design Practice, Design Studies, and Design Exploration." *Design Issues* 24 (2008): 4–18.

FINDELI, A. "La recherche en design, questions épistémologiques et méthodologiques." *International Journal of Design and Innovation Research* (1998): 1.

FINDELI, A. "Rethinking Design Education for the 21st Century: Theoretical, Methodological, and Ethical Discussion." *Design Issues* (2001): 17.

FINDELI, A. "La recherche-projet: une méthode pour la recherche en design." *Symposium de recherche sur le design.* Tenu à la HGK de Bâle sous les auspices du Swiss Design Network, 2004.

FINDELI, A. "Research Through Design and Transdisciplinarity: A Tentative Contribution to the Methodology of Design Research." *Swiss Design Network Symposium 2008.* Bern, Switzerland: Focused, 2008.

FORLIZZI, J., J. ZIMMERMAN, and E. SHELLEY. "Crafting a Place for Interaction Design Research in HCI." *Design Issues* 24 (2008): 19–29.

JONAS, W. "Design Research and its Meaning to the Methodological Development of the Discipline," in *Design Research Now,* edited by R. MICHEL. Basel, Boston, Berlin: Birkhäuser Verlag AG, 2007.

JONAS, W. "Research Through DESIGN Through Research – A Problem Statement and a Conceptual Sketch." In *Wonderground.* edited by DESIGN RESEARCH SOCIETY. Lisabon, Portugal, 2006.

LINARD, M. "Concevoir des environnements pour apprendre : l'activité humaine, cadre organisateur de l'interactivité technique." *Sciences et techniques éducatives* 8 (2001): 211–238.

LÖWGREN, J., and E. STOLTERMAN. *Thoughtful Interaction Design: A Design Perspective on Information Technology.* MIT, 2004.

MORIN, EDGAR. "Sur l'interdisciplinarité." *Bulletin Interactif du Centre International de Recherches et Études transdisciplinaires* 2 (June, 1994). *http://nicol.club.fr/ciret/bulletin/b2c2.htm.*

PREECE, J., Y. ROGERS, and H. SHARP. *Interaction Design: Beyond Human-Computer Interaction.* New York, 2002.

SCHÖN, D. A. *The Reflective Practitioner: How Professionals Think in Action.* New York: Basic Books, 1983.

VYGOTSKY, L. S. *Mind in Society: The Development of Higher Psychological Processes.* Cambridge, Mass.: Harvard University Press, 1978.

ZIMMERMAN, J., and J. FORLIZZI. "The Role of Design Artifacts in Design Theory Construction." *Artifact* 2.3 (2008).

PART

3

EMERGING
QUESTIONS

ABSTRACT+
COMMENTS

Research in Pragmatic Semiotics and Design and the Difficulties of Conceptualization

Sarah Belkhamsa

Design Studies is a research domain that attempts to define its own key questions and research tools to best deal with the complexity of the field. As most research is concerned with practice, these studies face some difficulties in keeping their distance from the tools that have already been developed in both the laboratory and the industry.

According to our study of the literature, Design Studies stem from the broader field of Visual Studies, itself a part of Cultural Studies. Although theoretical approaches to design are not a new thing, most of Design Studies' opponents claim that academic and scientific approaches are not compatible with the creative process.

Nevertheless, research in design began more than a century ago and is accessible through many books, journals and designers' essays. Among others, the books of TILLEY (1991), MARGELIN and BUCHANAN (1995) [a] MILLER and LUPTON (1996), GLASSIE (1999), GUIDOT (2006) and BURDEK (2006) come to mind. Concerning journals, there are *Design issues* (history, theory and critics); *Design Studies* (The international journal of design), *The Journal of Material Culture; Studies in Design* and *Material Culture*, or to cite some French journals: *Design Recherche, Design Magazine,*

[a] V. MARGELIN and R. BUCHANAN, *The Idea of Design: A Design Reader,* edited by R. BUCHANAN, The MIT Cop. London: Cambridge, 1995.

and *Design*.[b] Concerning professionals, we can cite the work of VÉRONIQUE VIENNE and MICHAEL BIERUT (1994), as well as the essay of WILLIAM DRENTTEL and STEVEN HELLER (1994, 1997).[c] We must note, however, that these researchers are mainly borrowing their methods from sociology, anthropology, ethnology and semiotics.

This overview has allowed us to see that the field of Design Studies is focusing on three main topics that are not articulated very often: the design and production fields, the product in itself, and finally the reception process.[1] Thanks to participative design, researchers have been interested in the feedback process between users and designers for a few years.

In our research center (CRICC), we are hypothesizing that the absence of a clear conceptualization in this domain is due to a lack of a theoretical framework which would be able to encompass a research object that is simultaneously dynamic in interaction with and within a moving context.[2] According to our research hypothesis, the study of the product within its open context during the action and interaction process is ideal for developing an adapted conceptual framework.[3] In this domain, S. VIHMA's work is very close to our approach.

In this context, we are attempting to develop a pragmatic and interactive semiotic approach in order to study the connection between the program of use integrated

01—In my opinion, the economic bubble is missing in your schema. Your approach is without any economic context. The designer himself is not the focus, he is a part of the economy. The design means building business too. When you are talking about the user, he is also a person who pays to use things. **02**—I am an engineer in computer science, and I am more interested in doing things than in theorizing. My question is: while you are trying to explain the good or bad logical reasoning of the designers, I am wondering if they are really that

b See, S. BELKHAMSA, *Recensement International des Revues sur le Design*. Poster sesssion présenté aux 6éme éditon des Ateliers de Recherche en Design, Secrets de recherche. Centre de recherche images cultures et cognitions, Université Paris 1 Panthéon-Sorbonne et Parsons School (June 11–12, 2009) France.
c See *www.designobserver.com*, *www.designwritingresearch.org*, *www.underconsideration.com*.

117

concerned as to whether they are thinking through an abduction, an induction or a deduction logical process? Are you going to propose a tutorial to improve the process of design? **03**—You have explained that you are mainly focusing your research on material culture, so I am wondering what concept of sign you are addressing when you refer to the immaterial and more abstract or more cultural properties such as feelings and emotions? I think they are dimensions that are very important within the interaction process between the object and the user.

in the product by the designer and the users' habits in action. Yet how are we to study actions and from which conceptual framework and methodology? How are we to study the impact that the product has on the user and at the same time record the impact that the user has on the product?

In this domain, activity theory, cognitive psychology and ecological psychology offer interesting conceptual backgrounds that need to be articulated to match with applied and field research. On the other hand, only a few pragmatic semiotic researchers are to be involved in this adventure.[4]

For this lecture and debate, we shall try to study the gap between the activity theory frameworks and the research in the field. We hope to be able to illuminate the difficulty of conceptualization and how and why pragmatic semiotics does not have a direct application in the field of design. We will present some of our apparatus in applied semiotics and our attempts to conceptualize our research.[d]

—
d Research in collaboration with PROFESSOR BERNARD DARRAS, Université Paris 1 Panthéon Sorbonne, 2007–2008, and financed by the "French Institute of Cooperation" (IFC).

04—Could you explain what the relevance of semiotic theory is to when demonstrating that the object communicates and why you did not connect your work to the concept of *Affordance* developed by J. Gibson?

FINAL PAPER

—

Pragmatic Semiotics and Design: How Do the Artifacts Communicate?

Sarah Belkhamsa

Reflections

Any communication with a scientific audience generates intellectually productive encounters; this is especially true if it is one of the first meetings with a community. In my case, I can attest that this debate with design researchers really helped me to structure my work. In line with the title of the *Q&H* meeting in 2008, my initial project was to

discuss the hypothesis that the absence of a "rigorous conceptualization" in the domain of design studies is due to the absence of a theoretical framework capable of handling this object of study in its dynamic and interactive nature, which constantly changes through action. To look at these issues from a fresh point of view, I have tried to approach them from an epistemological and methodological perspective in considering product design as an object of study with an epistemic nature which consists of a complex triadic system linking the pragmatic programs of designer and user.

But after discussion, three main epistemological criticisms of this presentation have caught my attention:

— The first concerned what might be called a presumption or a prejudice. In my opinion, the artifact is capable of communicating its functions and its other symbolic dimensions.

— The second was about the relevance of the semiotic theory in demonstrating that the object communicates.

— Finally, the third concerned the relationships between the internal (representational) and external orientations in the semiotic philosophy of C. S. PEIRCE.

KEITH RUSSELL's pertinent question encouraged me to refocus my work on its initial issue: the communication of objects. I then realized that I had built my research on the assumption that the object communicates and produces meaning. Thus, I decided to integrate this comment and develop it further by focusing my efforts on the initial question, "Do objects communicate and if so, how do they produce meaning?"

SUSAN VIHMA's remarks also led me to explore the externalist dimension of PEIRCE's theories. I knew this point of view, but I was reluctant to integrate it into my research. This led me to read the recent texts by SUSAN VIHMA, which allowed me to see that my systemic and constructivist approach to the semiotics of design was very close to hers.

The productive discussions that I had with PROFESSOR KEITH RUSSELL, SUSAN VIHMA and KHALDOUN ZRAIK really helped me focus on the core of my research and its main issues, without neglecting the practical purposes of such an investigation.

Introduction

In the context of this article, we wish to investigate the theoretical questions that product design research faces based on the pragmatic semiotics of CHARLES SANDERS PEIRCE.[1] This semiotic theory constitutes neither a homogeneous nor a stable base. Much to the contrary, it is a complex articulated group of dynamic paradigms. In addition, researchers often face a number of obstacles when they attempt to apply these paradigms to the object of their research. Alas, product design remains a relatively unexplored complex "semiotic" system. As such, pragmatic semiotics as applied to product design remains fairly rare. The three authors we have selected for study constitute what seems to us to be the most accurate representation of what the field has to offer.[2]

As is the case with all theories of sign, pragmatic semiotic theory is based on the supposition that the world is to be considered as a significative universe. As we shall see, this is also the case for the industrial product, because for semioticians, it constitutes a true complex cultural system of transmission.[3]

Using three pragmatic semiotic studies that were devoted to product design and were presented by M. NADIN (1999)[4], G. PRONI (2003)[5] and S. VIHMA (2003)[6], we propose to examine the way in which these researchers ascribe sign status to the object, how they characterize and define it, how they address product design via theory, and finally, how they implement these theoretical models into the study of the object.

—

1 All the artifacts of daily use that are the result of a design process.

2 After a long inquiry, we consulted different semiotician pragmaticians (BERNARD DARRAS, PARIS 1, NICOLE EVERAERT-DESMEDT, BRUSSELS, JEAN FISETTE, UQAM, MARTIN LEFEBVRE, CONCORDIA) who confirmed the rarity of such studies. Only Brazilian LUCIA SANTAELLA could have been added to our study, but her texts are published in Portuguese.

3 Let us recall concisely that, according to PEIRCE, any sign is composed of three sub signs: the Representamen which concerns the pertinent aspects of the sign, the Object of the sign which refers to the sign's aboutness

(what the sign is about), and finally, the Interpretant of the sign which is the translation rule which links the sign to the experience and to the culture of the interpreter.

4 NADIN, M. "Design and Semiotics," in *Semiotics in the Individual Sciences 2*. Bochum: Brockmeyer, 1990: 418–436.

5 PRONI, G. "Outlines for a semiotic analysis of objects." *Versus*. (gennaio-agosto 2002) Milano: Bompiani, 2003: 91–92.

6 VIHMA, S. "On Actual Semantic and Aesthetic Interaction with Design Objects." *Proceedings of the 5th European Academy of Design Conference: The Design Wisdom*, April 28–30, 2003.

1) Design as a sign

The first perspective to be discussed here questions the way in which each of the three authors conceives design as a triadic sign and how s/he determines its different semiotic aspects and its interpretation process. All the authors acknowledge from the outset that the artifacts of product design are signs, but that they differ from the other signs in at least three dimensions.

First, this phenomenon is caused by the materiality of the Representamen, as well as by the implication of actions and use in the sign's Object and its Interpreter. Regarding this subject, NADIN puts forward the idea that the signs of product design are more complex than those of language or image. According to him, the Representamen of a product, of an interior or building decoration is constituted of several superimposed semiotic layers (the materials, textures, etc.). For PRONI, the artifact-signs have two major properties distinguishing them from the other types of signs: one property being the material qualities of the Representamen, which are ordinarily used for practical purposes and that enter into interaction with other physical entities, and the second property being their Object, which is consistent with their use and indicates the material qualities of the sign. "The artifacts are more complicated than the standard signs, because their Representamen is in some way part of their meaning"(PRONI 2003). For him, "Use and consumption are semiotic phenomena as legitimate as interpretation." Finally, for VIHMA, the complexity of the object as a sign lies in the fact that the study calls for the articulation of several perspectives and extensive knowledge context and use.

Second, the authors affirm that design requires a heterogeneous interpretative process composed of several levels of interpretation. By establishing a symmetry between way that design work is structured and the way it is interpreted, NADIN shows that design is the structuralization process of a type of semiotic language. Thus, conceiving of a product amounts to implementing the principles of a specific language starting from an unlimited unit-signs' index. For PRONI, the interpretation of the design involves two kinds of cognitive processes: finding the

significance, which is mental and abstract, and finding the use, which is rather material and concrete. The cognitive facts constitute a kind of general diagram, whereas interpretation is only achieved in the material substratum. According to him, applying semiotics to understand the way objects are used is akin to interpreting discourse; it is therefore about taking the analytical tools provided by any standard sign system and applying them to the analysis of models or diagrams of use. However, he insists on the fact that in a semiotic analysis project, it is important to specify the abstraction level at which the object is treated and not to exclude the analysis of material dimensions and interactive properties.

Third, design itself includes semiotic aspects. For NADIN (1999), "the Design principles are semiotic by nature." Consequently, the conception process is a semiosis that begins with the designer and ends with the user (the opposite is also possible). Concerning this semiosis, NADIN distinguishes: the kind of representation used, the coherence of the representation, the means used, the type of interpretation made possible and necessary, as well as the relation between the original design and the final product. According to him, these dimensions must all be taken into account so that it is possible to understand the semiotic process, through which every design is created. At his end, PRONI's work concentrates on the fact that "the artifact communicates besides having practical uses." He rightly specifies that interpreting an artifact in the apprenticeship phase is not the same as interpreting the artifact when it is well known. For him, "use" can be defined as a way to interact with an artifact in order to attain a goal, and the interaction "is a feedback process of action and perception: the subject acts and monitors the effects of the action to tune the next act, repeats this loop until the process is stopped or brought to an end." Consequently, for him "the function is expressed as a scheme of interaction. The use-scheme of an artifact consists in use-sequences that follow a use-syntax." For PRONI, the use therefore constitutes the main semiotic aspect of the product design, and through its form, the object "determines" the limits of possible usage and use diagrams.[7] This power to determine the

action and the interpretation is certainly common to all the signs, but the artifacts have in addition the ability to adjust the limits of their possible uses. It is exactly over this particular point that VIHMA enumerates the different semiotic aspects of the design. The limits of the object's action and the idea of determining use are central questions which she addresses, using the hypothesis that, "the Artefacts in use constitute habits of action. They seem to play a bigger role both physically and semantically (or semiotically, if you like) than they are usually given in design analyses." She then offers another approach to design's interpretation by putting forth the idea that the relationship between the subject and the object goes both ways and "things can be conceived as more than passive responses to various activities and the relation between people and things as reciprocal or mutual. The relationship becomes more interactive by giving the artefact a bigger role." She therefore specifies that the originality of her project is to examine the way that interaction takes place by focusing specifically on the objects involved.[8] Subsequently, VIHMA links the affordance concept to PEIRCE's habit concept. She describes affordance as an agent of construction, acquirement and incorporation of habit. She underscores this hypothesis by specifying that, "Habits are formed by affordances of the built environment. However, habits are no fixed rules and they can be changed to improve interaction. ... In addition to its concrete qualities and practical functions, an artefact embodies (or materializes) representational features, which are interpreted (Concerning this subject, see our study on the relation between the affordance, the enactivism and the habit: DARRAS & BELKHAMSA 2008)."[9]

7 "The artefact does not force its use: we can use an object in a non-standard way. ... the artefact conditions the interaction because of its material structure and shape. ... To follow PEIRCE's terminology, the unforced conditioning artefacts exert on us is called determination, meant in its etymological sense of 'setting the limits.'" – PRONI, G. "Outlines for a Semiotic Analysis of Objects." *Versus.* (gennaio-agosto 2002) Milano: Bompiani, 2003: 91–92.

8 "In my view, it would be helpful to study how objects take up space and influence also other objects, not only persons using them" (VIHMA 2003).
9 B. DARRAS, and S. BELKHAMSA. "Faire corps avec le monde. Une étude comparative des concepts d'affordance, d'enaction et d'habitude d'action." *Recherche en communication* 29 (2008): 125–145.

To conclude this first section, we must note that the positions of authors markedly diverge on certain conceptions of the semiotic survey itself. For NADIN, the subject of his work is rooted in the design process as an approach of conception, whereas PRONI treats the "artefacts of usages" as signs in the same way that other semiotic events are. Consequently, he concentrates his study on semiosis and on the triad that makes up the sign. As for VIHMA, she endeavors to open up a new perspective of semiotic study by shifting her attention toward the interaction between artifacts and users. In this she gets closer to the paradigm of "Agency" developed by the cultural studies and accepted our own semiotic approaches.[10] According to this perspective, the artifacts determine our actions as part of a materialized culture. By using them, the culture and the power relations (agencies) that they convey become incorporated as integrated and stabilized habits. It is in this point that we share VIHMA's position regarding the artifacts-companions of action. Like her, we claim that the artifact is a materialized agency activated on the occasion of its use by a user in a particular context.

2) The relationship between design and semiotic theory

In this field, NADIN emphasizes the difficulties faced by semiotic theory when applied to design. He mentions that, "Design is a general concept, reflected in the underlying quality of objects, actions and representations which various people make possible in a given culture and within a value framework," and that, "Design happens to be a rather unsettled field of human creativity, without critical method (and without methodic criticism), and without the means to construct one for itself" (NADIN 1990). He also notes that the semiotic topic "design applications" has an interdisciplinarity, an instability and a scale which contain complex specificities that are difficult to comprehend. But for him, the real debate remains to "know if the design functions by intuition or if it requires a method

10 DARRAS, B., and S. BELKHAMSA. "L' « objet » oublié des Sciences de l'information et de la communication et des Cultural Studies." In FRANÇOISE ALBERTINI et NICOLAS PELISSIER (Dir.), *Les Sciences de l'Information et de la Communication à la rencontre des culturales Studies Collection Communication et Civilisation.* Paris, L'Harmattan, 2009: 155–174.

(semiotically founded)." As for designers, the signs theory should allow them to examine the "semiotic implications of everything that they conceive." NADIN makes reference to the production of a precise sign system suited to the user, to his/her expectations and his/her environment. Here, semiotics can operate like a rational system used to analyze communication and the way that problems are conceived of, so as to evaluate answers. Semiotics, combined with the conception phase, then manifests itself as a new development model that can guarantee relevance, coherence, integrity and an understanding of society's signs system. According to him, it is essential to understand that there is not a single universal answer to address complexity. However, semiotics encourages a very concrete analysis of the contextwhich design is supposed to address.

PRONI is quite close to NADIN's position. To him, semiotic analysis is only possible as the result of interpretation models that vary according to the interpretative communities, circumstances and environments. He constructs his research protocol in accordance with this theory, "Performing a semiotic analysis means simulating the interpretation of a sign by a community of interpreters (culture, group, organization, etc.) in a given place and time. We may define interpretative circumstance as the system composed by a community of interpreters, and the space and time of sign-reception." In such simulation conditions, the analysis must also take into account the analyst's social group. Hence, we cannot attribute any universal value to the analysis; the process of scientific investigation is infinite, although it is always intended to generate a better understanding of the dynamic object and the final Interpretant. This also applies to the author, as interpretation does not occur independently of a socially-based cognitive background. In the Peircean theory, he recalls that "semiosis is a social process." The analyst's work therefore resides in taking a cultural model, making this model consistent with the signs and developing a map of this model's possible Interpretants. In other words, the analyst must draft a network of senses and possible habits. The final goals of semiotic analysis can be either of a general nature or specific to a group. The final objective is to constitute a complete map of the Interpretants relating to either the entire sign or only one of its aspects.

For PRONI, the projects of semiotic analysis in design can be of three kinds:

— Assisting the designers in rationally constructing a map or network of the product's significance

— Supervising an object's different Interpretants during the conception process

— Foreseeing reactions to a sign (politics, marketing)

In her article, VIHMA recognizes that, for a long time, she considered the semiotic approaches to design as studies of representational qualities likely to improve the understanding of the complex interpretative functioning of objects. For the Peircean semiotic modality, she distinguished three types of relationships from the references: the iconic relation linked to emotions and impressions, the relation of indiciality which is a causal connection between the interpretation and its subject of study, and finally the symbolic relation as a description of the context and the explicit position of the person that interprets it. "In addition, interaction is conceived as including both subjective and more general points of view ... the interpreter should have the possibility to experience them as part of their environment, experience the milieu of the activity, and so on. Iconic references in particular cannot be formed otherwise." But, as we shall see in the next chapter, her theoretical conception has changed considerably.

3) Models of applied semiotics

With regards to applied semiotics, NADIN has an unconventional position: he suggests that design has, in fact, already applied the semiotic process. Studying design as a sign therefore comes down to examining all the semiotic functions accomplished through human activity. In order to explore these semiotic functions, the author proposes an application based on the relationship between object/subject duality and the triad of the sign. This leads to the intermediary conception of design as a mediator materialized between the designer and the user. The object acts as a complex communication interface composed of several semiotic layers that finds its end as a sign only at the moment it fulfills its pragmatic dimension to the user.

In his article, PRONI offers an initial theoretical setting for the semiotic analyses of what he calls "artefacts of use." He then plans to analyze them "classically" on every level of the triad: the perceptive qualities (Representamen), the uses and productions (Object), and the social speeches (Interpretants). Concerning the first level, he proposes to start by examining its determined Representamen, on the one hand, via its perceptive properties and on the other hand, via the internal syntax of the sign-object. He even suggests overlooking our acquired knowledge: "The purpose of this effort is to describe the artefact in a complete way without being concerned with its socially coded values." The second level discusses the Object of the artifact. He proposes concentrating on the uses and describing diagrams of use, the user's model, the external syntax, the pragmatic relation that the object maintains in competition with other objects and the production implying the processes and materials as well as the producer's implicit image as conveyed by the artifact. Concerning the third element of the triad, the author proposes three hierarchical categories of the Interpretant. The first deals with the object-sign value of the artifact, the second deals with the relation of the Interpretant with the artefact's use (properties, use and consumption) and the third with the Interpretant's relationship with the artifact's speech (the object and the communication).

VIHMA (2003) deliberately approaches the question of applied semiotics from the perspective of design and PEIRCE's semiotic philosophy as a theoretical setting. Her objective is to shed light on the theoretical questions inherent to the design process. In this article, she recommends an approach that is both better articulated and more external than the approaches used in these first applied studies: "Things can be conceived as companions, and not just as meaningful tools." Moreover, she specifies a little farther along: "The formulation, things as companions ... aims at combining experiences of the product environment and the design process." This approach can be very beneficial from the point of view of design and its study, because the objects and the topic are considered side by side. The study can concentrate on the influence that these objects have on people's behavior. VIHMA acknowledges here that

during her previous studies she had neglected this "companionship" between the user and the artifact.[11]

Consequently, "the interpretation was still too user-centered, even though environmental and functional qualities were also described in detail." But in the new approach that she puts forth here, she uses the articulated sets of objects and the interior spaces that are made up in active objects' systems as a starting point. Consequently, she studies the objects' agencies and the way in which they affect human action, thought and emotions. VIHMA suggests that the conception of interaction is not confined to the physical and symbolic level only, as it is often the case that, "Artefacts in use constitute habits of action. They seem to play a bigger role both physically and semantically (or semiotically, if you like) than they are usually given in design analysis." She illustrates her theoretical argument with the help of two brief studies of waiting rooms in bus stations. She examines the largely coordinated objects in these waiting rooms, and the ways in which they do or do not complement the process of waiting.

Conclusion

Among other things, this study allowed us to dispel the doubt that is often expressed regarding the capacity of the object to communicate and contain meaning. By referring to the semiotic theory of PEIRCE, accepted as an authority in this field, these three authors showed that the object communicates and has significant properties. On this account object design as a sign is an interface (NADIN), a mediator (PRONI) and a companion of mutual interactions (VIHMA).

During this study, we also noted that each author focused his/her scientific attention on a part of the designer-object-topic relationship and on one of the axes of Peircean theory. In his article, NADIN takes into account the three key players of design: the designer, the product and

11 VIHMA, SUSANN. *Products as Representations*. A semiotic and aesthetic study of design products (diss). Publication Series of the University of Art and Design Helsinki UIAH, A 14, 1995.

VIHMA, SUSANN. "Jäähalli – pelin takia" (The Ice Stadium – For the Sake of the Game) In: HELKAMA, IRIS (ed.): *Helsinki Interiors*. Rakennustieto Oy, Helsinki, 1996: 95–109.

the user as a final consignee. Thus, he proposes that the design process be defined as a semiotic construction process. Instead, PRONI concentrates his interest on the relationship between the object, the user and context. By doing so, he neglects the semiotic intention at the genesis of the semiosis chain and intends to determine the triad of the sign in the user's mind and action. NADIN's conception seems more global than PEIRCE's and PRONI'S. PRONI's theory occasionally comes close to structuralist methodologies, notably when he suggests that an interpreter (the analyst) can be the spokesman of an interpretative community. In contrast, VIHMA offers a completely different perspective that is both more external and more articulate about the concepts of affordances, habits and mutual interactions, particularly in the ability of objects' to determine and direct our actions.

ABSTRACT+
COMMENTS

The Cohering Project [1] in the Built Environment Modeling Intentions and Actors Dynamic: An Approach by Design

Michel de Blois
Carmela Cucuzzella

This paper will present some of the challenges faced by designers in design research when they are confronted by traditional methods of research. We present a description of how the "question and hypothesis" are devised. We also reflect on how this process relates to specific "iterative" and "satisficing" characteristics, that are posed by design problems and practice with regards to traditional scientific research. We use two examples to illustrate our inquiry and ensuing position. The first example is drawn from a course exercise that was conducted on a hypothetical qualitative analysis case. Observations that were gathered during this exercise are then used to inform our reasoning, which will constitute the foundations of the initial steps of the doctoral research with regards to the development of the question and hypothesis phase. We briefly introduce the latter before initiating a conversation between the two examples.

01— What is the cohering project concept?

Introduction – *My Doctoral Research*

The construction industry is characterized by a high degree of uncertainty. This research is aimed at revealing the iterative nature of problem solving in uncertain situations, which in turn will highlight the existence of the "cohering project" concept. The situations that are addressed comprise of design and construction problems resulting from poor concepts and design specifications, lack of information and inefficient allocation of resources in the early phases of projects.

The term "project behavior" is used to frame the general object of study of the research. It refers to the whole project process as it unfolds through individual and collective action. It defines the effective dynamic evolution and behavior of the "project as a system," as opposed to the planed linear project traditionally perceived and operated in a mechanistic way, and refers to organizational concepts (LE MOIGNE 1999; MORIN 1977).

Organization, which is seen as a structuring process for projects (in a built environment), is studied "in action" as a manifestation of design. One of the objectives is to reveal the organizing properties inherent in design, when used as a decision process (problem-setting-solving) for project managers and decision makers (in uncertainty situations). The study goes on to analyze and describe the very real and practical (as opposed to formalized and planned) organizational methods that characterize projects which are implemented collectively. The individual contributors become very involved through their multiple roles within the project. Decision processes are used to model the way that their their different intentions and aims interact. These interactions describe the "cohering project" phenomenon. The "cohering project" concept can thus help to explore actual project behavior. This unfolding dynamic activity defines the bounding systemic elements of the project process.

The following matrix *(Figure 1.)* illustrates the scope of the research and lays out the main theoretical fields that will drive the analysis and arguments. Briefly, the matrix defines the possible dimensions of inquiry and enables a multidisciplinary investigation.

Reflection on Research Design

A hypothesis has a different meaning depending on what scientific paradigm is used for the research. The discourse on how a hypothesis should be developed and defined differs considerably from one end of the spectrum of the traditional sciences (often a Cartesian approach) to the other end, which deals with social matters (often more Constructivist).

The process of establishing proper research questions and hypotheses possibly represents the most underestimated phase of the whole process. For the junior researcher, this is even truer, since what occurs beyond these research questions is often uncharted territory. The questions give rise to a series of activities that will in fact prove extremely complex, and perhaps futile, if they are not properly set.

The present discussion addresses the strategic importance of three interlinked elements that are essential in the research design: a) a proper (pertinent) and well defined question formulation that addresses a clearly stated problem; b) a consequent theoretical framework that will feed and support the argumentation and c) that can both be expressed and communicated adequately in conceptual and operational frameworks (the methodology).

The research draws on the experience of a simulated fast track study conducted within the framework of a graduate course on research methodology (VAN DER MAREN 2008). It was designed specifically to highlight the traps, inconsistencies and potential hazards of a faulty and inconsistent research design structure. The focus was to develop methodological skills for the analysis of qualitative data, which was supplied for the purpose. Qualitative analysis and interpretation had to be done based on a conceptual framework that was hastily developed from a brief description of the context. The question was developed on the same basis.

The analysis and interpretation that followed dramatically highlighted the weaknesses of the research structure, as it had produced poor results and tied the process in methodological knots. It was therefore possible to rapidly conclude that the research

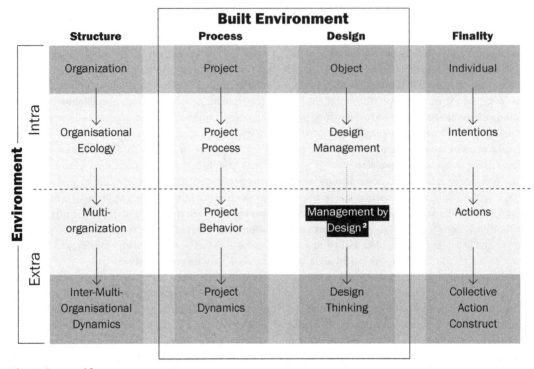

Figure 1: Conceptual frame, DE BLOIS 2008

question must be very closely linked to a conceptual and theoretical framework that can be "operationalized" and that subsequent research questions should also be developed in conjunction with a methodology "overview."

It might seem to be the wrong sequence of thought or procedure during research to address the questions and/or hypothesis from the methodology angle, but the experiment was designed exactly for the purpose of emphasizing the importance of cohesion between question, hypothesis and theoretical framework. And in this case, it made it possible to understand the fundamental importance of that stage for the remainder (and the eventual success) of the research being conducted. In other words, the exercise that consists of devising and structuring the strategy and the logistics behind the research forces a second cycle of reflection. Here we reflect on the validity of the original questions

and the operability of the theoretical framework. It is then possible to assess if the question can be answered with the support of the chosen (implied) methodology and tools considering the availability and accessibility of information.

It is therefore insufficient to address proper questions unless it is possible to answer them within a justifiable theoretical framework[3] (DENZIN and LINCOLN 2005; LESSARD-HÉBERT *et al.* 1996; POUPART *et al.* 1997; GAUTHIER 2003). What this means is that a research question, traditionally, requires the foundation of a theory if it is to be answered in a coherent manner (even in the case of grounded theory, the researcher is influenced by some background theory). Otherwise, without a theoretical framework, the analysis will not have an operational foundation, often resulting in an incoherent interpretation of the original research question. Consequently, depending on the designated field of

02—What is "Management by Design?" What does the matrix say about the research? **03**—Spanning two disciplines, does the research have to draw on multiple approaches? This question is a spinoff of the *Simon vs Schön* remarks. It raises this fundamental inquiry into "How to devise proper questions," on what basis, and according to which theoretical framework. Can we be *abductive* instead of deductive or inductive. It also raises the question: what is design research? How can it be scientific?

research, defining questions can be associated with an iterative process, whereby the questions are refined in order to "tame" the field, and material is treated within the structures of the available and reviewed literature. The important thing is to define what a design research question actually is.

Design Questions and Hypotheses

Design science problems, as understood here, tend to be defined by their "fuzziness," meaning that design addresses ill-defined or ill-structured problems as opposed to well-defined ones. Furthermore, the resulting solutions to design problems do not pretend to be optimal but rather "satisficing" (SIMON 1969).

The present inquiry and the actual research cited above deal with the practice of devising questions that span more than one field of expertise, including management and design. More precisely, this study tries to accommodate two traditions of inquiry that coexist in the vast field of project management in the built environment: the rational approach and the "situativity" approach. It also addresses specific decision-making processes in situations of uncertainty. The research aims to reveal the organizational methods of the design activity when used as a decision process (problem-setting-solving) for project managers and decision makers. If managers manage the design process, why don't designers design the managing process? In other words, the research uses the design approach, or design thinking, to describe what has been seen as a rational process.

Item	'Simon'	'Schön'
designer	= information processor (in an objective reality)	= person constructing his/her reality
design problem	= ill-defined, unstructured	= essentially unique
design process	= a rational search process	= a reflective conversation
design knowledge	= knowledge of design procedures and 'scientific' laws	= the artistry of design: when to apply which procedure/piece of knowledge
example/model	= optimization theory, the natural sciences	= art/the social sciences

Table 1: Paradigm confrontation: rational problem solving vs reflection-in-action. (Source: DORST and DIJKHUIS 1995)

The very nature of the design activity is neither well defined nor well understood. The "ill-structured" nature of design problems is also well established. Consequently, can we assume that the same applies to design research?

Design is multidisciplinary by nature. It deals with a growing number of issues from diverse fields. Moreover, design research considers beyond the "material" issues the central role of the "human." The potential clash between the traditional sciences, dealing with the material world as it is (such a most engineering) and the social sciences needs to be addressed. Although it is possible, if not necessary, to "borrow" the necessary theories and methodologies from other disciplines, their articulation and application must be carefully orchestrated (FINDELI 2004). Trying to emulate other disciplines can prove very tricky. Other than being prone to scrutiny and criticism from other scientific disciplines, there are, at times, a staggering amount of theories and schools of thought that support and animate each branch of science.

Returning to our main research, we can see that the existence of more than one paradigm in the design field adds to the complexity of defining our own identity and scientific tradition. The present research, as illustrated in *Table 1*, embraces the position adopted by DORST & DIJKHUIS (1995, 1996) in confronting Symbolic Information Processing (SIP) to the Situativity approach (SIP) (SCHÖN 1983) (DORST and DIJKHUIS 1995; VISSER 2006; SCHÖN 1987; SIMON 1969). SIP is mainly associated with rational thinking. SIT refers to "reflection in action." An examination of the nature of the research subject, design management in general and decision making in the context of construction projects in particular reveals two approaches to problem solving. SIP and SIT thus offer a suitable theoretical framework to address both situations. These two positions reflect the main schools of thought and practice in both design (action) and management (decision making). Furthermore, the literature on these subjects strongly refers to two important authors, SIMON (1969) and SCHÖN (1983), when tracing the foundations of design theory and action.[4]

Furthermore, the way that design is perceived depends more on the field studying it than on the actual methods employed when conducting the activity. Design protocols (CROSS *et al.* 1996) have shed new light on the characteristics and the diversity of disciplines and approaches that are used in the activity and process of design.

Design activity and the nature of design problems are not the main focus of this research. Yet one cannot underestimate the consequences that these have on the resulting "scientific value" of the research process and ultimate outcome. The acknowledgment sought from the scientific community and the emergence of an authentic design research discipline, though, substantially motivate our approach.

04— Why Schön and Simon?

Designing the Research

The very title of this conference raises some fundamental theoretical questions for design science, just as it presents challenges with regards to the design of the research itself. "Questions and Hypotheses" are indeed embedded in the research vocabulary and are unavoidable stepping stones in the process of designing research (if not the things that ultimately justify its very purpose). But surprisingly, as simple as this terminology may seem, it is confusing in many ways. Though semantically dissecting the meaning of both terms seems excessive, it would nonetheless be prudent to clarify certain distinctions that are not necessarily clear in the literature, at least for the novice.

Whether the research is guided by a deductive or inductive approach will determine, in certain aspects, if the researcher is dealing with postulate or hypothesis. A hypothesis normally calls for a process of verification that results in a true/false result. Even if it seems obvious to most seasoned researchers, this has proven more complex than previously thought in the emerging field of design research. The fact that there is no stable or generally accepted "scientific" tradition in our field of research makes it even more hazardous and prone to critique from the more traditional and established sciences. Although it is possible, if not necessary, to "borrow" the necessary theories and methodologies from other disciplines, their articulation and application must be carefully orchestrated.

During the design of the present research project, it has become clear that the choice of methodological approach represents a considerable challenge. This choice is determined by the question itself, and how the researcher plans to answer that question. Although one can decide, quite rightly, to adopt a more entrenched position in which one would favor a specific (scientific) school of thought, such an approach would still fall short of what the design research is trying to achieve.

From the traditional scientific point of view, the research process starts with the identification of a problem from which a general question is derived. That general question is then refined to produce specific questions that will be used to generate the hypotheses. In the social sciences for the most part, the researcher is able to formulate the question on the basis of the research material generated in the field. Furthermore, the theoretical framework should be left open so that it can be properly developed from questions that have not yet been refined.

The actual process of designing research is very well documented. If you stay within a given established field, then the process is relatively straightforward in the sense that you can find precise "recipes" which have been adapted to each field in order to address specific questions that commonly arise. It is difficult to come up with an approach, apart from a deductive one, that takes the hypothesis as a starting point for the inquiry.

The challenge of this research is revealing the iterative nature of problem-solving in situations of uncertainty, namely design and construction problems resulting from poor concepts and design specifications, lack of information and inefficient allocation of resources in the early phase of the project. From that, a number of subsequent questions quickly arise. What should the role of design in project management be? Why is design activity managed? What are the arguments in favor of evolving towards designing the management of projects? Is it justified and justifiable? Is project management a design activity? And so on.

These are some of the first questions that initially triggered this research. The built environment context,

MICHEL DE BLOIS — ABSTRACT

as a whole, provides the field of inquiry. Knowing that projects are traditionally managed before even being designed, there is a great deal of questioning and inquiring that has to take place before any answers can be drawn out. It was clear from the onset of this process that this research would be controversial, though it relates to the traditional paradigm of rational processes: planning, solution-driven problem solving, and information processing. All of these result in linear programming and processes being fragmented in multiple and isolated subtasks organized in a logistic hierarchy. Additionally, the more organic and iterative nature of the design activity could be the subject of debate.

Discussion topic

The distinction between "hypotheses" and "questions," as addressed in the process of this design research (by the junior researcher trying to define the research program), confronts many potential conflicting approaches. The dilemma comes from the very nature of the design activity itself. The multitude of disciplines needed and brought into the process of designing (whether objects, buildings, landscape) adds to this complexity. Knowing that he cannot be an expert in all domains, the designer must rely on other disciplines' contribution. He is positioned as a mediator-processor who will define, "digest" and articulate the problem-solution space material.

Therefore, one cannot draw a definite line between prescribed approaches (methodologies) as easily as one can in the hard sciences. It is difficult to initiate a clear debate around the nature and role of the question and hypothesis phase of the research. As we make the following assertions, it becomes evident that design research does not fall under the umbrella of traditional sciences and needs to borrow from many of them. As a reminder: a) the designer is in the process of producing "that-which-is-not-yet" (NELSON and STOLTERMAN 2003); b) the potential solutions are not finite ones, they are satisficing (SIMON 1969); c) the situation and contributors influence the process (CROZIER and FRIEDBERG 1977; DE BLOIS and DE CONINCK 2008;

SCHÖN 1983); d) the material needed to devise solutions is often a mix of quantitative and qualitative data and information; e) the very nature of design problems is termed "wicked" (RITTEL and WEBBER 1984; RITTEL and WEBBER 1973); and f) designers are known to leave the problem space open (as much as they can) (ROWE 1987; OWEN 2007; LIEDTKA 2004). In this context, it is difficult to settle on a fixed question, because it is most likely to change during the research as more information is made available and the research might profit from the question being reframed. Furthermore, it is even worse to identify a hypothesis when we do not know what the solution might be. In this context, deduction and induction make way for "abduction."

Conclusion

Since a design solution will likely come out of a multidimensional space (multidisciplinary in nature), it would be pretentious to base the research on a hypothesis that, by definition, wishes to validate the "feasibility" of a pre-determined potential solution. Design wants to discover and devise new things that are "not-yet," and these solutions are drawn through processes and activity contextually set in action, as well as from hard data. Designers are always in a research mode. Their inquiries, through assimilation, remix the problem data with new data and temporary solutions as they become available throughout the design and project process.

Traditionally, hypotheses have a fixed objective where alternatives are discouraged and there are no "maybes," only clear true or false responses. This is why questions seem to drive design activity, and also why design research must question the proper use and justification imposed by the hypothesis – unless hypotheses are formed retroactively. The term assumption seems an appropriate compromise for the hypothesis, since one does not wish to be self-congratulatory by setting out a hypothesis with a pre-determined answer. The designer/researcher aims to provide direction and foundation on which to build an evolving potential "satisficing" solution, without setting strict limitations, and while adopting an "open system" view.

FINAL PAPER

—

An Approach by Design for Project Management and Organizational Design

Michel de Blois

Carmela Cucuzzella

Introduction

The present inquiry focuses on the experience of devising questions that span more than one field of expertise, namely management and design. It tries to accommodate two traditions of inquiry that cohabit in the vast field of project management for the built environment: the rational approach, or SIP, information processing (SIMON in VISSER 2006) and the "situativity" approach, or SIT (SCHÖN in VISSER 2006). The research addresses specific decision-making processes and wishes to reveal the iterative nature of problem solving in uncertain situations, namely design and construction problems that result from poor concepts and

design specifications, lack of information and inefficient allocation of resources in the early phase of the project. It aims at revealing the organizational methods of the design activity when it is used as a decision process (problem setting and solving) for project managers and decision makers. If managers manage the design process, why don't designers design the managing process? In other words, the research uses the design approach, or design thinking, to describe what has been seen as a rational process in project/design management.

One of the challenges thus resides in the juxtaposition of two traditions of inquiry and the resulting consequences for research design. "Design management" as a project discipline confronts not only theoretical foundations, but also respective pragmatic preferences. Design or "design thinking" as an approach to project management thus raises considerable challenges in theory and in practice (BOLAND and COLLOPY 2004). Project managers perceive design as a "business function" articulated around problem-solving and optimization. Designers who are engaged in the management process tend to adopt a "problematization" perspective and are "solution focused." Management is considered to be a rational and linear approach. Design tends to be highly iterative and blends analysis and synthesis (GEDENRYD 1998). In this context, investigating the interface between design and management requires a mediation of approaches, which would generate numerous and significant interrogations and dilemmas. One of these is the role and meaning of the basic building block, the "hypothesis."

Reflection on Research Design

The hypothesis, has a different meaning depending on what scientific paradigm is used for the research. The discourse on how hypotheses should be developed and defined differs considerably from one end of the research spectrum, i.e. the traditional sciences (often a mechanistic, rational, mono-methodical, logical and positivist activity approach – hard or quantitative), to the other end, where more social matters are dealt with matters which are (often more constructivist and centered around humans – soft or qualitative).

This process of establishing proper research questions and hypotheses possibly represents the most underestimated phase of the whole research process. For the junior researcher, it is even truer, since what occurs beyond these research questions is often uncharted territory. The questions give rise to a series of activities that will prove extremely complex. The present discussion addresses, with regards to devising hypothesis, the strategic importance of three interlinked elements that are essential in the research design: a) a proper (pertinent) and well-defined and formulated question that addresses a clearly stated problem; b) a consequent theoretical framework that will feed and support the argumentation; and c) that can both be expressed and communicated adequately in conceptual and operational frameworks (the methodology).

These elements, well documented in the literature (LESSARD-HÉBERT et al. 1996; POUPART et al. 1997; SILVERMAN 1997; REASON and BRADBURY 2001; CRESWELL 2003; GAUTHIER 2003; MILES and HUBERMAN 2003; DENZIN and LINCOLN 2005) are nevertheless sometimes confusing for design researchers. Design research draws on multiple knowledge bases, practices, theories and traditions for its conduct, as stated for example by BROADBENT (2002), CROSS (2006, 2007) and FINDELI (2008), and furthered by FRIEDMAN (2003) as follows: 1) natural sciences, 2) humanities and liberal arts, 3) social and behavioral sciences, 4) human professions and services, 5) creative and applied arts, and 6) technology and engineering. Design therefore "may involve any or all of the following domains, in differing aspects and proportions."

Adding to this apparent confusion, quantitative, qualitative, or even a mix of the two methods are solicited. Strong and well-tested traditions in each field thus render cross-pollination of methods tricky for the design researcher who deals with multiple dimension problematics: aesthetics, logic and ethics (FINDELI and BOUSBACI 2005). It is therefore insufficient to address proper questions unless it is possible to answer them within a justifiable theoretical framework (LESSARD-HÉBERT et al. 1996; POUPART et al. 1997; GAUTHIER 2003; DENZIN and LINCOLN 2005).

Consequently, depending on the designated field or angle of research, defining questions can be associated with an iterative process where the questions will be refined in order to "tame" the field and material is to be cross-referenced with available literature. The important thing is to define what a design research question actually is.

Design Questions and Hypotheses

Our main concern resides in the choice of approach (SIP or SIT), and thus our stance or preference for a designated theoretical angle. Ideally, both should be explored in one discourse, though this poses logistical challenges. At this point we would like to postulate that "project design management" has more to do with "design situations" than "rational searching," as commonly accepted in the project management field (MACMILLAN *et al.* 2001; BOLAND and COLLOPY 2004; DE BLOIS and DE CONINCK 2009). Therefore, we consider project/design management, as well as the research design, to be design problems and by extension "wicked problems." Design science problems, as understood here, tend to be defined by their "fuzziness" and "wickedness" (RITTEL and WEBBER 1973, 1984; BUCHANAN 1992; COYNE 2005), meaning that design addresses ill-defined or ill-structured problems as opposed to well-defined ones. Furthermore, resulting solutions to design problems do not pretend to be optimal but rather "satisficing" (SIMON 1969). Consequently, can we assume that the same applies to the "design" of design research itself? "It is, therefore, true that in design problem solving, solutions are almost never predictable. This turns designing into an indeterministic process which is difficult to model and even more difficult to prescribe" (GOLDSCHMIDT 1997).

Furthermore, the very nature of the design activity is neither well-defined nor well understood. This is true in our case of the construction industry (MORRIS *et al.* 1999; HEDGES *et al.* 2000; KAGIOGLOU *et al.* 2000; AUSTIN *et al.* 2002; MACMILLAN *et al.* 2002; BIBBY 2003; POT 2005) and in the definition of the design space (ROWE 1987; OXMAN 1995; GOLDSCHMIDT 1997; DORST and CROSS 2001; DORST 2006): "Convention has it that in a well-defined problem, the initial state is given.... In an ill-defined

problem, ... the initial state is usually vague, and the goal state either unknown or ambiguous"(GOLDSCHMIDT 1997). Again, the same can be assumed for the design of design research.

Design is multidisciplinary by nature. As we mentioned, it deals with a growing number of issues from diverse fields. Moreover, design research goes beyond the "material" issues to consider the central role of the "human." The potential clash between the traditional sciences, dealing with the material world as it is (such as most engineering) and the social sciences needs to be addressed. Although it is possible, if not necessary, to "borrow" the necessary theories and methodologies from other disciplines, their articulation and application must be carefully orchestrated (FINDELI 2004). Trying to emulate other disciplines can prove very delicate, even precarious. Other than being prone to scrutiny and criticism from other scientific disciplines, there are, at times, a staggering amount of theories and "schools of thought" that support and animate each branch of science.

In this context, we can foresee that the existence of more than one paradigm in the design field has implications for the complexity of defining our own identity and scientific tradition. The present research, as illustrated in *Table 1*, embraces the position described by DORST & DIJKHUIS (1995, 1996) in confronting Symbolic Information Processing (SIP) for the project management approach, to the Situativity approach (SIP) (SCHÖN 1983) for the design thinking approach (SIMON 1969; SCHÖN 1987; DORST and DIJKHUIS 1995; VISSER 2006). SIP is mainly associated with rational thinking. SIT refers to "reflection in action." The nature of the research subject, "design management" in general and decision-making in the context of construction projects in particular, reveal two similar approaches to problem solving. SIP and SIT thus offer a suitable theoretical framework to address both situations as well as their converging interfaces. These two positions reflect the main trains of thought and practices in both design (action) and management (decision-making). Furthermore, literature on these subjects strongly refers to two important authors, SIMON (1969) and SCHÖN (1983) when tracing the foundations of design theory and action.

Item	'Simon'	'Schön'
designer	= information processor (in an objective reality)	= person constructing his/ her reality
design problem	= ill-defined, unstructured	= essentially unique
design process	= a rational search process	= a reflective conversation
design knowledge	= knowledge of design procedures and 'scientific' laws	= the artistry of design: when to apply which proce-dure/piece of knowledge
example/model	= optimization theory, the natural sciences	= art/the social sciences

Table 1. Paradigm confrontation: rational problem solving vs reflection-in-action. (Source: DORST and DIJKHUIS, 1995)

Designing the Research

During the design of the present research project, it has become clear that the choice of methodological approach represents a considerable challenge. This choice is determined by the question itself and how the researcher plans to answer that question. Although one can decide, quite rightly, to adopt a more entrenched position in which one would favor a specific (scientific) school of thought, such an approach would still fall short of what the design research is trying to achieve.

Whether the research is guided by a deductive or inductive approach will determine, in certain aspects, if we are to deal with postulate or hypothesis (SWAN 2002). A hypothesis normally calls for a process of verification that results in a true/false result (CHALMERS 1999; POPPER 1968). Even if it seems obvious to most seasoned researchers, it has proven more complex than previously thought in the emerging field of design research. The fact that there is no stable or generally accepted "scientific" tradition in our field of research (CROSS 2006, 2007;

FRIEDMAN 2003) makes it even more hazardous and prone to critique from the more traditional and established sciences. Although it is possible, if not necessary, to "borrow" the necessary theories and methodologies from other disciplines, their articulation and application must be carefully orchestrated.

The adequate articulation of the concepts of "question," "hypothesis" and "postulate" thus raises some fundamental theoretical questions for design science, as much as they present challenges with regards to the design of the research itself (epistemological choices) (FRIEDMAN 2003). "Questions and Hypotheses" are indeed embedded in the research vocabulary and unavoidable stepping stones in the process of the design of the research (if not what ultimately justifies its very purpose). But surprisingly, as simple as this terminology may seem, it remains confusing in many ways. Though semantically dissecting the meaning of these terms seems excessive, it would nonetheless be prudent to clarify certain distinctions that are not necessarily made clear in the literature and are yet to be explored.

Discussion topic

The distinction between "hypotheses" and "questions," as addressed in the course of this design research (by the junior researcher trying to define the research program), confronts many potential conflicting approaches. The dilemma comes from the very nature of the design activity itself. The multitude of disciplines needed and brought into the process of designing (whether objects, buildings, landscape) adds to this complexity. Knowing that he cannot be an expert in all domains, the designer must rely on other disciplines' contributions. He is positioned as a mediator-processor who will define, "digest" and articulate the problem-solution space material.

Therefore, one cannot draw a definite line between prescribed approaches (methodologies) as easily as one can in hard sciences. It is difficult to initiate a clear debate around the nature and role of the question and hypothesis phase of the research. As we make the following assertions, it becomes evident that design research does not fall under the

umbrella of traditional sciences and needs to borrow from many of them. As a reminder: a) the designer is in the process of producing "that-which-is-not-yet" (NELSON and STOLTERMAN 2003); b) the potential solutions are not finite ones, they are "satisficing" (SIMON 1969); c) the situation and contributors influence the process (CROZIER and FRIEDBERG 1977; SCHÖN 1983; DE BLOIS and DE CONINCK 2008); d) the material needed to devise solutions is often a mix of quantitative and qualitative data and information; e) the very nature of design problems is termed "wicked" (RITTEL and WEBBER 1973, 1984); and f) designers are known to leave the problem space open (as much as they can) (ROWE 1987; LIEDTKA 2004; OWEN 2007). In this context, it is difficult to settle on a fixed question, because it is most likely to change during the research as more information is made available and the research might profit from the question being reframed.

Conclusion

Since a design solution will likely come out of a multi-dimensional space (multidisciplinary in nature) (BUCHANAN and MARGOLIN 1995; FRIEDMAN 2003; DORST 2006), it would be pretentious to base the research on a hypothesis that, by definition, wishes to validate the "feasibility" of a pre-determined potential solution, knowing that design problems and outcome are essentially "unique" (SCHÖN 1983) and allow for a variety of different solutions (HARFIELD 2007). Design wants to discover and devise new "things" that are "not-yet" (NELSON and STOLTERMAN 2003), and these solutions are drawn through processes and activity contextually set (CLANCEY 1997; GERO and KANNENGIESSER 2002) in action (SCHÖN 1983; JOAS 1996), as well as from traditional hard data. Designers are always in a research mode (ZEISEL 2006). Their inquiries through assimilation remix the problem data with new data and temporary solutions as they become available throughout the design and project process (CROSS 1995; MACMILLAN, et al. 2002). It would therefore be coherent to approach the design of the research on the same premises as we do for design problems: as a conversation (SCHÖN 1983; SIMON 1969) and co-evolution of problem/solution (DORST and CROSS 2001).

Traditionally, hypotheses have a fixed objective where alternatives are discouraged and where there are no "maybes," but only clear true or false responses. This is why questions (or problem space definition) seem to drive design activity, and why design research should consequently consider questioning the proper use and justification imposed by the hypothesis framework (SWAN 2002; JONAS 2001) – unless hypotheses are formed retroactively, as in the iterative/recursive design "process." The term assumption, in this case, seems an appropriate compromise for the hypothesis, since one does not wish to be self-congratulatory by setting out a hypothesis with a pre-determined solution (optimization) or answer. The designer/researcher truly aims at giving direction and foundation to an evolving potential "satisficing" solution, all without strict frontiers, while adopting an "open system" view.

References

AUSTIN, S., NEWTON, A., STEELE, J. and WASKETT, P. "Modeling and Managing Project Complexity." *International Journal of Project Management* 20 (2002): 191–198.

BIBBY, L. "Improving Design Management Techniques in Construction." Loughborough: Laughborough University, 2003.

BOLAND, R. J. J., and F. COLLOPY. *Managing as Designing.* Stanford: Stanford University Press, 2004.

BROADBEND, J. "Generations in Design Methodology," in *Common Ground: Proceedings of the Design Research Society International Conference at Brunel University,* edited by D. DURKING and J. SHACKELTON. Stoke on Trent: Stafford University Press, 2002.

BUCHANAN, R. "Wicked Problems in Design Thinking." *Design Issues* 8 (1992): 5–21.

BUCHANAN, R., and V. MARGOLIN. *Discovering Design: Explorations in Design Studies.* Chicago: University of Chicago Press, 1995.

CHALMERS, A. F. *What is this Thing Called Science?* Maidenhead: Open University Press, 1999.

CLANCEY, W. J. *Situated Cognition.* Cambridge; Cambridge University Press, 1997.

COYNE, R. "Wicked Problems Revisited." *Design Studies* 26 (2005): 5–17.

CRESWELL, J. W. *Research Design: Qualitative, Quantitative and Mixed Methods Approach.* Thousand Oaks: Sage Publications, Inc., 2003.

CROSS, N. "Discovering Design," in *Discovering Design: Explorations in Design Studies,* edited by R. BUCHANAN and V. MARGOLIN. Chicago: University of Chicago Press, 1995.

CROSS, N. *Designerly Ways of Knowing.* London: Springer, 2006.

CROSS, N. "Forty Years of Design Research." *Design Studies* 28 (2007): 1–4.

CROZIER, M., and E. FRIEDBERG. *L'acteur et le système.* Paris: Éditions du Seuil, 1977.

DE BLOIS, M., and P. DE CONINCK. "The Dynamics of Actors' and Stakeholders' Participation (ASP): An Approach of Management by Design." *CIB-W096, Design Management in AEC.* Sao Paulo: CIB Rotterdam, 2008.

DE BLOIS, M., and P. DE CONINCK. "The Dynamics of Actors' and Stakeholders' Participation (ASP): An Approach of Management by Design." *Architectural Engineering and Design Management* (2009): 176–188.

DENZIN, N. K., and Y. S. LINCOLN, eds. *Handbook of Qualitative Research.* Thousand Oaks: Sage Publications, Inc., 2005.

DORST, K. "Design Problems and Design Paradoxes." *Design Issues* 22 (2006): 4–17.

DORST, K., and CROSS, N. "Creativity in the Design Process: Co-Evolution of Problem-Solution." *Design Studies* 22 (2001): 425–437.

DORST, K., and J. DIJKHUIS. "Comparing Paradigms for Describing Design activity." *Design Studies* 16 (1995): 261–274.

DORST, K., and J. DIJKHUIS. "Comparing Paradigms for Describing Design Activity," in *Analysing Design Activity,* edited by N. CROSS, H. CHRISTIAANS, and K. DORST. Chichester: Toronto, Wiley, 1996.

FINDELI, A. "La recherche-projet: une méthode pour la recherche en design." *Symposium de recherche sur le design.* Bâle: Swiss Design Network, 2004.

FINDELI, A., and R. BOUSBACI. "L'Éclipse de l'Objet dans les Théories du Projet en Design." *6ième colloque international et biennal de l'Académie européenne de design, EAD: Design-System-Evolution* Brême, 2005.

FINDELI, A., BROUILLET, D., MARTIN, S., MOINEAU, C. and TARRAGO, C. "Research Through Design and Transdisciplinarity: A Tentative Contribution to the Methodology of Design Research." *FOCUSED: Current Design Research Projects and Methods.* Mount Gurten, Bern: Swiss Design Network, 2008.

FRIEDMAN, K. "Theory Construction in Design Research: Criteria: Approaches, and Methods." *Design Studies* 24 (2003): 507–522.

GAUTHIER, B. *Recherche sociale: de la problématique à la collecte des données.* Sainte-Foy: Presse Universitaire du Québec, 2003.

GEDENRYD, H. "How Designers Work." *Cognitive Studies.* Lund: Lund University, 1998.

GERO, J. S., and KANNENGIESSER. *The Situated Function – Behavior – Structure Framework.* Dordrecht: Kluwer Academic Publishers, 2002.

GOLDSCHMIDT, G. "Capturing Indeterminism: Representation in the Design Problem Space." *Design Studies* 18 (1997): 441–455.

HARFIELD, S. "On Design 'Problematization': Theorising Differences in Designed Outcomes." *Design Studies* 28 (2007): 159–173.

HEDGES, I. W., V. I. HANBY, and M. A. P. MURRAY. "A Radical Approach to Design Management." *CLIMA 2000 Conference.* London: 2000.

JOAS, H. *The Creativity of Action.* Chicago: Polity Press, 1996.

JONAS, W. "A Scenario for Design." *Design Studies* 17 (2001): 64–80.

KAGIOGLOU, M., R. COOPER, G. AOUAD, and M. SEXTON. "Rethinking Construction: The Generic Design and Construction Process Protocol." *Engineering Construction & Architectural Management* 7 (2000): 141.

LESSARD-HÉBERT, M., G. GOYETTE, and G. BOUTIN. *La recherche qualitative: fondements et pratique,* Montréal: Éditions Nouvelles, 1996.

LIEDTKA, J. "Design Thinking: The Role of Hypotheses Generation and Testing." In *Managing as Designing,* edited by R. J. J. BOLAND, and F. COLLOPY. Stanford: Stanford University Press, 2004.

MACMILLAN, S., J. STEELE, S. AUSTIN, P. KIRBY, and S. ROBIN. "Development and Verification of a Generic Framework for Conceptual Design." *Design Studies* 22 (2001): 169–191.

MACMILLAN, S., J. STEELE, P. KIRBY, R. SPENCE, and S. AUSTIN. "Mapping the Design Process During the Conceptual Phase of

Building Projects." *Engineering Construction & Architectural Management* 9 (2002): 174–180.

MILES, M. B., and A. M. HUBERMAN. *Analyse des données qualitatives.* Paris: De Boeck Université, 2003.

MORRIS, J., J. ROGERSON, and G. JARED. *A Tool for Modelling the Briefing and Design Decision Making Processes in Construction.* Cranfield, UK: School of Industrial and Manufacturing Science, Cranfield University, 1999.

NELSON, H. G., and E. STOLTERMAN. *The Design Way, Intentional Change in an Unpredictable World.* Englewoods Cliffs: Educational Technology Publications, 2003.

OWEN, C. L. "Design Thinking: Notes on its Nature and Use." *Design Research Quarterly* 2 (2007): pp.16–27.

OXMAN, R. "Viewpoint Observing the Observers: Research Issues in Analysing Design Activity." *Design Studies* 16 (1995): 275–283.

POPPER, K. R. *The Logic of Scientific Discovery.* New York: Harper & Row, 1968.

POT, P. "Optimalisation des formes d'organisations dans l'industrie de la construction." *Faculté Collège du management et de la Technologie.* Lausanne: École Polytechnique Fédérale de Lausanne, 2005.

POUPART, DESLAURIERS, GROULX, LAPIERRE, MAYER, and PIRES. *La recherche qualitative: enjeux épistémologique et méthodologiques.* Montréal: Gaétan Morin, 1997.

REASON, P., and H. BRADBURY, eds., *Handbook of Action Research.* London: Sage Publications, Inc., 2001.

RITTEL, H. W. J., and M. WEBBER. "Dilemmas in a General Theory of Planning." *Policy Sciences,* 4 (1973): 155–169.

RITTEL, H. W. J., and M. WEBBER. "Planning Problems are Wicked Problems." In *Developments in Design Methodology,* edited by N. CROSS. New York, John Wiley & Sons Inc, 1984.

ROWE, P. G. *Design Thinking.* London: MIT Press, 1987.

SCHÖN, D. *Educating the Reflective Practitioner.* San Francisco: Jossy-Bass, 1987.

SCHÖN, D. A. *The Reflective Practitioner. How Professionals Think in Action.* Aldershot, Hants, Ashgate, 1983.

SILVERMAN, D. *Qualitative Research: Theory, Method and Practice.* London: Sage Publications, Inc., 1997.

SIMON, H. A. *The Sciences of the Artificial*. Cambridge, Mass.: MIT Press, 1969.

SWAN, C. "Action Research and the Practice of Design." *Design Issues* 18 (2002): 49–61.

VISSER, W. *The Cognitive Artifacts of Designing*. Mahwah, New Jersey: Lawrence Erlbraum Associates, 2006.

ZEISEL, J. *Inquiry by Design*. New York: W. W. Norton & Company, 2006.

ABSTRACT+
COMMENTS

Education for Design for Interaction: Prototyping, Interaction Vision and a Personal Design approach

Stella Boess

This paper discusses the way product design and research are approached in the design project "Exploring Interactions" at the *Delft University of Technology (TU Delft)*.[1] The project is a key part of the Design for Interaction Master's Program. The backdrop of the design project within the Master's Program is outlined first. The Design for Interaction Master's Program, which started in 2002, focuses on person-product interaction as a basis for the design of new products and services. It responds to a change in design thinking towards a human-centric approach and to the increased demand from industry for innovative approaches to products and services.[2]

The technological aspects of digitalization and the increasing complexity of products also play a role. The program seeks to educate "the new design professional" or "new design team." This designer or design team should be able to "tie together the inputs and requirements, solve conflicts in overlaps, spot gaps in the available information, and come up with new concepts to match those needs" (STAPPERS *et al.* 2009). A growing body of research from the behavioral sciences is becoming increasingly relevant to design. But this body of research needs to be adapted and merged with design thinking in order to work for design education,

01—You could consider turning several of the aspects you mention in your presentation into specific research questions. **02**—A research question here could be: how does the project and the Master's program prepare the students to become design researchers, to progress from the Master's to PhD? In the presentation you mention the goal that the project should enable the students to develop *experiential, reflective and critical* thinking and to act as designers. There could be a clearer account of these meta-cognitive aspects. How does this suggest a possible progression to a PhD? This was a major problem encountered when getting design PhD programs ratified in the US. What kind of design knowledge can be called worthy of a PhD, or of a Master's?

as we have discovered from past experience (STAPPERS *et al.* 2007). The design students work in a project-driven rather than a theory-driven way. Theory and techniques support their work. Tools include context-mapping (STAPPERS *et al.* 2009), Vision in Product Design (HEKKERT and VAN DIJK 2001), emotionally-oriented design (DESMET *et al.* 2007) and role-playing (BOESS 2008).

The design project Exploring Interactions (EI) is one of two major design projects the students undertake in the Design for Interaction Master's Program. The author is a coordinator of this project and is jointly responsible for developing the project further to suit the needs of students. The project challenges the students to do research into a situation from everyday life, to develop design concepts that intervene in that situation and to evaluate those design concepts.[2] The notion of exploration is key in the approach to research and design in the EI project. Rather than drawing up a list of requirements, the students start by exploring a chosen situation and formulating their own design goal for that. After conducting their (mostly qualitative) research into the situation, and into the lives, concerns and experiences of the people in that situation, they go on to formulate an *interaction vision*. This is the touchstone from which the students' design project evolves. A second central element of the course is the generation of *prototypes* as tools for exploration. Prototyping does not serve to test a hypothesis about an interaction, but rather to explore what issues emerge from the intervention that the prototype makes (STAPPERS *et al.* 2009). The students carry out further small-scale exploratory studies in their chosen situation to develop specific aspects of their project. Finally, the students evaluate their designs according to two criteria: how their design proposal is used, understood and experienced by users, and whether their design proposal fits their interaction vision.

03—This is another potential research question, worthy of research in its own right. You want the students to have the opportunity to design for interaction. You partly do that through *forced experiences*, as you say. But taking into account the distinction that Dewey made between experiences and experiments, the students may not reach the level of cognitive understanding that you're predicting. Finding ways to shift a forced experience into the world of personal experience is an issue we all have to address; in other words,

The course facilitates a true designer's approach. It challenges the students to engage *personally* with their design project and to develop their identity as a designer (HUMMELS 2004). The program is geared towards developing investigative designers, who are able to integrate designing and researching into their design process. In the EI project, the students are brought into contact with two potentially conflicting demands of professional practice: that of ensuring research quality and that of ensuring the research's usefulness to the design process. We tutors have a parallel dilemma: how to convey the constraints of research quality and at the same time encourage students to be as exploratory as they can be in both their research and their design activities. The paper reflects on the ways in which we as tutors on this course support this learning process for the students.[4]

it's a key characteristic of professional designers to be able to embrace experiments as experiences. 04—What kind of research is it that you're doing on your program? Do you treat the program as an experiment? Do you test variables, do you set controls?

FINAL PAPER

Questioning the Student Experience in Design Education

Stella Boess

Introduction

This paper discusses the educational aspects of the design project "Exploring Interactions" at the Faculty of Industrial Design Engineering (IDE) at the *TU Delft*. It does so with reference to the discussion that followed my presentation at the *Question and Hypotheses* conference. The paper briefly addresses each of the three questions raised during the discussion. The second of these questions is then discussed in more depth in the remainder of the paper.

Questions at the conference

How does your course project and Master's Program at Delft prepare the students to become design researchers, given, for example, the problems that M.A. programs have in getting ratified in the U.S.?

The Bachelor's and Master's programs in the Faculty of Industrial Design Engineering (IDE) at the *TU Delft* are designed to prepare students for further research activities. The program leads to a Master of Science (MSc) and not a Master of Arts (MA). The students learn to conduct and report research in a structured way and to combine research and design activities purposefully. The faculty also has a well-established program of PhD research. That said, there is a wider issue of the legitimacy of design-inclusive research that is still being discussed widely and at the *TU Delft.* It concerns the criteria that should be used to assess design-inclusive research, for example by scientific funding bodies. This issue is too complex to be discussed here.

How do you assess whether the students treat what you teach as their own experiences, rather than treating them purely as experiments of no consequence to them?

The Exploring Interactions (EI) design project course in the Master's Program Design for Interaction aims to encourage students to: design for interactions between people and with products, services and systems, focusing on the use experience rather than on objective measures of e.g. usability;

— Experience and learn to deal with their freedom to explore a personal design style;

— Use research and design skills effectively and appropriately in conjunction.

Because the course is conducted on a large scale (the last project we ran had 100 students and ten tutors), and because of the need to achieve specified learning goals, we as course organizers impose a general structure on the students' progress, and some of the tutoring is offered in a standardized way. We need to make sure that we do not override the students' own flow and exploration. This question will be discussed further below with reference to Deweyan concepts.

What kind of evaluative research are you are doing on your program? Is it hypothetico-deductive research or theory-building research?

The IDE Delft faculty carries out regular qualitative and quantitative internal audits and also receives periodical external audits from international advisory boards. These audits provide feedback on the overall objectives and effectiveness of the courses. We as course organizers of Exploring Interactions also monitor the course ourselves through qualitative evaluations. In the first instance, the aim of these evaluations is not to generalize the findings, but rather to apply them directly in order to adjust parts of the course or develop new ideas for it. On occasion, we write up the lessons learned about specific aspects in a structured way (see BOESS 2008). While these inquiries seek to generate new theoretical relationships that could lead to further research, they primarily help us to adapt the course structure. That is why qualitative and action research approaches are the main methods of our research (see SCHÖN 1983; SCHÖN and ARGYRIS 1991).

Approach in the remainder of this paper

From the three questions posed at the conference, I elaborate on the second one in the remainder of this paper. It has direct relevance for my evaluation of design teaching and is an opportunity for me to explore new research questions. For the purposes of this paper, I will focus particularly on a part of the EI design project course that I have investigated previously: role-playing workshops. The role-playing workshops are a standardized part of the course and aim to experientially familiarize students with user experience. This makes them particularly open to analysis in light of DEWEY's work (e.g. 1938). Choosing these workshops as a focus also allows me to look back on research questions I have previously asked about them. The previous questions and findings can be compared to Deweyan notions.

How do you assess whether the students treat what you teach them as their own experiences, rather than treating them purely as experiments of no consequence to them?

The focus on interactions and user experience in the EI project requires the students to become closely acquainted with the situation they are designing for and to engage with it in-depth (e.g. KRIPPENDORFF 1993; KOSKINEN and BATTARBEE 2003; ERICKSON 2006). Many authors have emphasized the need for such an engagement to be experiential and close rather than abstract and distant (e.g. DEWEY 1938; BURNS *et al.* 1994; BUCHENAU and FULTON SURI 2000; BRANDT and GRUNNET 2000; KLOOSTER *et al.* 2004). These authors argue that experiential engagement and design insight can best be achieved through live, bodily activities rather than through abstract, static information. KOSKINEN and BATTARBEE (2003) argue that with an objective, distanced stance (such as in ergonomics), a designer cannot access human feelings or the diverse situations besides work situations, in which new products and technologies are increasingly used. For this, immersive and empathetic approaches are needed. The role-playing workshops we provide to students in the EI project course are an example of such approaches. They are part of a larger toolbox of possible approaches that can be used when designing for experience, as for example outlined by FORLIZZI and BATTARBEE (2004). In order to design for interactions successfully, I would like to see the students work in the following ways:

— Experientially: choosing approaches which allow them to experience the interactions they are designing for (e.g. BUCHENAU and FULTON SURI 2000);

— Reflectively: being able to listen to the feedback that comes from the situations they are designing for (SCHÖN in BENNETT 1996);

— Critically: being able to develop criteria for desirable approaches and outcomes, and questioning their own design ideas in relation to the situation they are intended for (e.g. DUNNE 1999).

Role-playing workshops

The EI project features role-playing workshops at two points during the project *(Figure 1)*: right at the start and about one-third of the way in, when the students are at a transition point between doing research into a real-life situation and designing for that situation. The role-play

workshops offer the students a way to connect experientially with the situation they want to design for and prototype interactions with things that do not exist yet. As this paper is about research questions that could arise from these role-playing workshops, and not about the workshops themselves, they are only briefly described here: in the workshops, we guide the students as they simulate interactions between people and with things in order get a feel for the qualities of those interactions. The students also experiment with the information that they have gathered in prior research in a practical context, and try to transfer this information into design ideas and concepts. BOESS, SAAKES and HUMMELS (2007) and BOESS (2008) discuss the workshops in more detail.

Figure 1: An overview of the design project course Exploring Interactions, running over five months. The top row shows the design activities of the students. The bottom row shows the research activities of the students. The students carry out the two types of activities in parallel so that the activities feed into each other. The figure also shows the points in the project when we provide role-playing workshops for the students. The pale circles indicate these points: at the beginning of the project and about one-third of the way in (the last two phases are longer than the first two).

Looking back on research questions previously asked

We have not to date translated the reflective, experiential and critical attitude of the students into specific theory-guided research questions about the success of the role-playing workshops. Both with coauthors and on an individual basis, I have previously evaluated the workshops using action research methods (BOESS et al. 2007; BOESS 2008). In our evaluations we looked at the practical problems of integrating role playing workshops into design teaching and into our own designing. We reflected on how these problems impact the usefulness of the techniques to design students and professional designers.

By usefulness we meant:

—Whether the techniques enabled the students and designers to relate to user research data in an experiential and empathetic way, and

—Whether the techniques were of help to them in ideation.

In those evaluations, we found, for example, that students who were under time pressure focused on producing results rather than on experiencing and exploring.

—The use of plenty of scrap materials and of physical activity during the workshops enhanced and stimulated the students' ability to engage in the role-play.

—The unfamiliar role-play activity sometimes felt unnatural to the students and to us. This resulted, for example, in embarrassed laughter. We could partly offset this awkwardness by providing a structured preparatory framework and a calm and secluded setting.

—The students found it hard to transfer the experience of the real-life situation to the stark setting of the project studio, far away from the original experience, and to imagine possible new interactions within that setting.

The last finding in particular motivated me to try and encourage the students to use the techniques themselves, in the situations they are designing for, and in the context of their own research and design work. In BOESS (2008), I reviewed the further progress made by focusing on three questions: whether the techniques helped the students understand and question interaction, whether the techniques helped the students with ideation, and whether the role playing workshops inspired students to use the techniques in their own work.

We found that:

—When the role-playing task was narrow and about a specific product, the students also took the props they used as prototypes for actual design ideas. It also seemed that they regarded the workshop more as a tutor-led workshop than as a technique they could adopt themselves (*Figure 2, left*).

—When the task was broader and more situational, the students' post-activity discussions focused on the first-hand experience of interacting and on the effects that objects have in interactions. The students did not

treat the props as design prototypes, and did not discuss any improvements to be made to them *(Figure 2, right)*.

— Some of the students adopted role-playing techniques in their own subsequent work. They used it more as an evaluation technique than as an ideation technique.

Figure 2. Left: a narrow task, acting with rough pill dispenser prototypes and proposing improvements to them.
Right: a broad task, mountaineering, exploring power relationships: who reaches the top first? Who controls equipment? Who knows the way?

Reflection in the light of Deweyan concepts

Connecting our evaluations of design education with Deweyan concepts

In our evaluations, we did not explicitly question whether the students were really enabled to work experientially, reflectively and critically; we only took those criteria as guiding ideas. Yet there is extensive literature available in the fields of child and adult education that is loosely or explicitly based on the educational philosophy of JOHN DEWEY (e.g. DEWEY 1938) and that also discusses all or some of these criteria. For example, SCHWARTZMAN (2006) also identifies all three criteria as important in learning, based on DEWEY. I coincidentally adopted the same criteria, perhaps because the interaction design literature that I am familiar with bases itself on readings of e.g. DONALD SCHÖN, who also reflected a great deal on education and drew on DEWEY's work. Literature advocating role-playing in the design field draws on e.g. the work of AUGUSTO BOAL, who in turn drew on the work of PAOLO FREIRE, who in turn drew on DEWEY's work as well. The fields of design and education are thus not completely removed from each other.

I also did not define or explicitly question the notion of experience in previous evaluations. When evaluating course content, our points of reference were mainly the learning goals of the course itself. We reflected on what works and what does not. In terms of designing and improving the course, this is adequate. The teaching staff consists of design researchers and practitioners, so we are not primarily focused on pedagogical concepts. Yet an excursion into the field of theory might bring new ideas to the discussion of design education. In the following section, I investigate whether Deweyan concepts can improve our focus on the students' experience.

Evaluating the student experience

We have the long term aim that the students will choose approaches that allow them to experience the interactions they are designing for. We think this will make them better designers because of the rationales from the literature cited above, where I explained the focus on interactions and practical experience in the EI design project course. The role-playing workshops were designed to convey such an approach to them. We can now say that this is only one of two notions of experience that we should take into account.

The other notion of experience, framed in DEWEY's (1938, 43–45) work, concerns the educational experience of the students in the workshops. Using this notion, we can say that the teaching offered should:

— Connect with the students' prior potential for experience at that moment and engage them in seeking future experiences (continuity), and

— Take into account their "internal" needs by imposing "external" activities to enable them to engage with the situations they are designing for (interaction).

Regarding the second notion, we can aim for the students to have an educative experience, not a mis-educative or non-educative one. We then need to match the objective expressed in the first notion, which is initially external to the students, to the continuity and interaction for the students that enable them to engage with this objective. The concepts of continuity and interaction show our previous conclusions in a

new light, beyond the practical issues. The notions can shed light on the learning experience of the students. For example:

— Using plenty of scrap materials and physical activity in the workshop activities has a positive effect on students, which indicates that these aspects help them connect the activities with their prior life experience, because they can make their own choices and close engagement in this.

— The unfamiliar activity of role playing sometimes felt unnatural in the workshops and resulted in embarrassed laughter. This seems insufficiently connected to students' past and expected future experience. We need to use body language and physical gesture in a way which relates more to their prior experience and try to anticipate situations in which they might use such techniques in the future.

— The students found it hard to transfer the insights from their prior research into the stark setting of the project studio. We could focus more on examples of how the techniques can be used in real-life settings rather than in the studio setting. They still need some imagination to learn the techniques in this setting. We could add exercises to the workshop designed to encourage them to try the techniques outside of the studio.

New research questions based on Deweyan concepts

New research questions can be formulated to further evaluate the role-playing workshops in the Exploring Interactions project course. They are, for example:

— How can the role-playing exercises be made to connect with the students' prior experience in life and as design students? Generally, the exercises are new to them. We have not previously investigated how well and in what ways the students are able to connect the exercises to their own lives.

— How can the potential benefits of using role-play techniques in design practice be conveyed to the students in such a way that they are motivated to use them in their future design practice?

— What questions and problems do the teaching methods raise for the students? Do those questions relate to interests they have in their lives and in their ideas about their future careers? Can the teaching efforts incorporate these questions?

Conclusion

I have found that Deweyan concepts can raise new research questions about the effectiveness of our teaching methods. We never previously explicitly questioned whether the students can connect the course content with their own prior experience and with their own expectations for the future. The research that we have previously conducted has enabled us to improve the learning module over time, as shown by our and the students' evaluations. The evaluation using DEWEY's work revealed possible reasons for this. On the other hand, adopting an overly narrow focus on Deweyan concepts alone might have prevented us from gaining some of the insights that we have now. For example, we engaged with the problem of whether designers should ideate while being engaged in-depth with a situation. I know from experience that sometimes, it is better to step out of the situation in order to develop ideas, yet this would seem to be contradicted by DEWEY's tenet of immersion. Even if my example is a misreading of DEWEY, the example illustrates a problem of action research that is also pertinent to design research: practical problems can be brought to light through theoretical concepts, but should not be overburdened by them. A more theoretically-oriented research using Deweyan concepts could investigate specific aspects of the students' experience. The outcomes could inform new approaches to design education and contribute to a more theoretically-based evaluation framework of design education methods. Theoretical concepts can be used in design research to illuminate practical problems, or to embark on more theoretically-oriented research.

Acknowledgements

I am one of two co-organizers of the Exploring Interactions project. It is also shaped to a significant degree by PIETER DESMET, and is founded on education design decisions that were made by THEO ROODEN and CAROLINE HUMMELS. At some points in the paper I use "we" instead of "I" when referring to efforts that included those and other contributors. Acknowledgement is also due to the students of the course and the initiative they showed when participating.

References

BENNETT, J. "Reflective Conversation with Materials, an Interview with Donald Schön by John Bennett." In WINOGRAD, TERRY, *Bringing Design to Software*. Addison-Wesley, 1996, *http://hci.stanford.edu/bds/9-schon.html* (accessed July 5, 2009).

BOESS, S. U. "First Steps in Role Playing." *Procs. CHI 2008, April 5–10*, 2008. Florence, Italy: 2017–2024.

BOESS, S. U., D. SAAKES, and C. HUMMELS. "When is Role Playing Really Experiential?" *Case Studies, Procs. TEI*, 2007.

BRANDT, E., and C. GRUNNET. "Evoking the Future: Drama and Props in User Centered Design." *Procs. Participatory design Conference PDC00*, 2000: 11–20.

BUCHENAU, M., and J. FULTON SURI. "Experience Prototyping. *Proc. DIS*, ACM Press (2000): 424–433.

BURNS, C., E. DISHMAN, W. VERPLANK, and B. LASSITER. "Actors, Hairdos & Videotape – Informance Design." CHI *Conference Companion*, ACM Press (1994): 119–120.

DEWEY, J. *Experience and Education*. New York: Touchstone, Simon & Schuster, 1938/1997.

DUNNE, A. *Hertzian Tales. Electronic Products, Aesthetic Experience and Critical Design*. London: Royal College of Art, 1999.

ERICKSON, T. "Five Lenses: Toward a Toolkit for Interaction Design," in *Theories and Practice in Interaction Design*, edited by SEBASTIANO BAGNARA, and GILLIAN CRAMPTON SMITH. Routledge, 2006: 301–310.

FORLIZZI, J. and S. FORD. "The Building Blocks of Experience: An Early Framework for Interaction Designers." *Procs. DIS 2000, ACM*, 2000: 419–423.

FORLIZZI, J. and K. BATTARBEE. "Understanding Experience in Interactive Systems." *DIS2004, August 1–4*, 2004, Cambridge, Mass.: ACM, 2004: 261–268.

KLOOSTER, S., R. APPLEBY, and K. OVERBEEKE. "Design (Education) Moves," in *The Changing Face of Design Education*, edited by P. LLOYD, N. ROOZENBURG, C. MCMAHON, and L. BRODHURST, *Procs. IEPDE*, 2004.

KOSKINEN, I. and K. BATTARBEE. "Introduction to User Experience and Empathic Design," in *Empathic Design. User Experience in Product Design,* edited by I. KOSKINEN, K. BATTARBEE, and T. MATTELMÄKI. Finland: Edita, 2003: 37–50.

KRIPPENDORFF, K., and R. BUTTER. "Where Meanings Escape Functions." *Design Management Journal* (1993): 30–37.

SCHÖN, D. A. *The Reflective Practitioner. How Professionals Think in Action.* U.S.: Basic Books, 1983.

SCHÖN, D. A., and C. ARGYRIS. "Participatory Action Research and Action Science Compared: A Commentary," in *Participatory Action Research,* edited by WILLIAM FOOTE WHYTE. Newbury Park, CA: Sage, 1991: 85–96.

SCHWARTZMAN, L. "A Qualitative Analysis of Reflective and Defensive Student Responses in a Software Engineering and Design Course." *Procs. Koli Calling,* 2006.

ABSTRACT+
COMMENTS

Conceiving Convincing Concepts:

How to conceptualize and conceive a PhD Project Design through a "systematic" mental map linking architectural investigations and statements (assumed or not), own project experiences and generalized outcomes? And how can such a Research Design then be used to explore emancipatory, "missionary" and tendentious fields in certain architectures?

Dag Boutsen

1. Introduction

By developing an adaptive theory using a "systematic" mental work map, I will lead you through the thinking process of a PhD that I have just begun in the field of participatory architecture and urban design.

Under the title of "True" Participation, I will explore formal expressions in architecture.[a] Trust is used here to mean confidence between the aesthetic elements (forms) and the ethical conditions (actions) in architecture.[1]

"The public should be involved in planning as much as possible!" was the catchphrase of the Sixties, which continued into the Seventies. Today it is imposed by law.[b]

role of the architect or urban planner should consist of allowing this creation or auto-construction to take place. However, today's participative architecture has been narrowed down to a set of administrative and juridical procedures. Between those two extremes, both embedded in a false sense of democratic architecture, we do find a middle ground of some sensitive and emancipatory architectural approaches.

[a] "True" Participation involves exploring formal expressions in architectures based on trust. It is an investigation of design-concepts produced in adaptive ways, and resulting in transformable spatial environments *(Chalmers University, Göteborg, Sweden – Department of Architecture Sint-Lucas, Brussels, Belgium).*

[b] The original thinking behind participative architecture is that the human habitat is a spontaneous creation and that therefore the

01—How are you going to ground and formulate trust? It has to be done at some point. If you can't ground trust, you can't ground the research question.

According to Keith Russell, the larger question "from the outside" refocuses on the notion of trust in architecture. The shown list of examples of non-standardized criteria related to visual impact components in architecture or urban design showcases a possible outcome in inventively applying trust.

Thousands of papers have been written on "public" involvement in architectural and urban design. The number of people having written about it – most of them in an ideological and frustrated perspective opposing existing situations – is larger than the number of people who have actually been involved in it. Almost every aspect of participation has been "academically" described.

Recently, PETER BLUNDELL-JONES and JEREMY TILL have tried to explain the renewed interest in this field. They feel that the time is right for a re-evaluation of participation, particularly given the European political context in which "participation" has become a buzzword, with little thought given to what the word actually means.[c]

At least three (new) reasons can be summed up here: Firstly, in contemporary global politics, where issues of democracy are so contested, true participation in the processes of change is becoming increasingly rare, while at the same time the need for it is growing.

Secondly, because true participation concerns real engagement of all those involved in the process, rather than a superficial interest, it could provide a counterpoint to the image-fueled world of the media.

The final point refers to a contemporary view of standard versions. The danger with a normative technique is that it sees the user (once again) as standard, there to be subjected to common methods. Instead, one has to accept that multiple users necessitate multiple desires, multiple contexts and multiple forms of participation.

—
c PETER BLUNDELL JONES, DOINA PETRESCU, and JEREMY TILL. *Architecture and Participation.* ISBN-10: 0-415-31746-0. Routledge, January 2, 2005.

The example of trust – in my presentation – was used several times in Alain Findeli's lecture to illustrate the differences between a design question and a research question: "A research question goes beyond a design question." This research topic is clearly situated beyond practical usage, according to Mike Press. Simply put, "trust in everyday life is a mix of feeling and rational thinking" *(Lewis and Weigert 1985, 972).*

To elaborate on this notion of trust and where it stands in relation to participatory design, it is necessary to focus on authorship in architecture. The oversimplified hypothesis, that most of today's architectural languages are too narrow or limited to be used in conjunction with "true" participation, actually stems from the dislocated situation or standpoint of the architectural authors.

My research has been conducted in the context of re-newed attention towards participatory processes in all development fields. We still do not have a debate of values and meanings in the forms, the patterns, the shapes and the proto-types of the visual inputs and outputs when working with possible users, inhabitants and those who are involved or interested in a fully participatory design process. We can advance by defining alternative aesthetic ways of designing, new forms of architectural practice and new conceptual qualities that arise from the intertwining of "professional" and "non-professional" knowledge.

169

The political dimension is too often avoided by differentiating between the functional and the aesthetic, which involves seeing the former as a purportedly objective terrain of ergonomics and efficiency and the latter as a kind of private language supposedly above the political debate.

The functional and the aesthetic are NOT isolated, neutral terms. They must be placed within a more complex politicized world.[d]

I will investigate this particular link between aesthetic dimensions and participation, and thus sustainability – two items rarely linked to each other. The discussion on the forms related to participation, built or not, has rarely been researched as such.

2. PhD framework

The PhD will examine the various emancipatory and democratic values that are incorporated into the investigated participatory architecture and urbanism. This practice-led research on PD (Participatory Design) aims to analyze my own and others' socially and politically engaged design processes that are located in specific local contexts. The research will describe instructional design tools that can be used in multiple contexts.[2] Unavoidably, I will start generalizing lists of work methods in order to end up with a how-to-guide. The different adventurous stories of interesting PD-cases will be rationalized and will lose their unique reasons for their success in the process.[3] By questioning and evaluating the qualities of both the design processes as well as the design outcome in a "scientific" or "research" manner, I will suddenly split the two roles that I usually play, as the (co-)designer of a project and as designer with a clear agenda and critical expertise which I use to provide service, activities and outcome.

d It is too easy to dismiss some of these participation-aesthetics as "crude" or "unsavoury." This kind of critique simply reinforces the presumed superiority of the standard architectural categories of refined and clean.

02—What is the aim of your study? What is the object of your thesis? Too wide, too many things ... it is *just* a PhD. Instead of analyzing objects and their aesthetic effect, I use Morten Kyndrup's test: Can I make a deliberate attempt at designing objects with a high degree of "implicit aestheticity" that invite the formation of aesthetic relations?

03—Don't you need generalizations in order to complete a complex architectural project, especially if "laymen" are participating? Don't you think they are using generalizations as well and they are successful?

The Zilvervloot project, as an example, is developed

by different authors, experts and "laymen." The visual result is therefore multi-layered. There are many ambiguities concerning the meaning of the different architectural components and signs. The problem of the "meaning" of these signs is that they conceal a more complex reality. The common expression "to have a meaning" adapts well to situations in which a thing or a sign has the same meaning for everyone. In this case, however, one must be aware that the actions and the things do not just have one meaning, they have a great many meanings.

It is not possible to discuss the interpretation of the meaning of forms in a univocal way. It is very easy to get stuck in hermeneutics, dealing with the philosophy of language and semiotics, in perceiving the architectural form and not the process or intention. What are the different significances of "formalistic" architecture, and when do these forms take the shape of intentions and processes?

Peter Watkins's work with alternative forms and processes is useful here. In summary, his film work with (mainly) non-professional actors has always been driven by a desire to add a new dimension and a new process to television, which it still lacks today: programs where public are invited to directly, seriously, and deeply participate in the expressive use of the medium to examine history – past, present and future.

La Commune (France 1999) is an attempt to break away from the formula of Monoform.

Broadly speaking, his "process" is apparent in the extensive way in which he involved the cast in the preparation, during the filming, and in the way that some of the people continued the process after the filming was completed. His "form" is visible in the long sequences and in the extended length of the film which emerged during the editing. What is significant, and very important in *La Commune,* is that the boundaries between "form" and "process" blur together, i.e. the form enables the process to take place – but without the process the form itself is meaningless.

Very similar to my relation, as an architect to *The Zilvervloot* project, Peter Watkins also deliberately wanted to retain certain hierarchical practices (including being a director with overall control) in order to see whether a "mix" of these and more liberating processes could result in something that satisfied two conflicting forms of creativity – a stand-alone and ego-centric form, and an open and pluralistic form.

The focus on time and space in the film, or the territorial aspects of social space in general, how it works and how it is continuously de- and re-constructed, is the reason why I continue making comparisons between film or theater and architecture in this debate on deconstruction of authorship, as an important ground for trust.

The interplay of perspectives, the way that stances are adopted, the issue of possible contestability, the way power is exercised and (potential) meanings are expressed in the staging and actualizing of possibilities, are extremely useful for the actual effect the architecture has as a collaborative representational action, opposing the focus on attaching a specific meaning to the project.

Value creation and co-creation in film and architecture are unavoidably linked with systems of criticism, and are therefore discussed in the following paper.

How then can I enhance my skills to run PD-projects from A to Z in a narrative way? And how can I handle cognitive values? The following mental map shows a design for a research project which is flexible and will evidently evolve and change.

The research project develops within three interacting layers: methods, form, concepts.

The middle and most important layer is called "Form." This layer will use stories to investigate elements of form in participatory design. These stories are named with personal titles. By doing this, I intend to set up a discussion, with a layout and a list of themes. In this discussion I will start with every item as a real and detailed story in order to generalize and make it abstract later on, looking for more conceptual and abstract research outcomes. Using these facts (and a description of their context), I want to emphasize the personal character of forms.

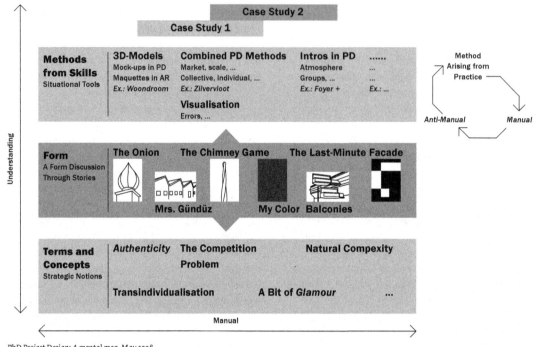

PhD Project Design: A mental map, May 2008

This list of titles is currently incomplete and will develop during the project; it will eventually present an overview in the form of a discussion from a distance and will be analyzed later on in semi-objective diagrams and mental maps.

I'll regularly refer to their origins as situated in participatory processes because this is important and necessary in the search for understanding these "forms." These participatory processes are described in the upper layer, called "Methods." The methods here are derived from and based on implicit and explicit skills, gained from more than 15 years of experience in a number of participatory projects.[e] This layer consists of different marked out sub-themes, each of which are portrayed in one exemplary project.

The sub-theme "3D-models," for instance, will investigate the different use and meaning of models in Participatory Design-phases (PD-phases) and Action Design-phases (AD-phases).[f] Using theories of EHN, KYNG, TVERSKY and others, the tacit and explicit (or tangible and intangible) knowledge embedded in these models will be differentiated.

The practice-led research within the Art & Design Research Centre at *Sheffield Hallam University,* England, is of particular interest to these investigations.[g] Two or more case studies which pop up during the course of the PhD project will be incorporated into this layer.

In describing the forms through PD-methods, a "glossary" that clarifies certain concepts is needed. In the layer "Terms & Concepts," I will try to elaborate on

—

e A *skill* is the learnt capacity or talent to carry out pre-determined results, often with the minimum outlay of time, energy, or both.
f *Participatory Design and Action Research: Identical Twins or Synergetic Pair?* Brisbane, Australia: Marcus Foth & Jeff Axup.

g C. RUST. "Creative Methods for Unlocking Consumers' Tacit Knowledge: Practical tools for designing user experiences." Briefing paper for the Faraday Packaging Partnership *Farapack Briefing Packaging Industry Conference,* York, UK: October 21–22, 2004.

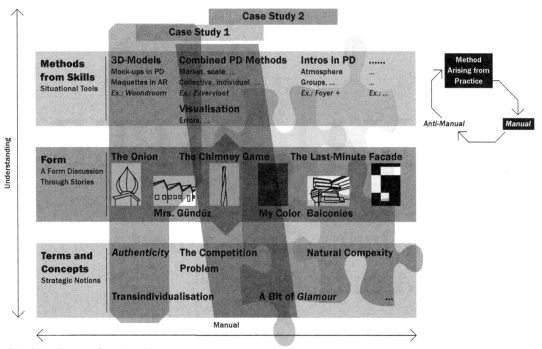

PhD Project Design: A mental map, May 2008

appropriate definitions needed to read through this thesis. "Complexity," for instance, is a term that is used in very different ways. The contextualization of these notions and hypotheses, both in the field of PD as well as in this thesis, will be developed in this layer.

The three layers, starting from the middle one, are linked in different ways.

As a whole, the scheme can be compared to the research finding methods of KARI KURKELA, setting up theories of "formal" musical functions in diagrams.[h] The map can then be read vertically and horizontally.

Vertical shapes that overlap with some items in the three layers, will enhance the viewer's understanding of certain types of architecture that are based on trust. Horizontal shapes will be helpful in building up a kind of manual, which will eventually result in a how-to

guide for policymakers and practitioners in PD. As described in the introduction, there will always be an awareness of the danger of a "standard" manual. Therefore, the "anti-manual" will act as a "neutralizer."

Finally, for now, this Project Design Map will function as a work plan and "contents" page, the page numbers being fictive of course and to be filled in during the course of the research project.

—
h KARI KURKELA is the head of a Research and Development Project for Music Schools (known as MOP) at the *Sibelius Academy*.

Reference:
LEWIS, J. DAVID and A. WEIGERT. *Trust as a Social Reality*, U.S.: Social Forces, University of North Carolina Press, 1985.

FINAL PAPER

The Janus-Faced Aspect of Architecture

Dag Boutsen

Abstract

This paper is intended as a discussion of the intuitive character of the PhD-research undertaken by a socially-engaged architect which will look into his "contested" architecture. It will develop two main fields of discussion. Firstly, it will report on *The Zilvervloot,* an exemplary case study within the thesis which represents aspects of trust-based architecture. I will reflect on the origins, the evolution and the perceived outcome

of this project by drawing a parallel between this Dutch building and the British film *Slumdog Millionaire*. This comparison seeks to emphasize the commonalities in both projects relating to their outwardly oriented meanings and values. Parallel to this discussion, I will develop a more general discussion on the role that values and ideologies play in research about socially inspired architecture and in the architecture itself. I intend to characterize some aspects that are crucial for design research on the border of the architectural practice and to relate these aspects to the discipline of criticism.

1. Introduction

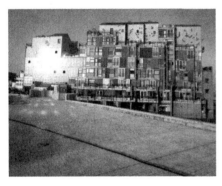 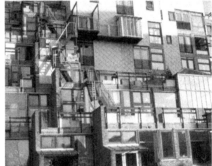

Figure 1: La Mémé, Maison Médicale, L. KROLL, 1970

It seems now that this paper was inevitable. I have always been attracted to contradictions, so LUCIEN KROLL's office was and still is fertile ground for me. Architecture's Janus-faced features appeared a long time before I even started thinking of becoming an architect: on the one hand was this intriguing building called *La Mémé* – a project impossible to understand without the necessary background and maturity – which I discovered as a teenager, while on the other hand there were selfish dreams of creating beautiful buildings for others one day. *La Mémé* was constructed about three decades ago two kilometers away from where I grew up in the east side of Brussels. My first job at KROLL's office was the result of coincidence and some luck, and the shape of architecture's contradictions grew visible. I slowly understood KROLL's varied and even

contradictory personality. *La Mémé* initially appears to many to be the natural manifestation of a collectively conceived design process, fully inspired by participatory design. Yet at the same time, the building has been totally designed by the one and only LUCIEN KROLL himself, in such a brilliant way that it is now listed for conservation as a monument.

La Mémé is one of the first examples of "Open Building," combining a concrete structure with flexible infills and changeable facades. The ultimate controlled design represents openness and possibilities of evolution in time. And the origins are, I now know, genuinely based on participatory processes. Janus with two heads, or more? History insists in any case that this building is part of architectural history.

Yet GEERT BEKAERT and FRANCIS STRAUVEN, the two leading Belgian architectural critics of the last decades, have been reluctant to embrace this architectural style or period.

> FRANCIS STRAUVEN (2008, 10): "... *Formlessness of the populism and eclecticism of the postmodernism ...*"
> GEERT BEKAERT (2008, 15): "... *Lucien Kroll rejects all <u>explicit</u> architectural <u>form</u> and expects the good to come of <u>a dubious theory</u> of participation in which the inhabitant <u>would</u> have the final word ...*"

Populism and Postmodernism are, according to STRAUVEN, "over and out." In the second quote, BEKAERT deliberately enumerates five vocabulary components – which I have underlined – in order to express his disbelief of the architecture of KROLL's most important building. Even in 2008, BEKAERT is still disapproving of an architectural ideology that has been recognized as important in over 1000 articles worldwide.

2. The Zilvervloot and Slumdog Millionaire

Architecture can be highly contestable, as the example in the introduction shows, because of its unfamiliar appearance and non-mainstream characteristics. Understanding this kind of architecture is consequently a delicate matter. What is more, this "understanding" cannot always be expressed through standardized research language or criticism, nor should it be.

If we want to bring the fields of research and criticism about this type of architectural practice forward, we need to understand the very idea of what this architectural practice and the identity of these architects consist of. PETER ROWE (1997, 5) declares that architectural practice:

> "[...] requires substantial expansion [...] because [...] the design problems presented by society continue to transcend 'normal' practice [...] this is not only a matter of increasing the scope and usefulness of architectural services, but also of addressing the socio-cultural role of architecture more critically."

The Zilvervloot

The participatory design processes in *La Mémé* in combination with construction techniques based on flexible components have been influencing many other projects in and outside of KROLL's office in numerous ways. A major project with a number of literal and more general similarities to *La Mémé* is situated in Dordrecht, The Netherlands. *The Zilvervloot*, a building complex that was commissioned by Woonbron and completed in 2006, is the first phase in the project to revitalize the Admiraals Square in Wielwijk. This housing and shopping project clearly complements the current, one-sided discussion about the way that post-war cities are renewed by creating exceptional residential quality. The banality of the existing situation is complemented by a sturdy showpiece. Various material choices, color patchworks and architectural tools are deployed in every possible way.

La Mémé and *The Zilvervloot* similarly appear as complex patchworks; *The Zilvervloot* is however not composed by the means of a technical grid unifying the whole. *The Zilvervloot* also contains a variety of architectural signs and symbols, which have not been abstracted as they were in *La Mémé*.

The Zilvervloot is more a chain of different stylish objects, rather than a connection of visually related, but different, components.

The Zilvervloot project, a mix of 130 different apartments and supermarkets along with smaller shops, emerged step by step during a consultation period with neighborhood committees, future inhabitants and the local parties that were involved that took place through discussions,

Figure 2: La Mémé, L. KROLL, 1970
connection of visually related, but different, components

Figure 3: The Zilvervloot, Dordrecht, D. BOUTSEN, L. KROLL, 2006, chain of stylish different objects

workshops, drawings, models, etc. The design has been altered over and over again, as the workshops constantly conflicted with the conclusions that were drawn during other participatory dialogue between construction advisers and co-architects about technical research on flexibility in the housing schemes.

Figure 4: Images of design workshops related to The Zilvervloot (2001–2003)

There is an obvious correlation between the slow and fully participative design process and the aesthetic outcome of this project. Its resulting uniqueness strengthens attests to the strengths of residents' involvement in their immediate surroundings, which enables them to experience the residential building as a collective object. This architecture is based on different types of trust. As a matter of fact, the correlation mentioned above is currently a subject of my PhD research.

The aim of this research is to explore, understand and situate the specific architectural and urban characteristics that have been instinctively, yet efficiently used in a particular series of architectural and

urban projects – *The Zilvervloot* is an important case here – based on a design process which was essentially a co-productive journey involving non-architects in the sketching and modeling practice. The emphasis is on approaches which create opportunities by capitalizing upon the strengths and assets of specific communities.

Cultural values, ideologies and dreams are important political elements in this discussion. They directly relate to MIESSEN's concept of controlled participation in political reality: "What was once seen as the defensive preserve of architects – mapping, making, or manipulating spaces – has become a new "culture of space" produced and shaped by an ever increasing number of disciplines. "Did Someone Say Participate?" showcases a range of forward-thinking practitioners and theorists who actively trespass – or "participate" – in neighbouring or alien knowledge-spaces. They share an essential interest: the understanding, production and altering of spatial conditions as a pre-requisite of identifying the broader reaches of political reality" (MIESSEN 2006).

In this context, the spatial practitioner is presented as someone who facilitates interaction that stimulates alternative debates and speculations. These alternative debates are situated at the borders of the discipline of architecture, beyond today's impoverished mono-disciplinary and mono-cultural architectural practice.

An external perspective includes a variety of perspectives to create a multifaceted interpretation of a building or a text, even if these interpretations conflict with one another.

This general insight and understanding was already described in post-structuralist criticism. In 1968, BARTHES published "The Death of the Author," in which he announces a metaphorical event, namely the "death" of the author as an authentic source of meaning for a given text. BARTHES argues that any literary text has multiple meanings and that the author is not the prime source of the work's semantic content. It is particularly important to analyze the ways in which the meanings of a text or a building shift in relation to certain variables, usually involving the identity of the reader or the inhabitant/user.

This social criticism can also be expressed in a fictional form.

Slumdog Millionaire

The multifaceted perception of *The Zilvervloot* can, in certain ways, be compared to the controversial debates on the British film *Slumdog Millionaire* (BOYLE 2008).

If we were to take a step back and compare film and architecture, we would find that the design process is the same in each in that both require a team of designers collaborating together. There are also similarities in the way that both try to present certain values to society so that they can be critiqued by the public (SAGI DAR ALI 2000). If one first looks at the basic elements of screenwriting in film, the writer is required to have a clear premise before beginning to write the script. Similarly, architecture takes on a challenge – to create a thesis – in order to introduce a concept for analysis and critique.

For those who don't know the film:

Set and filmed in India, *Slumdog Millionaire* tells the story of Jamal Malik (Dev Patel), an 18 year-old orphan from the slums of Mumbai, who is about to experience the biggest day of his life. With the whole nation watching, he is just one question away from winning a staggering 20 million rupees on India's "Who Wants To Be A Millionaire?" But when the show ends for the night, police arrest him on suspicion of cheating; how could a street kid know so much? Desperate to prove his innocence, Jamal tells the story of his life in the slum where he and his brother grew up, of their adventures together on the road, of vicious encounters with local gangs, and of Latika (Freida Pinto), the girl he loved and lost.

Each chapter of Jamal's increasingly layered story reveals where he learned the answers to the show's seemingly impossible questions. But one question remains a mystery: what is this young man with no apparent desire for riches really doing on the game show? When the new day dawns and Jamal returns to answer the final question, the Inspector and sixty million viewers are about to find out.

The film has been a subject of discussion among a variety of people. I will set out five points of similarity between this film and *The Zilvervloot:* 1) The film is a tale "with the edge of a thriller and the vision of an artist" (KAZMI 2009), and *The Zilvervloot* was officially promoted through

the slogan "A Living Dream" *(see www.zilvervloot.nu)*, 2) *Slumdog Millionaire* was never meant to be a documentary on the down and out in the slum of Dharavi, just as *The Zilvervloot* is not a literal translation of specific local participatory actions, but it is mixing the author's background with situational aspects, 3) The film is "Indian at its core and Western in its technical flourish" (BAMZAI 2009); *The Zilvervloot* also contains a mix of cultural influences, including Dutch, Belgian – because of the author – and other European archetypal influences, 4) *Slumdog Millionaire* is "a tribute to the irrepressible self" (GIRIDHARADAS 2009); *The Zilvervloot* is described as a "blooming landscape where coincidences, clumsiness or contradictions are brought in to enlarge the complexity" (HENDRIKS 2004), 5) The film displays the "human aspect of the slums" (SHETTY 2009); *The Zilvervloot* is all about "friendly scale" (DE HAAN 2005).

These five similar elements show, in a very particular way, the relationship between the most important cultural form – cinema – and the most important form of social organization – the city – in the twentieth and twenty-first centuries, as this relationship operates and is experienced in society as a lived social reality (SHIEL 2001). It is not the intention of this paper to fully resolve the relationship between the two fields, nor to investigate the useful and fruitful interdisciplinary contact between Film Studies and Sociology in addressing key elements which the two disciplines have in common. It is rather to underline the ever-relevant relationship between culture and society, particularly in what is now commonly referred to as the postmodern social and cultural global context; this relation is complex and manifold.

Despite the film's success, it is the subject of controversy due to the way it portrayed Indians and Hinduism. Likewise, *The Zilvervloot's* success from the point of view of the local community is not widely recognized by professionals. The mainstream professional press deliberately portray this kind of architectural design as belonging to limited historical contexts and/or paradigms, which suggest that the designs have only a limited significance when it comes to discussions about architectural form.

Let me try to illustrate some of these controversies:

According to WALTER CHAW (2009), *Slumdog Millionaire* "is an uplifting piece of crap that combines two of our favourite pastimes: winning the lottery and cultural obliviousness." In referring to the kiss at the end of the film, AMY NICHOLSON (2008) criticizes the film as "a glossy Disney cartoon that is not going to solve the problems that now infuriate us." These comments fully correspond with STRAUVEN's previously mentioned statements on "the formlessness of populism and eclecticism of postmodernism."

GEERT BEKAERT's critique of explicit architectural form based on a dubious theory is also very similar to the critique of MICK LASALLE (2008). LASALLE states that, "the movie has an arbitrary structure: it has a fable-like quality, similar to the 'Arabian Nights' tales, but the direction is straight-up realism: quick cutting and handheld cameras that are constantly moving." Substantial design cannot be based on a mixture of design languages, according to these critics.

The last and very classical example is the critique of MATIAS ECHANOVE and RAHUL SRIVASTAVA (2009) stating that "the film misrepresents and stereotypes the Dharavi slum in Mumbai." In the following section, I will focus on several points about the notion of stereotyping, more specifically regarding architectural symbols and signs as stereotypes. There is a renewed attention to slums worldwide thanks to the cinematic and stereotyped slum of DANNY BOYLE's movie. Curiously enough, research on the Dharavi slum proves that this slum is the most active and lively part of an incredibly industrious city. "No master plan, urban design, zoning ordinance, construction law or expert knowledge can claim any stake in the prosperity of Dharavi. The immigrants have created a place that has proved to be amazingly resilient and able to upgrade itself. ... In many ways, Dharavi is the ultimate user-generated city" (ECHANOVE and SRIVASTAVA, affiliated with the research collective *Partners for Urban Knowledge Action and Research*).

3. Values and ideologies

Cinema and architecture never cease to intervene in society and participate in the maintenance, mutation and subversion of systems of power.

Referring back now to the types of participatory designs described, these understandings need to be related to the problem of authorship – belonging to participatory processes – and to an appropriate understanding of meanings and values in the world of criticism. The short, 1998 essay "The Strange Death of Architectural Criticism" (is also the title of a book), is an attack on a contemporary world of criticism. MARTIN PAWLEY (2008) makes a good point here about the lack of critics who are able or willing to tear into a building, the way TV critics tear into a new show, based on open dialogues with the authors. In a review of this book, EDWIN HEATHCOTE shows support for the idea that criticism often lacks cultural depth and remains enslaved to celebrity culture. He adds however, "that building is culture, potentially more loaded with meaning and the weight of history than any other art form" (HEATHCOTE 2008).

In order to fully grasp the phenomenon of authorship combined with celebrity and people's cultures, the looking at dramatic criticism can be helpful. Two reasons explain this mental exercise. Firstly, unlike in architecture or cinema, the public and the performer(s) in theater share the same environment, both in terms of time and space.

Secondly, theater is about the interplay between reality and appearances. FERDINANDO TAVIANI (1991) has looked thoroughly into this interplay in "The Secret Art of the Performer." I explore TAVIANI in the following demonstrative quotes, but replacing all theatrical notions with architectural ones:

"One of the opinions about participatory design in architecture could be summarized as follows: the best architecture occurs when an intimate union is created between the architect and the user/inhabitant, when both come to feel in the same way, or when one of them succeeds in transmitting thoroughly to the other what s/he is thinking and experiencing. A corollary: the architect must be able to transmit his emotion to the user/inhabitant. This opinion is neither transformed nor amended by that other opinion which says that the power of architecture is related to its fiction and to our awareness of fiction, which perfects emotional, rational and artistic communication" (TAVIANI 1991, 256).

TAVIANI subsequently turns this thought around: "I believe that common sense demonstrates exactly the opposite: it is the divergence, the non-connection or even the mutual lack of awareness between the users' or spectators' view of the architecture and the architects' view of the architecture that makes architectural art an art and not an imitation or a replica of the known ... Great architecture in this opinion has this characteristic: the more the architecture connects users without obliging them to consent, the richer this architecture is" (TAVIANI 1991, 256).

In evaluating this type of richness, whether in a film, in a piece of theater or in an architectural project, both researchers as well as critical writers would have to understand, according to TAVIANI, that a project does not only mean to see what its authors (the "extended" architect or designer) have put into it, and what has been hidden deep within it, but rather to make discoveries during a carefully studied journey.

The Zilvervloot can be seen or analyzed as a varied, stratified complex of stereotypical signs.

Figure 5: The Zilvervloot, some architectural elements, 2006

Slumdog Millionaire is based on chapters with different cinematic styles that progress slowly.

"To make these projects understood" does not mean to plan discoveries but to design, "to lay out, embankments along which the user and his attention will navigate, and then to make a minute, multiform, unforeseen life appear on these embankments" (TAVIANI 1991, 256). Users will be able to immerse their perspectives into this life and will be able to make their own discoveries.

The Zilvervloot was developed by different authors, experts and "laymen." The visual result is therefore multi-layered. There are many

ambiguities concerning the meaning of the different architectural components and signs. The problem of the "meaning" of these signs is that it conceals a more complex reality. The common expression, "to have a meaning" adapts well to situations in which a thing or a sign has the same meaning for everyone. In this case one must be aware that the actions and things do not just have one meaning, they have a great many meanings.

These ambiguities are not serious when one examines the architectural phenomenon a posteriori. They become extremely serious, however, when they are examined a priori, from the point of view of the architects and the design process. Architectural critics or semiologists tend to examine architectural phenomena from the end point, or from the result. Could their process be more useful for those who must begin at the beginning, that is for the authors and co-authors of the design, whose final goal is the design through the users' eyes?

Translated to research, this question can only be responded to by integrating the concept of non-linear thinking. In this way, feedback loops interact to produce changing responses over time. And knowing this guarantees openness to the mental models of others. The recognition of patterns in these models happens, as I state in the paper's title, on the border of architectural research.

4. Conclusion

In this paper I discussed various standpoints towards contested design, especially the standpoints of artistic researchers and design critics. I presented the cases of *La Mémé, The Zilvervloot* and *Slumdog Millionaire* and focused on the complex and delicate matter of the way that meanings are perceived. As such, I hinted that it was impossible for research on contested design to be liberated from values.

I argued that architecture is sometimes about fiction and that the research of fiction includes intuitive methods. Design reviews on these types of architecture should be examined a priori, from the point of view of the design process, both in the worlds of research and criticism.

References

BAMZAI, K. "Maximum movie about maximum city," Jan. 23, 2009. *India Today. http://indiatoday.digitaltoday.in/index.php?option=com_content &task=view&id=26128§ionid=67&Itemid=1&issueid=89.*

BARTHES, R. "The Death of the Author," 1967. In *Image, Music, Text*. New York: Hill and Wang, 1977.

BOYLE, D. (director), L. TANDAN (co-director), and P. SMITH (producer). *Slumdog Millionaire*. Writers S. BEAUFOY, and V. SWARUP. UK: Celador Films, Film4, 2008.

BEKAERT, G., and F. STRAUVEN. In TIELT, L. *De Standaard architectuurbiblio-theek : 1000 jaar architectuur in België*, 2008.

CHAW, W. "Slumdog Millionaire," Feb. 29, 2009. *Film Freak Central http://filmfreakcentral.net/screenreviews/gomdog.htm*

DAR ALI, SAGI. "A Film Approach in Design," 2000. *http://www.arch.mcgill.ca/prof/mellin/arch671/winter2000/sdarali/frames.htm*

DE HAAN, H. "Een inspirerend stukje stad in kille buitenwijk," Dec. 6, 2005. *De Volkskrant. http://www.volkskrant.nl/archief_gratis/article558678.ece/Een_inspirerend_stukje_stad_in_kille_buitenwijk*

ECHANOVE, M. and R. SRIVASTAVA. "Taking the Slum Out of *Slumdog*," Feb. 21, 2009. *The New York Times. http://www.nytimes.com/2009/02/21/opinion/21srivastava.html*

GIRIDHARADAS, A. "Horatio Alger Relocates to a Mumbai Slum," Jan. 17, 2009. *The New York Times. http://www.nytimes.com/2009/01/18/weekinreview/18giridharadas.html*

HEATHCOTE, E. "The Strange Death of Architectural Criticism." *Iconeye, Icon Magazine Online* 57 (March 2008): *http://www.iconeye.com/index.php?option=com_content&view=article&id=3290%3Athe-strange-death-of-architectural criticism&Itemid=64*

HENDRIKS, R. "De werken van Lucien Kroll – Aanmoedigen tot verandering." *Puur Bouwen* (September 2004): 22–24. *http://www.daad.nl/wp-content/uploads/pdfs/DAAD%20De%20werken%20van%20Lucien%20Kroll.pdf*

KAZMI, N. "Slumdog Millionaire," Jan. 22, 2009. *The Times of India. http://timesofindia.indiatimes.com/moviereview/msid-4018046,prtpage-1.cms*

LASALLE, M. "Slumdog Millionaire saves the best for last," Nov. 18, 2008. *Houston Chronicle Movie Critic.* *http://www.chron.com/disp/story.mpl/ent/movies/6119649.html*

MIESSEN, M., and S. BASAR. "Did We Mean Participate or Did We Mean Something Else?," 2006. *http://www.studiomiessen.com/dssp.shtml*

MIESSEN, M. *The Violence of Participation (Spatial Practices Beyond Models of Consensus).* 2007. Roundtable: Research Architecture; *http://roundtable.kein.org/node/548.*

NICHOLSON, A. "Slumdog Millionaire," Nov. 13, 2008. *Inland Empire Weekly.* *http://www.ieweekly.com/cms/story/detail/slumdog_millionaire/1814/*

PAWLEY, M. *The Strange Death of Architectural Criticism, Martin Pawley Collected Writings.* Black Dog Publishing, 2008.

SHETTY, P. "So what do British Asians think of Slumdog Millionaire?" Jan. 18, 2009. *The Guardian.* *http://www.guardian.co.uk/film/2009/jan/18/slumdog-millionaire-british-asian-reaction*

ROWE, P. G., *Reflections on Architectural Practices in the Nineties,* edited by WILLIAM S. SAUNDERS. Princeton Architectural Press, 1997.

SHIEL, M., and T. FITZMAURICE, *Cinema and the City: Film and Urban Societies in a Global Context (Studies in Urban and Social Change).* Oxford: Blackwell Publishers Ltd., 2001.

TAVIANI, F. *(freely* recited from) "Views of the Performer and the Spectator" in *A Dictionary of Theatre Anthropology: The Secret Art of the Performer.* edited by E. BARBA and S. NICOLA. London: Routledge, 1991

ABSTRACT+
COMMENTS

The Value of Irritating Artifacts Related to Design and Usage

Katharina Bredies

Background

Designers nowadays acknowledge the creative effort of users during use. From a constructivist point of view, the steps taken by a user to understand an object in a particular context can be seen as an active process of production of meaning that is not just determined by the given object. KLAUS KRIPPENDORFF argues accordingly that the "user's ability to create meanings for their surroundings and act on them is not radically different from designers' ability to develop a design" (KRIPPENDORFF 2006). The creative potential of situated meaning production becomes especially evident in the reuse of existing designed objects that BRANDES *et al.* describe as "non-intentional design" (BRANDES *et al.* 2000).

However, until now, user-centered design methods mainly aimed at anticipating user behavior and understanding. The designers' role is usually to operationalize the activity that the object is designed for and to "encode" it into the design. If the user can "decode" the designer's understanding of the activity, he/she will successfully interact with the artifact. To guarantee a mutual understanding between designer and user, users are involved in the design process, be it through data (from observation or interrogation) or directly (as in participatory design). The design of a given object can then be efficiently optimized, since the designer can adopt and refer to existing meaning and therefore offer conceptual models that are easy to understand.

In any case, users are often only involved during the design phase, while their creative input during use is neglected. Usage patterns that emerge over time are harder to incorporate into the design process. Experience prototypes and iterative design are common strategies to let experience of usage inform the design of an object. Those short-term methods give design important clues, but are limited in time, so there is no full appropriation. They nevertheless often serve as a justification for a particular design decision.

For new original artifacts that still need to obtain a particular meaning, a strictly user-centered design process can therefore limit the variety and originality of the designs. Here, it is nearly impossible for the designers to predict and project all kinds of use, even when referring to user research or participation. Even with careful user evaluation, designers have hardly any influence on the way society actually adapts artifacts or how their meaning evolves (JONAS 2007).

Because users' personal experiences differ, the situation and the use context are often not fully predictable, so distinct interpretations of artifacts are possible only in closed domains. While in situ interpretation is ambiguous and clearly causes usability problems for life-critical activities, it is less problematic in many other contexts. Studies on affective computing demonstrate how various interpretations of an artifact enrich the user's personal relationship with technology, especially in a private surrounding and with innovative technological artifacts (BOEHNER 2005; HÖÖK 2004; HÖÖK 2006; SENGERS, et al. 2005; SENGERS and GAVER 2006). They give evidence that designers can actively address the users' production of meaning instead of regarding it as a problem.

Problem statement

Designers acknowledge the creative effort of the users during use, but user-centered design methods nevertheless focus on anticipating use more than trying to explore how to design for emergent use patterns. This is efficient when optimizing the design of an object, but can limit the variety of the results when designing new original artifacts whose meaning still have to be explored through use.

Hypothesis

Even when based on user research or user participation, the designers' capacity to predict and project use is inherently limited. However, referring to existing meaning always requires a mutual understanding, which is less likely to be available in the case of new and unknown artifacts. As an established meaning for new original artifacts often has to evolve, addressing shared understanding may not be the most successful design approach.

A more promising development may be the deliberate refusal of the designer to offer a definite meaning, but instead to present defamiliarized and surprising artifacts that provoke diverse interpretation.[1,2] Positive

01—Can you read irritation as an adjustment and meeting of expectations? **02**—Due to my experience, this seems like a funny statement. Is this really the case? A designer does not actually intend to fix meanings. On the contrary, she often knows a lot

about various possibilities for uses of an artifact. **03**—The idea of "positive irritation" remains unproblematized. Examples could help. **04**—What about anticipation, what about frustration, as a matter of interpretation afterwards. It's kind of an interpretation of the design product. Very often you can get this kind of information or interpretation once the design is finished. Then you can explore the irritation, but during the design process, we can't catch this kind of question. How do you think that you can use old cases in which you have analysed questions related to anticipation, frustration, irritation, to reuse them in a design process? **05**—The aim of the research is not very clear, or it is not well communicated. One of the obstacles lies

irritation will force the user to apply its own personal meaning and use context.[3,4] As there is no routine to fall into, the situated and improvised aspect of action becomes dominant (SUCHMAN 2007).

Defamiliarization enables us to critically investigate the assumptions that an object carries (BELL *et al.* 2005) and can encourage idiosyncratic use (DUNNE 2001). The effects may be a very personal account of an object's possible usages and a more enjoyable and successful appropriation process. It may also enable the situated reuse of artifacts that are not narrowly designed for one particular task.[5,6]

in the word "irritation." Maybe it is not the right word and it does not fit the goal. **06**—A real-life context is interesting to explore the irritation. Non-intended use and real-life

Question:

Once the irritation[7,8] moves beyond being merely criticism and starts to influence appropriation, it should be a much more useful response in real life during the design of original artifacts. How do irritating objects then change the users' production of meaning, their behavior and relationship to the object?[9,10,11]

observations raise the question of who is in power and who defines what is the right or wrong use. **07**—How can we think about irritation productively? What might be inside this concept? Is it like the estrangement technique in constructivist and surrealist art? Or like Heidegger's notion that we only recognize things as things when they break down? What is the essence of irritation, and what is within irritation? This means you have to map irritation and look for instances of irritation towards artifacts. **08**—You can better name it exploration, or a source for exploration. Irritation is

something that comes in the end. You might want to include it into an iterative process where the irritation is at the beginning and feeds back into the design process. It can be an opportunity to engage people, capture the experience, and document it. **09**—Is forbidding something an example of how to irritate people, and to make them do the opposite? **10**—How can you take the frustration of the user to be good, useful information? **11**—Is this a design method or do you want to design products that do something irritating? **12**—Is the statement thus limited to HCI? **13**—Designers have an intrinsic interest in experimenting with irritation. Designers use irritation as a tool in the process all the time. There are two

Value and importance

By now, user-centered design is well established and agreed upon as best practice (especially in HCI)[12] (INTERNATIONAL ORGANIZATION FOR STANDARDIZATION 1999), but its limitations have become evident as well (GREENBERG and BUXTON 2008). As a reaction, HCI researchers have reoriented towards more uncertain and less "scientific" activities that are very familiar to designers. However, many of them have been taken for granted or mystified as creativity. There is a need to explore and describe "designer" strategies like the playful confusion of expectations and the involvement of new usage patterns to give them a comparable seriousness.[13]

tensions in your topic: You need to valorize design irritation in design reception. Also, you should not only look forward, but capture the historical dimension of irritating aspects in design reception.

KATHARINA BREDIES — ABSTRACT

Qualification

The approach is more related to design's critical role, as described by DUNNE (2001), than to a classical product development cycle. However, it can be regarded as complementing user-oriented methods, emphasizing the original design work and acknowledging the inherent uncertainty that new design artifacts contain. Although the outcome of irritating objects in usage can inspire user-centered design processes in hindsight, it should not be just another form of knowledge production for them.

Confusing artifacts emphasize the creation of new meaning through variations, while user-centered design focuses on addressing existing meaning. Despite the risk of causing frustration in users, playing with and confusing meaning is an inherent form of creating desirable design artifacts (LUDDEN et al. 2008). A surprising play with the meaning of form, material, function and implied use context offers a latent usefulness, but leaves the defining power to the user.

FINAL PAPER

—

Unready-Made Artifacts for Open Interpretation

Katharina Bredies

Background

As the technology around us became more and more complicated, the field of usability emerged to bring back the human perspective to product and interface design. In short, good usability means that people should be able to understand and use a product without reading a 100-page manual. Put differently, the products around us should be "intuitive" to use. Lately, industrial and interface designers have discovered how qualified they are to promote a human-centered perspective and bring engineers' rational, technical inventions closer to everyday reasoning by using interface metaphors, analogies and narratives. In interface design, we can find several glorious examples, such as the Wii game

controller, the iPod wheel-like touchpad or the visual desktop meta-phor on most of our computer screens.[1] A popular assumption behind those "intuitive" products is that they rely on common skills and thus are ready-to-be-used without long learning phases.

However, the notion "intuitive" is critical in this context. We weren't born with a natural desire to steer touchpad wheels, not even with a desire to push buttons. What we share with our common perceptive ap-paratus is just a basis for a lifelong acquisition of diverse skills. When designers address common skills such as handling physical artifacts, they might have forgotten the effort it took as toddlers to acquire them. Watching elderly users when they encounter computer mice, we get an idea of how nonintuitive they can be. Another problem with intuition is that it relies on routine, no matter how strange the routine might be. For a software programmer, a fast and efficient command line might be much more intuitive than fumbling around with graphic pens. Every change made to an existing artifact is potentially threatening to a cur-rent practice. It is a familiar experience to anybody who repeatedly bumps into a newly-bought table at home – any change forces us to re-adapt to our environment.

Also, the amount of "intuitiveness" needed depends on the design problem. When designing an artifact, designers judge the skills of the artifact's users and their willingness to learn.[2] For an "intuitive" arti-fact, designers need to address broad and common skills and obvious concepts. However, an approach that is useful when designing a cockpit could be pointless in designing a game.

In any case, the feeling of responsibility for the human condition that human-centered designers often claim to have is ambiguous. Many designers (like engineers) love to produce variations of the design to check if there is a promising alternative to the conventions at hand. In these cases, they also change the interaction by changing the product,

1 For most of which, unfortunately, the assist-ance of designers during the development pro-cess is not accounted for.

2 We can find an advanced description and vocabulary of how users are "inscribed" into artifacts, respectively distributed between the artifact and the user, in LATOUR (1992).

constantly dissatisfied with the status quo[3] and always in search for a problem to solve.[4] And despite some harsh delimitation towards a technically-centered attitude,[5] designers and engineers are sometimes not that different in that they produce problems by producing the solution first. The desktop works more or less fine, but can't we find a better way of dealing with data? Varying for variation's sake is in the designer's nature; she can't help it.[6] If the new variation works in practice, it is considered an innovation. If not, the designers are punished by the usability experts, who assault them with their guidelines and pattern catalogs. By looking at the masses of different chairs, pullovers, cars, shoes and can openers that are still not "intuitive" to use, we might as well doubt the general compatibility of "intuitive" usability and design.[7] We are therefore suggesting that intuitive use relies heavily on learning and cannot be entirely designed. Involving the particular task, the former knowledge of the user,[8] and the situation at hand,[9] it seems difficult to immediately meet all the different needs involved in intuitive use. This is far more realistic after a period of learning and adaptation.

So when we think about design as making products more intuitive, we should not forget the wonder we feel as users when we first encounter a new artifact. This surprise and wonder at first sight pushes our experience as beholders beyond our expectations. Exotic alternatives are central to design. Our proposition therefore is that making artifacts which

3 The definitive reference at this point is of course HERBERT SIMON's definition of design as courses of action "aimed at changing existing situations into preferred ones": SIMON (1996). Here, we should pay attention to the word "aimed." The intended situation might be preferred according to the applied problem definition. There is no guarantee that the applied interventions will produce this situation anyway. Following design theorist WOLFGANG JONAS, we can characterize design as variation, producing alternatives without having control over its adoption in society. See JONAS (2005).
4 If there is not yet an obvious problem, designers design one. See JONAS (1993).

5 Early user-centered accounts, such as from NORMAN, argue for a basic difference between technology-centered design and user-centered design. Following NORMAN, a similar figure is presented in KRIPPENDORFF (2006: 40).
6 WOLFGANG JONAS has theoretically embedded this position in evolutionary and social systems theory, see JONAS (2006).
7 For an extensive complaint about bad usability, see NORMAN (1990).
8 See a recent definition of intuitive use in C. MOHS, J. HURTIENNE, et al. (2006: 75–84).
9 LUCY SUCHMAN presents a (by now heavily cited) account on why action cannot be planned detached from the situation, and how the action changes according to the situated understanding. See SUCHMAN (2007).

are not ready-to-use opens up the possibilities for the user to experience and interpret the "unready-made" artifact anew. We will explore the background, design practice and some implications of this idea in the following paper.

A solid floating basis: Krippendorff's meaning

To have a solid basis from which to tackle our topic, we are referring to the design theorist KLAUS KRIPPENDORFF, who adopted radical constructivism and WITTGENSTEIN's linguistic philosophy for a theory on design and meaning (KRIPPENDORFF 2006). We find his account particularly useful because it relates the malleability of linguistic meanings to design artifacts and use.

KRIPPENDORFF claims that people do not perceive artifacts, but what the artifacts mean to them. The meaning of artifacts is therefore not fixed, but has to be coordinated through their whole life cycle among all involved stakeholders. KRIPPENDORFF's constructivist perspective also implies that an artifact's meaning is reenacted and coordinated when it is used, which is an activity not entirely different from an artifact designing itself (*Ibid.*, 145). Also, a good portion of the artifact's meaning can be accessed through the discourse around it.

The designer, on the other hand, participates in the discourse about the artifact and expands her understanding with the understanding of the other stakeholders (as she interprets it); she applies what KRIPPENDORFF calls "second-order understanding" – her understanding of others' understanding. This also means that artifacts can always be interpreted differently, and as designers, we need to investigate the meanings of the stakeholders, as they can change constantly.

KRIPPENDORFF's account of meaning provides us with a powerful concept for regarding "intuitive" and disruptive[10] artifacts in terms of what we would like to call their interpretation space.[11] For "intuitive"

10 In our case, disrupting existing meaning in the family of artifacts.

11 For the moment, I am trying to avoid the word "contingency" here, since there is no room to explain this specific concept in depth, though it may be suitable.

artifacts, the interpretation frame should be clear, e.g. the prospective use context. The construction of meaning is directed to a particular kind of interpretation, while it is very difficult to come up with deviating ones; the interpretation space is thus narrowed down. Uncommon artifacts are more difficult to associate with a particular context and behavior, as they are ambiguous. This creates conflicting ways for users to construct meanings, and thus extends the interpretation space of the artifact so that the interpretation can develop in many (potentially "wrong") directions.

This original reinterpretation is an opportunity for the design process to extend into the use phase. This is why we wonder: what exactly encourages those reinterpretations? What can we as designers do to make situated reinterpretation an original part of designing?

Broadening the interpretation space in design practice

We will find examples of design for design-in-use in two different fields, both of which create experience in use by extending the interpretation space of artifacts: Critical Design (CD) and Non-Intentional Design (NID). CD treats design artifacts as objects in the public discourse (DUNNE 1999; DUNNE and RABY 2001). It borrows strategies from Situationism, Dadaism and Surrealism to make the implicit assumptions in the artifact accessible through estrangement. In HCI, similar strategies were taken up to investigate the reinterpretation and appropriation of technology in everyday use (DOURISH 2003; SENGERS and GAVER 2006; DIX 2007; GAVER and SENGERS et al. 2007).

NID, on the other hand, is a term coined by UTA BRANDES and MICHAEL ERLHOFF (2006) to describe the various spontaneous reworks, reuses and misuses of things designed for a different purpose. It is thus also close to appropriation and a form of design-in-use. To us, those two fields represent different approaches with the aim of encouraging a reconstruction of the artifact's meaning in use (BREDIES 2009). We suggest that both also work by producing a breakdown in the meaning of the artifact. The artifact's meaning changes when it appears in an unexpected and unconventional way (either through design as in CD, or through reuse, as in NID).

But if those strategies for opening up the interpretation space already exist, what are we still concerned about CD claims that a material and working prototype is not required to produce an analytic breakdown.[12] Concepts and scenarios are thus sufficient to communicate the idea. To change the meaning of artifacts in use, however, we need a usable material artifact.

Also, CD oscillates between deconstruction and production. Because it is critical, it needs to open up the unquestioned mainstream attitude; because it is design, it needs to provide a constructive alternative. However, once it has become (material) reality, the artifact might be read as a productive contribution, working against its designer's critical intentions.

Besides, CD products often have to be embedded in detailed scenarios to make them plausible. Films and texts mediate the products' intended function. The unconventional values in the artifact obviously need to be related back to everyday experience with a ready-to-hand reading, and close the interpretation space again.

Also, a critical approach exposes the mainstream perspective, but the criticism is itself just another perspective. A thoughtful and aware attitude is important for an analytic breakdown. Some might believe that criticism is intrinsically good, but as designers, we believe that it should in the end lead to some applicable (if not practical) conclusions for design practice.

NID (or design-in-use), on the other hand, is so omnipresent and at the same time so overlooked by professional designers that implications for design practice are still hard to draw. The issue has also been so carefully outlined towards other similar things such as DIY, amateur design, appropriation and intentional reuse (BRANDES, STICH *et al.* 2009, see *chapter* II), that any deliberate design act seems to be excluded. But what can the designer do, if even the breakdown of meaning is too intentional?

—
12 E.g. PELLE EHN gives a notion of analytic breakdown that goes back to HEIDEGGER's concepts of "ready-to-handness" and "present-at-handness." The world around us becomes transparent and natural, although it is culturally constructed; it is "ready-to-hand." To access the artificiality of an action or an artifact, we have to make it "present-at-hand" again, that is, analytically break down its naturalized meaning. See EHN (1988).

We would thus like to highlight the productive results of Critical Design projects, the material prototypes, beyond their role as discursive objects and as starting points for design-in-use. Critical Design re-established design strategies for estrangement, which are highly relevant for our purpose.

What we can take from CD is its subversive ideas, but without the need to resituate them in a plausible narrative. The mixture of estranged technology and the way it is implemented as a working prototype is highly interesting for design-in-use. With regard to NID, we hope to find a connection between estrangement and more flexibility when figuring out different meanings of the artifact in use. For NID, breaking down an artifact's meaning by reusing it is not exactly a conscious critique of its function. However, working prototypes of estranged material might open up the interpretation space for non-intentional design acts.

Next, we would like to propose some tentative links to pragmatist and phenomenological philosophy to support our arguments. As this paper does not aim to provide an exhaustive report of the two fields, we would like to refer to some useful concepts that they present as first hints on where we hope to find a more thorough theoretical foundation.

Both phenomenology and pragmatism have been used before to argue for an analytic and critical breakdown of an artifact's meaning. Therefore, we would like to investigate how these two philosophical perspectives consider the unfamiliar as a productive driver to (re-)create meaning.

John Dewey's notion of an experience

DEWEY presents an elaborated philosophy of aesthetic theory and experience in "Art as Experience" (DEWEY 1980). Basically, he describes aesthetic experiences as learning experiences, and the most joyful moments in human existence when we renew the harmony with our environment, and thus, when we learn from our interaction with the world. This point of view turns out to be very attractive for designers for several reasons:

— He considers obstacles as "an opportunity to learn" and surprises as a prerequisite to a learning experience.

— He distinguishes "perception" and "recognition" and claims that only in perceiving are we able to create a new experience. Recognition, on the other hand, means thoughtlessly appling prelearned patterns and scaffolds to the world and not to pay attention to sensory impressions.

— DEWEY also points out how we need to be active in "having" an experience: we need to actively perceive and reflect our sensual impressions in hindsight. An experience does not just happen; it has to be made. The "beholder has to be the creator of its own experience" (68).

— Here, he emphasizes how the meaning of the word "sense" extends from bodily impressions to interpreting the world as a system of signs. Signification thus starts with sensory impressions, and abstract thinking is not detached from sensing.

— By interacting with the material world directly, we experience with all our senses, and not from second-hand representations. This also means that not all the qualities of sensual experience can be translated into symbolic systems, such as language.

— The work of art is a form of experience that directly recreates another experience. We can see it as a material (not symbolic) form of expression which cannot be transferred directly into symbolic sign systems.

So for our purposes, DEWEY's account of experience can be considered a goldmine of arguments, as he also valorizes disruptive events as a trigger for educational experience, and the active role of the perceiver (or user) who needs to reflect on the experience.

Bernhard Waldenfels' notion of an experience

In "Bruchlinien der Erfahrung," BERNHARD WALDENFELS (2002) gives a detailed account of experience and its sticking points from a contemporary phenomenological perspective. His description of "strong" experience is in many aspects similar to DEWEY's learning experience. With regard to meaning and signification, the following conclusions are interesting:

— With reference to HUSSERL's intentionality, WALDENFELS identifies both an intention to interpret the world around us as well as a desire and need to act upon the world. So these are not mere mechanical reactions to the outside world, but driven by the experiencing subject.

— We are surprised and overwhelmed by an event or artifact if it does not "appear as something" to us. It strikes us with its lack of meaning, so to speak. We need to make it meaningful in hindsight; we are then creating an experience.

— In those moments, the world can be perceived as alien and external and can intrude into our mind and leave an impression. We need to change our picture of the world, according to the new experience.

As a representative phenomenological view, we can thus see the commonalities with the pragmatist perspective. We can also see a clear connection between interpretation and meaning, and the making of an experience in the breakdown of meaning.

Discussion and Conclusion

So far, we have argued that designers create a breakdown in the artifact's meaning when they change its setup. We therefore drew on KRIPPENDORFF's account of meaning production during a product's use. We then examined the strengths and opportunities of design fields that rely on breakdown as a strategy and made some preliminary links to the pragmatist and phenomenological concepts of experience through breakdown.

DEWEY states how an experience often begins with a surprise. By being surprised, we are paying attention to our senses, instead of just recognizing the situation as a familiar pattern. If we deal with a disruptive artifact, we need to experience it in that way, where our familiar patterns don't apply. By estranging everyday artifacts, Critical Design surprises us and exposes both our habits and the conventions we have in mind. We also need an implemented working prototype to experience the artifact directly. In the interaction with the artifact, we can reflect on our impressions differently than we would if we were imagining it. This means that prototyping is mandatory when exploring design-in-use.

Even more explicitly from WALDENFELS, we learn how human beings need the world to make sense to them. So we cannot interact with a surprising artifact for long, but we have to interpret it in a meaningful way. If the meaning of the artifact breaks down (e.g. through an

unconventional setup), we need to construct it anew. Uncertain artifacts demand a lot from the user (or beholder); they need to be understood and related to a certain context and activity – unlike ready-made products, which have familiarities that spare the users thought.

Where there is room to experiment, as with new technology, we should take its uncertain meaning as an opportunity to learn. Designers who consider themselves experts in the meaning of artifacts at the same time limit the meanings they offer to what can be understood. Engineers limit themselves more to what is functionally feasible, sometimes ignoring existing structures of meaning within a given context. However, we can perceive the engineer's apathy towards existing meaning as an advantage to learn from: engineers present new technology in a malleable and non-contextualized way, in search of a context which will adopt it.

Designers can explore variations in meaning by refusing to offer a clear reading. We can experiment more with disruptive variations that appear unreasonable at first glance, and not dismiss them with regard to a certain use context. This does not mean to ignore or dismiss the existing structures of meaning that we can access, or reinvent the wheel each time. It might, however, lead to a different, more artifact-based inquiry as a baseline for a redesign. Also, we should be clear on the kind of design situation where this approach might be suitable. If there is no need to broadly explore possible different use contexts and appropriation behavior of the users, a traditional user-centered design is probably more effective.

Disruption and breakdown are then means to perceive anew or to reconsider an artifact. Like this, designers can drive innovation forward with unconventional concepts and existing meaning can be renegotiated. It is thus a complementary design strategy to refuse a ready-made interpretation of the artifact, and an accepted purpose for it, and to instead explore the unexpected as a source for original interpretations.

By deliberately not setting up a correct reading and use of the artifact, the designer invites the user to come up with her own interpretation. It also means that for "unready-made artifacts," the designer needs a

designing user, with the ability and willingness to offer her original interpretation. However, it will not be possible without effort.[13] When leaving more room for interpretation, designers also make more work for the user. Designing-in-use requires work, but also provides an opportunity for users to participate in the design process. The engaged user-designer has to open up to experience the situation and reflect on her impressions. If the user is a consciously thoughtful or critical person, so much the better, as a critical eye helps to analytically break down an artifact.[14] But we have also seen that in the case of NID, users are unconsciously estranging things from their designed context and purpose, without necessarily being critical. We therefore suggest that disruptive variations help to provoke an experience in use, and ease design-in-use, consciously and critically as well as subconsciously.

—

13 Such a position is popular in participatory design, see e.g. SANDERS (2005).

14 This is the "critical practice" that RAMIA MAZÉ and JOHAN REDSTRÖM consequently ask for as a complement to critical design. See R. MAZÉ, and J. REDSTRÖM (2007).

References

BRANDES, U., and M. ERLHOFF. *Non Intentional Design.* Cologne, Germany: Daab Verlag, 2006.

BRANDES, U., S. STICH *et al. Design durch Gebrauch.* Basel: Birkhäuser, 2009.

BREDIES, K. "Designers and Users: Comparing Constructivist Design Approaches." *8th European Academy of Design (EAD) Conference.* Aberdeen, UK: European Academy of Design, 2009.

DEWEY, J. *Kunst als Erfahrung.* Frankfurt am Main, Germany: Suhrkamp, 1980.

DIX, A. "Designing for Appropriation." *21st BCS HCI Group Conference.* Lancaster, UK: British Computer Society, 2007.

DOURISH, P. "The Appropriation of Interactive Technologies: Some Lessons from Placeless Documents." *Kluwer Academic Publishers* 12 (2003): 465–490.

DUNNE, A. *Hertzian Tales. Electronic Products, Aesthetic Experience, and Critical Design.* London, UK: RCA Computer Related Design Research, 1999.

DUNNE, A., and F. RABY. *Design Noir: The Secret Life of Electronic Objects.* Basel: Birkhäuser, 2001.

EHN, P. *Work-Oriented Design of Computer Artifacts.* University of Michigan, 1988.

GAVER, W., P. SENGERS *et al.* "Enhancing Ubiquitous Computing with User Interpretation: Field Testing the Home Health Horoscope." *Proceedings of the SIGCHI Conference on Human Factors in Computing Systems.* San Jose, California: ACM, 2007.

GIBSON, J. J. "The Theory of Affordances." *Perceiving, Acting and Knowing: Toward an Ecological Psychology,* edited by R. SHAW and J. BRANSFORD. Hillsdale, CA: Erlbaum Publishers, 1977.

JONAS, W. "Design as Problem-Solving? Or: Here is the Solution – What Was the Problem?" *Design Studies* 14, no. 2 (1993).

JONAS, W. "Designing in the Real World is Complex Anyway – So What? Systemics and Evolutionary Process Models in Design." *ECCS 2005 Sattelite Workshop: Embracing Complexity in Design,* Paris, Centre for Advanced Spatial Analysis, 2005.

JONAS, W. "Research through DESIGN through Research – A Problem Statement and a Conceptual Sketch." *DRS Wonderground*. Lisbon: Design Research Society, 2006.

KRIPPENDORFF, K. *The Semantic Turn. A New Foundation for Design*. Boca Raton: Taylor and Francis, 2006.

LATOUR, B. "Where are the Missing Masses? The Sociology of a Few Mundane Artefacts." In *Shaping Technology / Building Society. Studies in Sociotechnical Change*, edited by W. BIJKER and J. LAW. MIT Press, 1992.

MAZÉ, R., and J. REDSTRÖM. "Difficult Forms: Critical Practices of Design and Research." *IASDR (International Associations of Societies of Design Research) Conference*. Hong Kong, 2007.

MOHS, C., J. HURTIENNE *et al.* "IUUI – Intuitive Use of User Interfaces: Auf dem Weg zu einer wissenschaftlichen Basis für das Schlagwort 'Intuitivität'." *MMI-Interaktiv* 11 (2006): 75–84.

NORMAN, D. A. *The Design of Everyday Things*. Doubleday Business, 1990.

SANDERS, E. "Information, Inspiration and Co-creation." *6th International Conference of the European Academy of Design*. Bremen, Germany: University of the Arts Bremen, 2005.

SENGERS, P., and B. GAVER. "Staying Open to Interpretation: Engaging Multiple Meanings in Design and Evaluation." *Proceedings of the 6th Conference on Designing Interactive systems*. University Park, PA: ACM, 2006.

SIMON, H. A. *The Sciences of the Artificial*. Cambridge, Mass.: MIT Press, 1996.

SUCHMAN, L. A. *Human-Machine Reconfigurations*. Cambridge: Cambridge University Press, 2007.

WALDENFELS, B. *Bruchlinien der Erfahrung*. Frankfurt am Main, Germany: Suhrkamp, 2002.

ABSTRACT+
COMMENTS

Critical Engagement; Design's Role in Counter-terrorism

Lisa Cresswell

On July 7th, 2005 at 8:50 am, multiple terrorist bombs detonated simultaneously in the City of London. The attack was an unprovoked and indiscriminate act of violence, causing mass casualties and maximum disruption within the London Transport Network. The events of 7/7 served to shape the perception of the traveling public.

This paper questions and examines design's role in the development of technology-based security alternatives that seek to positively communicate with and re-engage the public in urban environments.

The research supporting this paper originates from an EPSRC-funded scoping project investigating design's application in the realm of counter-terrorism. Written and informed by research gathered within the framework of the project, this paper aims to disseminate a critical assessment of the role of design in the future development of counter-terror communications within the public domain.[1]

01—What are the potential consequences of design in this context (counter-terrorism)?

207

What if it (the design solution) fails to operate or be used in the correct manner?

LISA CRESSWELL — ABSTRACT

Consideration is given to current design solutions offered and the constrains of design and technology in this sector.

Design's role in crime prevention has been well established (COOPER *et al.* 2002; EKBLOM 1997). However, much of the emphasis in terms of research has been on the redesign of products and environments (GAMMAN 2007 and 2005). The role that design can play within the domain of counter-terrorism has focused on the design resilience of the built environment (THORPE and GAMMAN 2007; ROACH *et al.* 2005). To date there has been no design research that has explored the development of innovative technology-based communications within the context of counter-terrorism.

This paper seeks to explore existing security approaches from multiple perspectives, presenting analyses on the impact of current conventional security measures, developments and applications in new technology and new approaches to re-engaging public awareness. Through the discussion the work will seek to explore the connections between design, technology and security, highlighting the critical need to understand and reform approaches to their combined application. Considering communication in the broadest context and accounting for multiple elements that serve to "communicate," inform and shape public perspectives, this paper addresses the disparities between existing security approaches and their effectiveness, with a view to understanding the complexities and requirements of effective counter-terror communication. Focusing predominantly on the multiple aspects that contribute to effective security, this paper will seek to highlight the inherent potential for design intervention.[2]

Analyses of existing approaches to security, supported by research findings, will be used as the basis on which to test the hypothesis that through design, interactive security approaches can positively re-engage the public and reduce fear in public spaces.

02—How can designers transfer and apply their skill set to projects of this level of complexity?

It is suggested that this can be achieved by applying design methods and thinking beyond the parameters of the discipline. Furthering this, it is suggested that design should recognize the benefits of interdisciplinary practice when addressing problems of this complexity and as such, should actively seek to collaborate with other disciplines/fields/professionals to discuss, share knowledge, learn and contribute on a shared platform. It is suggested that through this practice, the "mixing" of design methods/methodologies with those of other disciplines can establish a wider investigation scope, resulting in a broader knowledge base and more detailed understanding of complex issues and in the long-term, facilitating "better" design.

FINAL PAPER

—

Critical Engagement: Design's Role in Counter-terror Communication

Lisa Cresswell

Actions that reshape societies

On July 7th, 2005 at 8:50 am, multiple terrorist bombs detonated simultaneously in the City of London. Three bombs detonated on the London Underground and one on the upper deck of a London bus, indiscriminately targeting and killing civilians and bringing the City of London to a standstill. 52 commuters were killed and hundreds injured. This was an act of terrorism. The events of 7/7 immediately sharpened and re-focused the perspectives of all affected stakeholder groups, none more than the public.

"Terrorism is the most serious direct security challenge facing the UK, its allies and many countries across the world" (HM GOV. 2007, 68). *It is projected "that the scale of the threat is potentially still increasing and is not likely to diminish significantly for some years"* (BRIGGS et al. 2006).

Safer Spaces research

Safer Spaces is an EPSRC, AHRC-funded 18-month interdisciplinary project that explores the potential for design to contribute to counter-terror communication. In the context of the events of 7/7, Safer Spaces research seeks to examine the process of interactive counter-terror communication with a view to reducing fear and re-engaging public awareness in transport environments. The nine-person interdisciplinary research team is based throughout the UK and is formed from multiple disciplines including Design, Psychology, Social Geography, Media & Politics and Sensor Technology. Safer Spaces research is informed by team knowledge, documentation of previous terrorist events, current security documentation, key stakeholders relevant to the subject area and collaborative design practice. Written and informed by research gathered within the framework of the project, this paper aims to critically assess the future role of design in counter-terror communication.

Actions and reactions: Government-led approaches to security

The consequences and long-standing implications of the attacks of 7/7 reshaped British Government Security Strategy, serving to underpin and develop the longstanding technological security approaches adopted as part of previous strategy (HM GOV. 2006). The reorganization of this strategy reestablished a hierarchy of information requirements, focussed predominantly on the security needs of law-enforcement and largely discounting external social groups, readily enforcing security requirements on an apparently passive public. However, this approach, paired with a negative public attitude relating to existing security measures, simply served to further alienate a disillusioned public from the spaces in which such technologies operate (KOSKELA 2002). Government reports indicate that security measures employed to date are justified for purposes of crime deterrence

and therefore that the public will interpret and translate increased security measures into increased feelings of safety (HOME AFFAIRS COMMITTEE 2005). However, Safer Spaces findings supported by literature highlight that although the terms "security" and "safety" are inextricably linked, the boundaries of translation are not so straightforward. This very complexity presents the opportunity for design to explore and understand security-related issues from a public perspective and to utilize this understanding to rebuild an informed approach to security technology.

The fields of counter-terrorism and security are strongly connected; conventional security measures are drawn on within counter-terror strategy as established foundations that can underpin the strategies outlined. The connections between crime prevention and counter-terrorism are explored and disseminated in the work of ROACH, EKBLOM and FLYNN (2005). They deconstruct and adapt frameworks of understanding that are designed to communicate processes relating to conventional crime; they then translate, re-frame and reconstruct these in a counter-terrorism context. Similarly, this paper will draw on examples of conventional security measures to define key issues relating to public perceptions of security and seek to highlight that through design, these issues can be tackled and translated into the broader context of counter-terrorism.

Initiatives and implementations of security measures

Historically, counter-terror measures were reliant on conventional security measures adopted to help combat conventional crime. The UK government's long term strategy for countering international terrorism, CONTEST, outlines proposals to manage and combat terrorist activity before, during and after events, with emphasis on Prevention, Pursuit, Protection and Preparation (known as the four P's) (HM GOV. 2006). The approach to security in a counter-terrorism context is multi-layered (HM GOV. 2007). Focusing on technology-specific examples, multiple measures are employed in the pursuit of strengthened security, including the implementation of situation-specific technologies designed to detect explosive or harmful substances, while more common technologies are employed to monitor public urban space.

Disengaging public awareness; CCTV and the modern context

Security measures such as Close Circuit Television (CCTV) currently serve as the cornerstone for surveillance and the detection of crime (ARMITAGE 2002), as the use of this technology has become the "standard way to restrain crime and guarantee security" (KOSKELA 2002, 259). It is widely acknowledged that Britain has the highest volume of controlled and monitored space in Europe and this one-way tool used to monitor public space enjoys unequivocal investment with approximately three quarters of the total British Home Office funds spent on crime prevention being directed at CCTV (figures reflect investment from 1996–1998) (ARMITAGE 2002). Investment is directed despite a lack of quality research or evidence to support the implementation of such measures (ARMITAGE 2002, 1); investment reports (since 2002) highlight the failings in effectiveness and performance of CCTV systems, yet these reports remain largely unpublicized. The disparity between cost and effectiveness is marked, so it can be argued that CCTV is used for political impact as a tangible product that demonstrates spending on crime prevention. Translating these considerations into a user-centered design context, at no stage does the commercial implementation of this security measure seek to explore and account for public perception and interpretation of the presence of this technology encountered by that very public on a daily basis. Implementation without user consideration thus renders the public mute.

Safer Spaces research, as supported by the literature, highlights the true social cost of technologies such as CCTV. Research notes that the perceptions of technologies employed for security purposes can communicate negative associations and alter individuals' perceptions of the wider environment (KOSKELA 2002). A snapshot of public perspectives serves to highlight that in contrast to the projected increased feelings of safety and security, mass installation of measures such as CCTV instead serve to increase feelings of ambiguity of safety in the spaces in which they are employed; they symbolize the need for control, increase fear and alienate those in the public who express concern when considering this technology in a "big brother" context (GILL and SPRIGGS 2005). This electronic means of surveillance "replaces informal means of social control in an

urban environment: the eyes of the people on the street are replaced by the eyes of surveillance cameras" (FYFE and BANNISTER cited in KOSKELA 2002, 259). Presumably, the implementation of such a high volume of monitoring technologies serves to disengage the public from their responsibility of awareness when occupying public space, an arguably central marker on which effective security is founded. It is therefore critical that future developments in security consider the social implication and true effectiveness of the technologies implemented and crucially, that they work to positively re-engage the individual's awareness of public space.

New technology and new opportunity

Currently, the development and design of security measures seeks solely to align and capitalize on the advancement of technological capability, though there is little evidence to show that the application of these aspects are innovatively managed. In application and execution, contemporary technological developments applicable to urban security are encased in standardized design formats. These developments seek not to explore the parameters of new design applications, but instead to invest in improving existing design formats into smaller, more portable/compact systems (LUXTON 2008). This "static" approach to the application of technological advancements highlights the potential for collaboration and innovation in this sector.

Re-framing the application of new technology in a security context: learning by example

Safer Spaces findings relating to users' interpretations of security technologies demonstrate that users do not specifically report having negative associations with the actual technology, but instead formulate perceptions relating to the environmental context of the installation and the purpose and function that the technology is designed to represent. This, in combination with other defined elements, suggests that a design-led, intelligent and sensitive application of the technology – considered within the framework of a security directive – can alter users' perceptions of security technologies and the spaces in which they operate.

In relation to technology, there is an observed disparity between the development of advancements in new technology within the commercial security sector, and their application. This highlights the specifically static "standardized application," which is arguably based on the historical "acceptability" of established products. Re-framing this from a design perspective highlights an overwhelming opportunity for design, driven by innovation, using design-based methods such as cultural probes to research user perspectives and to positively contribute to the creation of user-centered security-led approaches and communications that integrate and capitalize on the potential of new technologies.

There are numerous existing research-led initiatives that aim to explore and develop the relationships between new technology (chemical, digital and sensor based) and design; the Newcastle University-based *Culture Lab* (*http://www.ncl.ac.uk/culturelab/*) and Scottish-based *Distance Lab* (*www.distancelab.org*) are two examples that both seek, through multidisciplinary team-based environments and collaborative cross-disciplinary partnerships, to explore the capabilities of design opportunities and potential applications for digital technologies. Both lab project folios display their ability to explore a diverse range of briefs that encompass a wide range of technology applications.

Research highlights that both *Culture Lab* and *Distance Lab* demonstrate the capacity to positively engage users through interaction. The London-based design team, *Jason Bruges Studio,* is translating this engagement into large-scale application in public space. This studio seeks to create immersive interactive spaces that combine architecture, interaction design and installation art with sensor-based technologies in the creation of immersive and responsive environments (*http://www.jasonbruges.com*). All of these studios present manifestos that disseminate their exploration to blur the boundaries between design and technology. Although none of the projects specifically address the way their approach could be applied to a security-based context, the work of *Bruges Studio* on the "O2 Memory project" and *Culture Lab's* "Space Pace Place Event" both isolate the key issue of recording and sharing visual data in a public space, broadly simulating and reflecting, and intelligently engaging the public

through interaction in the broad concept of two-way surveillance. Limited documented evidence exists that evaluates the overall successes of engagement and interaction levels around these and similar technological applications. However, with observation and broad evaluation of public experience (through visually recorded interactions/visual feedback, see *Distance Lab* 2009), it can be clearly acknowledged that these designs communicate positively and actively engage public interaction.

Future paths: Navigating through opportunity

Harnessing the creative qualities of these approaches and translating them into a security context arguably establishes a new platform and perspective from which to consider and explore positive interaction and re-engagement of the public in public space. It is presented that developments in security and counter-terrorism communications can be addressed and tackled in a similar manner. Safer Spaces research is one of the first commissioned multidisciplinary scoping projects that has been recruited to research the opportunity for new approaches to design in the field of counter-terror communication, yet there is limited existing research material in this field.

These projects demonstrate a coherent strategic approach in their pursuit of social interaction and engagement via means of new technology. All project examples operate in multidisciplinary teams spanning a range of disciplines and experiences, including, but not limited to design (*Bruges Studio, Culture Lab, Distance Lab*). Examples offered by *Culture Lab* and *Distance Lab* highlight that research-led projects exploring this field operate with a three fold agenda: placing focus on the user; problem solving in a situation-specific context and working to connect key elements that relate to the issue. These projects demonstrate that understanding the multiple elements that create the "whole" experience is vital to design success.

It is therefore proposed, specifically in the context of the Safer Spaces project, that the design of effective and successful security approaches is reliant on the formation of a comprehensive and sensitive understanding of the multiple facets that form effective security: connecting communication, technology, security requirement, situational

context and social implication in a user-centered framework to fully understand and evaluate the possibilities of development and application. Evidence has shown that the creation of multidisciplinary teams is an effective and recognized strategy that facilitates the integration of independent member perspectives and skills and nurtures an environment that encourages knowledge-sharing (FONG 2003). Moreover, multidisciplinary team-based discussions provide a platform for interaction and centralized engagement that leads to the creation of new and emergent knowledge (FONG 2003). Collaboration is key, as teams must draw from a wide and varied base to fully understand and address the complexities and challenges presented in multi-layered issues such as this. The Safer Spaces project has sought to build an interdisciplinary academic team. Guided by external (commercial, public and private sector) stakeholders and in collaboration with external design studios, Safer Spaces has sought to establish a platform that allows contributors the opportunity to share knowledge and ideas (using multiple methods including brainstorming and mind-mapping) and the space to explore the new opportunities harnessed in interdisciplinary practice.

It is well established that design has a large and varied skill base. This is reinforced in the commercial and research-led design examples of *Culture Lab* and *Distance Lab*. Design as a discipline is equipped with the skills and methods that allow designers to collaborate successfully within multidisciplinary teams; driven by innovation, design is well positioned to capitalize on and develop the opportunities created through emergent knowledge.

The ramifications of 7/7 combined with the long-standing negative interpretation of security measures provide a clear reason to pursue change and development in this field. To date, design's role in counterterrorism communication remains undefined. However, this flexibility translates into an opportunity which design must seek to capitalize on by communicating, through collaboration, the new opportunities that are available to engage a disillusioned public. Collectively, research in this field must seek to review and re-establish the parameters of truly effective security in a modern context.

References

ARMITAGE, R. *To CCTV or Not to CCTV?* London: Nacro, 2002.

BRIGGS, R., FIESCHI, C., and LOWNSBROUGH, H. *All Our Experience of Tackling Terrorism Tells us that the "Hardware" is Useless without the "Software."* London: DEMOS, 2006.

BRUGES STUDIO. *http://www.jasonbruges.com* (accessed: November 2008).

COOPER, R., A. WOOTTON, C. DAVEY, and M. PRESS. "Fundamentals of Crime Proofing Design," in *Designing Out Crime from Products and Systems (Crime Prevention Studies),* v. 18, edited by RONALD V. CLARKE. 2005.

CULTURE LAB. "Space Place Pace Event," May 28, 2008. *http://www.ncl. ac.uk/culturelab/events/item/space-place-event* (accessed: November 2008).

DAVEY, C., A. WOOTTON, R. COOPER, and M. PRESS. "Design Against Crime: Extending the Reach of Crime Prevention through Environmental Design." *Security Journal* 18, no. 2 (2005): 39–51.

DISTANCE LAB. *http://www.distancelab.org* (accessed: November 2008).

EKBLOM, P. *Crime Prevention Through Environmental Design – Time for an Update?* London: Design Against Crime Research Centre, University of London, 2007.

EKBLOM, P. *Making Offenders Richer: Design Against Crime Research Centre.* University of the Arts London, 2007.

FONG, P. "Knowledge Creation in Multi-Disciplinary Project Teams: An Empirical Study of the Processes and their Dynamic Relationships." *International Journal of Project Management* 21 (2003): 479–486.

GILL. M., and A. SPRIGGS. *Assessing the Impact of CCTV: Home Office Research Study* 292. 2005.

HM GOVERNMENT. *Countering International Terrorism: The United Kingdom's Strategy.* Norwich: HMSO, 2006.

HM GOVERNMENT. *The United Kingdom Security & Counter-Terrorism Science & Strategy.* London: Home Office, 2007

HOME AFFAIRS COMMITTEE. *Terrorism and Community Relations; Sixth Report of Session 2004–2005. Vol. 1.* London: The Stationary Office Limited, 2005

KOSKELA, H. *Video Surveillance, Gender, and the Safety of Public Urban Space: "Peeping Tom" Goes High Tech?* University of Helsinki, Winston & Son, Inc., 2002.

LUXTON, R. "Knowledge Sharing Event" *London College of Communication,* 2008.

MURPHY, P. *Report into the London Terrorist Attacks on 7 July 2005.* Norwich: HMSO, 2006.

ROACH, J., P. EKBLOM, and R. FLYNN. "The Conjunction of Terrorist Opportunity: A Framework for Diagnosing & Preventing Acts of Terrorism." *Security Journal* 18, no. 3 (2005): 7–25.

UZZELL, D. *The Station, an Environment of Insecurity: Myth or Reality.* Department of Psychology, University of Surrey, 2000.

ABSTRACT+
COMMENTS

A New Evaluation and Innovation Framework for Sustainable Design: Addressing the Limits of Current Sustainability Assessment Methods

Carmela Cucuzzella
Michel de Blois

This research will focus on the search for improved methods for innovation and evaluation based on prudence in the context of sustainable design. Prudence encapsulates the dimensions of prevention, precaution and foresight. Foresight is based on individual responsibility. Prevention is based on expert knowledge which is fundamental to understanding the associated risks of decisions taken. Finally, precaution is based on a collective decision process that results when the uncertainty based on a preventive approach is too great and too potentially damaging to ignore. Therefore, these three dimensions of prudence comprise a system that offers a promising approach for decision making in a context of sustainable design.[1]

01—The idea of prudence for a basis of evaluation in a design project is interesting. But how does this fit into already existing

219

frameworks of evaluation for eco-design or sustainable design? It would be interesting to understand how this idea would broaden the existing evaluation frameworks. What are the methods used in design currently? What is the evolution of evaluation methods in a context of sustainability? 02—What methodology is envisioned to understand or explore this?

03—Elaborate on the idea of efficiency and the larger wider of evaluation

CARMELA CUCUZZELLA — ABSTRACT

The objectives of this research are threefold. The first objective is to understand the theory of the precautionary principle and how it relates to evaluation and conceptualization processes of sustainable design. The second objective will be to understand if and how the precautionary principle can be used for evaluation within current sustainability assessment methods. The third objective applies if the precautionary principle has not yet been identified within sustainability assessment methods, and is to understand the advantages and disadvantages of putting a prudent framework in place for the purposes of evaluation and innovation in a context of sustainable design, and therefore contributing to new knowledge.[2]

The framework of prevention alone is inadequate for assessing impacts and supporting decision-making for innovation in a context of sustainable design because it provides only one perspective. According to HERTWICH, "energy efficiency can indeed substantially contribute to growth, and therefore increase the amount of goods and services consumed" (2005, 90). This is a mono-criteria approach, and according to HERTWICH, has limitations when seeking sustainability. A multi-criteria approach such as Life Cycle Analysis has similar problems because it is also based on a

strategy of efficiency, even though it does consider a wider set of impacts. Thus, when using a strategy of efficiency, net sustainable gain is often wiped out through the increase in consumption of goods and services – rebound effects. Therefore, a wider scope of evaluation is necessary to help capture the additional effects that reduce the net sustainable gain based on energy efficient solutions. An analysis of such rebound effects (positive, negative, direct and indirect effects) can help decision makers understand how products and services can be conceptualized so that the sustainable gain remains.[3]

Therefore, this research states that a more encompassing framework is necessary in order to have a more complete perspective of the impacts and benefits so that decision making for innovation can be supported in a more comprehensive manner in a context

proposed. What does this broader scope entail? What new ideas comprise this wider scope? **04**—Could your graphic be included in the final article? It would help clarify the various terms you are using. **05**—Can this be used as the theoretical basis of the evaluation approach that you would like to further elaborate on – an evaluation approach that goes beyond the establishment of mere facts and measurements? The idea of prudence spans many centuries. In which definition of prudence is this research embedded? **06**—How will this be proved true or false? What methods

of sustainable design. This framework should include prevention, precaution and foresight.[4] The precautionary principle can contribute to sustainable development through its broader temporal and spatial perspective, which can complement the current approach of evaluation and innovation. In this new perspective, the ideas of sustainable living systems and sustainable societies will be considered, in addition to sustainable products and services.

This research affirms that: 1) the precautionary principle is a fundamental principle of sustainable development; 2) design can contribute to sustainable development through the exploration, creation and assessment of alternative solutions to current problematic living systems within an innovation framework of prudence; 3) current evaluation methods are based on preventive approaches and present limits for a global vision in a context of sustainable design; and 4) a prudent framework for the evaluation and conceptualization of sustainable solutions can help overcome some of these limitations.[5] As a result, the research hypothesis is as follows: *The precautionary principle can complement current sustainability assessment methodologies when it is based primarily on a preventive approach, by contributing to new forms of evaluation and innovation methods in a context of sustainable design.*[6]

CARMELA CUCUZZELLA — ABSTRACT

The pertinent action of moving beyond a theory of sustainable development and into an operational mode of sustainable development reveals several challenges. In particular, the challenge of operating within a mode of sustainable design opens up the very general question of: What innovation framework(s) can be used in a context of sustainable design? However, a more discerning question, which will be the primary focus of this study, is: *What are the advantages and disadvantages of an implementation of a prudent framework for innovation and evaluation in a context of sustainable design, especially when compared to preventive approaches adopted by current sustainability assessment methods?*[7] The reason why prudence becomes the guiding mechanism, rather than foresight, prevention or precaution alone, is because these elements work together as a system.[8]

will be used? Could this hypothesis be making too many assumptions? **07**—This does not seem to represent a question that is exploratory. Understanding the advantages and disadvantages does not help explore how prudence can be implemented in the design process. A question that would be more exploratory may begin with "how". What is your objective for this research? This would help formulate your question accordingly. If you are exploring ways to integrate the idea of prudence in a design process, then this question may not get you there. **08**—This idea is very serious and innovative for design evaluation.

FINAL PAPER

A New Evaluation and Innovation Framework for Sustainable Design: Addressing the Limits of Current Sustainability Assessment Methods

Carmela Cucuzzella

Michel de Blois

Abstract

The currently dominant mode of design for addressing the environmental and social crisis rests on an approach of prevention, which is predominantly based on the logic of efficiency during the conceptualization of products and services. This mode of innovation aspires to technical

improvements of products and services so that the environmental impact is minimized throughout their entire life cycle: from the extraction of raw materials to the products' disposal. However, evidence suggests that environmental gains from technical improvements in product efficiency have historically been outweighed by an overall increase in consumption. This paper presents a research program that seeks to expand the evaluation frameworks that are currently adopted in design projects so that some of these limits can be dealt with. This expanded evaluation framework will attempt to complement existing evaluation approaches with one that is based on the precautionary principle. This framework is meant to help designers move beyond incremental (environmental and social) improvements towards radical transformations. This principle represents a fundamental shift in the way in which the design problem is addressed. The intent is to allow the designer to adopt a more global perspective of the problem so that the solutions proposed may engender transformational shifts and not just the incremental changes that often result from current modes of evaluation.

Introduction

This proposed research suggests that an implementation of sustainable development for industrial design requires a vision with a broader scope than the one adopted by existing design evaluation and innovation approaches when addressing current environmental and social predicaments. Current design approaches are primarily based on product optimizations (the increasingly efficient redesign of current products and services). The main reason for the need of a broader perspective is that at the worldwide level, evidence shows that environmental gains from technical improvements that are based on product efficiency (a micro- or meso-level approach) have historically been outweighed by an overall increase in consumption (rebound effects) (COOPER 2000). Thus, the need for a more macro-level approach to design innovation and evaluation is necessary for sustainable development. *Table* 1 presents various industrial design approaches that consider environmental, social, cultural, economic, or ethical criteria in their process of design.

Name of Design Approach	Scale of Approach	Type of Approach
Green Design Approach that responds to evolving laws	micro-level scope	**Process Approach** Industrial vision with short-term solutions
Eco-Design Approach to design that considers the environmental impact based on the life cycle of a product or service	meso-level scope	**Product Approach** Global vision with essentially short- and medium-term solutions
Sustainable Design Requires a sense of interdependence among the organization, those affected by the activities of the organization, and the environment	macro-level scope	**Global (temporal and spatial) Approach** More global vision with short-, medium-, long- and very long-term solutions

Table 1: *Various industrial approaches to design that consider one or more of: environmental, social, cultural, and ethical criteria (based on:* CUCUZZELLA 2007, 35*).*

The objective of this proposed research is to investigate a more adequate framework for the conceptualization of design projects (architectural, urban, industrial, landscape, and interior) in a context of sustainability. This framework will be based on an attitude of prudence and will attempt to address the concerns of sustainable development in a more holistic manner when compared with current methods and tools.[1]

1 Prudence represents the behavior of humans when faced with uncertainty (EWALD 1996). It comprises the elements of prevention, precaution and foresight (EWALD 1996). Prevention is based on the idea of traditional risk assessment. Here, a deontological approach to risk evaluation is primarily adopted, as is the case in traditional cost-benefit risk methods. Precaution is based on the idea of second order risks, and therefore has fundamental uncertainty at its base, where collective action and discourse are necessary for the resolution of

It will contribute to the pioneering work currently being conducted to assessing social implications, such as Social Life Cycle Analysis (sLCA), among others. Currently, sLCA considers social implications primarily through a production perspective (supply side), adopting a socio-economic point of view when evaluating impacts: i.e. child labor, forced labor, employment creation. This research seeks to find an operational approach that can help assess and establish sustainable solutions based on both consumption (demand side) and production perspectives (supply side) within a conceptual framework of prudence. It is intended to extend existing methods that evaluate social aspects of products.

Challenges faced by Sustainable Design

In the context of sustainable design, it becomes vital to understand the fundamental differences between efficiency, effectiveness, and sufficiency. This will nourish an understanding of how *transformational* changes to lifestyles may be manifested in contrast to *incremental* changes to products and services. These can be combined with an expanded evaluation framework for decision-making and may help address the great challenges faced by design in a context of sustainability.

An approach of *efficiency* is based on technocratic innovation. Advocates of technocracy claim that technology alone can solve the problems arising from the current crisis (LATOUCHE 2006; DE NOBLET 2002). This approach, although promising, is problematic on its own. According to MCDONOUGH and BRAUNGART, eco-efficiency refers primarily to *"doing more with less"* (2002, 51). In other words, it refers to more goods with less impact, a technical approach for addressing the crisis. Even if eco-efficiency may seem to be an obviously inevitable solution for sustainable

such situations. Here, an axiological approach to uncertainty evaluation is primarily adopted, as is the case in for policy-making for situations of uncertainty. Foresight is an individual ontology based on the idea of random future events. This is why precaution is best suited for assessing design projects in a context of sustainability. Consequently, it is important here to emphasize that precaution can extend the evaluation framework of a project, since a framework based on the notion of a project (as defined by BOUTINET 2005) is inherently based on the notion of uncertainty (TICKNER *et al.* 1998; TICKNER and GEISER 2004; RAFFENSPERGER 2004; MYERS and RAFFENSPERGER 2005). In addition, The Rio Declaration on Environment and Development (UNCED 1992) identifies 27 principles that seek to define the rights and

development, it cannot be considered as a long-term solution because it will only achieve the exact opposite: the industry will dispose of everything quietly, yet persistently (MCDONOUGH and BRAUNGART 2002; VAN DER RYN and COWAN 2007; PRINCEN 2005). Eco-efficiency essentially aims to make the conventional industrial system, which is clearly destructive to the environment, societies, and humans, a little less destructive (MCDONOUGH and BRAUNGART 2002).

A strategy of *effectiveness* may complement a strategy of efficiency. This is where goals become the guide for supporting decisions. To be effective implies that there is a goal to strive towards and that the decisions made during the course of a design project are meant to help move the project towards this goal. However, efficiency and effectiveness are only two dimensions in a variety of perspectives that address sustainable design. Beyond modes of efficiency and effectiveness, understanding humans' basic needs is an essential starting point for design in the context of sustainability. For example, a strategy of effectiveness would seek not only to render the product more resource-efficient and less toxic, but to eliminate waste altogether by relying on natural energy flows, etc. (MCDONOUGH and PARTNERS 1992). This is beyond the idea of efficiency which seeks to render the existing product less harmful to the environment.

A strategy of *sufficiency* implies a consideration of human needs. In the context of sustainable design, it becomes imperative that designers adopt a perspective from the demand side (and not just the supply side). If inconspicuous consumption practices are not challenged, then sustainability will be difficult to achieve, as designers will continue to feed the consumption frenzy regardless of the (environmentally) improved

—

responsibilities of nations. This declaration recognized the precautionary principle as a guiding principle. Principle 15, the precautionary principle, is defined as follows: "In order to protect the environment, the precautionary approach shall be widely applied by States according to their capabilities. Where there are threats of serious or irreversible damage, lack of full scientific certainty shall not be used as a reason for postponing cost-effective measures to prevent environmental degradation." This principle has begun to be put in practice in policy-making, but has not been implemented in a context of design for projects seeking sustainability. This is the focus of this research. This argument is also built in the master thesis of CUCUZZELLA (2007).

products that are introduced to the market (ROBINS and DE LEEUW 2001; PRINCEN 2003, 2005; JACKSON 2004, 2005; YASUKO 2004; HERTWICH 2005; SCHAEFER and CRANE 2005; MARCHAND and WALKER 2007; UNEP/WUP-PERTAL 2007; CUCUZZELLA and DE CONINCK 2008). The idea of consumption as it is practiced in the Western world is thus challenged and may have to be rethought in a context of sustainable design (PRINCEN 2003, 2005). The role of the designer is then not to design new products, but to design new modes of living by challenging the status quo. Questions such as how to improve quality of life are thus inescapable. To achieve this, the designer may have to work with the community (or other stakeholders) to help them understand the environmental impact that their daily lives have and find ways to change. Sufficiency implies that the "enough" limitation reflects both "social values" and ecological constraints (PRINCEN 2005). This is why the community ought to be involved in such a process; the designer cannot impose his/her notion of *"enoughness"* on the community, as this must be a solution that emerges from shared understanding (PRINCEN 2005). In such cases, social change is sought. Sufficiency thus relies more on individual behavioral changes and social innovation (REISCH and SCHERHORN 1999). Questions of self-management emerge at an individual and collective level in society (JACKSON 2005), where citizens must become aware of their environmental impact and find ways to reduce it.

According to STRAHEL (2001), sufficiency refers to *"doing the right thing,"* while efficiency refers to *"doing things right."* This implies that efficiency is a value-neutral goal, where the decision can be based on quantifiable elements of analysis. However, sufficiency then becomes a decision based on the value system of the decision-maker, so it becomes clear that decisions based on a logic of sufficiency require a collective decision-making process in which all those affected by the decision are represented.

Since the idea of sufficiency is seeking to *do the right thing* (an axiological perspective), in contrast to efficiency which seeks to *do the thing right* (a deontological perspective), there is a direct correlation between the idea of prevention (a deontological approach to risk evaluation) and

precaution (an axiological approach to risk evaluation) (CUCUZZELLA 2007). In addition, sufficiency and efficiency can be seen as design strategies, whereas precaution and prevention can be seen as their respective strategies for decision-support as presented in *Figure 1* (CUCUZZELLA 2007).

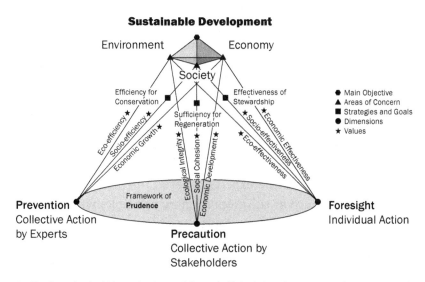

Figure 1: *Specific values and goals within a prudent framework for sustainable development* (CUCUZZELLA and DE CONINCK 2008; CUCUZZELLA 2009).

An Evaluation Approach for Sustainable Design based on Ethics

According to EWALD (1996), prudence refers to the way that humans deal with situations when they are faced with uncertainty. Prudence encapsulates the dimensions of prevention, precaution and foresight (EWALD 1996). Foresight is based on individual responsibility (EWALD 1996; BINDÉ 2000). Prevention is based on expert knowledge, which is fundamental to understanding the associated risks of decisions taken (KOURILSKY and VINEY 2000; EWALD 1996). Precaution is based on a collective decision process that results when the uncertainty based on a preventive approach is too great and too potentially damaging to ignore (EWALD 1996). Therefore, these three dimensions of prudence comprise a system that offers a promising approach for decision-making in a context of sustainable design.

It is important to highlight that prudence here represents a philosophical perspective and therefore has not yet been implemented in design practice in the context of sustainability. This research aims to create an understanding of how this may be manifested in a design project. *Figure 1* presents a model of the proposed evaluation framework based on prudence.

The precautionary principle is fundamental for assessing situations (specifically, design solutions), yet is laden with uncertainty, doubt and controversy (WHITESIDE 2006). There is an aversion among designers and decision-makers to assessing environmental and social implications using a precautionary approach because of the difficulty of this type of uncertainty. Designers and decision-makers would have to come to terms with the fact that they can no longer rely *only* on quantifiable results which the experts believe to be more reliable. This is why a principle such as the precautionary principle, which is only one component of a system of prudence, represents a promising approach for decision-making during the conceptualization stage of sustainable design projects. In fact, since technology is currently the primary area of innovation for addressing the environmental and social crisis, and today's technological innovations present great controversy and uncertainty for society, the precautionary principle may be an essential tool to support decision-making for designers. For example, biofuels which are meant to reduce the dependence on fossil fuels have created controversy, due to the land that is needed to grow the required crops and the impact this has on the communities that depend on such land for food (OECD 2007). Therefore, products that adopt this technology contribute to this controversy concerning the environmental impact and benefits of their products; this represents a case where the uncertainties (of the product's environmental impact and benefits) cannot be easily assessed using existing evaluation tools, such as LCA.

Such fundamental uncertainties for our global society cannot be ignored or avoided by designers and decision-makers. The ethical foundation inherent in a precautionary approach is meant to expand the evaluation framework needed for sustainable design projects. This

evaluation framework will consider the limits, criteria, indicators, unpredictable effects, and potential rebound effects arising from a multidisciplinary perspective.

For example, when adopting a strategy of efficiency, net sustainable gain is often wiped out through the increase in consumption of goods and services – referred to as rebound effects. Therefore, a broader scope of evaluation is necessary to help capture the additional effects that reduce the net sustainable gain based on energy efficient solutions alone. An understanding of such rebound effects (positive, negative, direct and indirect effects) can help decision-makers understand how products and services can be conceptualized so that the sustainable gain can be achieved.

According to HERTWICH, *"energy efficiency can indeed substantially contribute to growth, and therefore increase the amount of goods and services consumed"* (2005, 90). This is a mono-criterion approach for assessment, and according to HERTWICH, it has its limitations when seeking sustainability. A multicriteria approach such as Life Cycle Analysis (LCA) has similar problems because it is also based on a strategy of efficiency, though it does consider a wider set of impacts.

DYLLICK and HOCKERTS (2002) have identified criteria such as irreversibility, non-substitutability and non-linearity as fundamental indicators for economic, natural and social (human) capital. In addition, these authors claim, similarly to HAWKENS, LOVINS and LOVINS (2000), that economic capital is growing at the expense of natural resources. These are particularly alarming and important criteria when considering precaution as a framework. They claim that the depletion of natural and social capital often has no significant visible impact until a certain threshold is reached, at which point the effects become unpredictable.

Many other authors have addressed the threshold limit, where unpredictable effects ensure after a certain threshold of degradation or depletion has been reached (LADRIÈRE 1997; RAFFENSPERGER and TICKNER 1999; TICKNER and GEISER 2004; WHITESIDE 2006; DROZ and LAVIGNE 2006). This is what is referred to as the non-linearity principle. DYLLICK and HOCKERTS (2002, 135) use the example by EHRLICH and EHRLICH (1981, xi,

from DYLLICK and HOCKERTS 2002) to illustrate this idea: an airplane mechanic removes a single rivet before each flight. Evidently, a plane will be able to fly with less rivets until such a point where the plane will fall apart and crash.

In this sense, as progress in technological innovations increases, it seems that the human capacity to understand the consequences of these innovations decreases (ARENDT 1958; JONAS 1985; ELLUL 1987, 1990). There is a large gap between the production of long-term, potentially harmful effects from innovations and the ability to understand their outcomes. Many major scientific successes are linked to unforeseen problems which societies are, for the most part, unequipped to deal with (ARENDT 1958; ELLUL 1987; HARREMOËS 2003; ADAM 2004). According to JONAS (1985), the precautionary principle implies that humans must develop a sense of responsibility with respect to technological progress.

These issues place responsibility at the center of the ethics concern (ELLUL 1954; DROZ and LAVIGNE 2006; WHITESIDE 2006). An ethics of the future is necessary (JONAS 1985), yet imposes an important rupture from the way that decisions are traditionally made. Decisions need to embrace a broader scope of considerations; social, cultural, environmental, and political dimensions are necessary in the current global situation (LADRIÈRE 1997; ADAM 2004; MORIN 2004; WHITESIDE 2006). In fact, globalization implies that decisions will, more than likely, have a world-wide impact and therefore must be considered using a global and systemic approach.

Globalization within an economic perspective implies that countries are seeking to maximize exports and minimize imports, creating an international marketplace that is based on an imbalanced notion of trade (REES 2002). This dominant (expansionist) economic paradigm often equates human welfare to an ever-increasing material well-being (infinite growth in income) (REES 2002; HERTWICH 2005; PRINCEN 2005). Yet, this expansionist vision of the economy runs counter to the idea of sustainability (REES 2002). So, when designers cannot adopt a systemic perspective on their design problems, they may fail to visualize such a global, long-term perspective and therefore the decisions that they

make (and therefore ultimately their solutions) may be too narrowly constructed. This type of narrow and short term perspective is at the heart of the current crisis of sustainability (REES 2002).

In the next sections, the implications of conceptualizing a research design based on the problem identified above will be presented.

The Research Objectives

This research advocates a complex vision of the world by not only opening up the perspective of the design project so that a larger vision of its implications can be revealed, but also by strengthening the methodology of the design process when sustainable objectives are sought. A precautionary approach to design allows the process of risk assessment for design to embody the complexity of its environmental and societal implications on a larger scale. When used on their own, traditional evaluation methods are limited for design practice. To make transformational leaps towards sustainability, the claims, concerns and issues of each stakeholder, as well as their intentions, must be considered within the context of the design project. Once all the above are taken into consideration, the design discipline should explore new transformative approaches for assessment that could be used for innovation, and thus improve its sustainability credentials.

The main objective of this research is to understand how the precautionary principle can be incorporated into the design process to complement existing risk evaluation strategies (based on prevention) already adopted in the design process in the context of sustainability. The reason for selecting precaution and not prevention or foresight as the focus of this research is based on several reasons: 1) the relationship between precaution within a philosophical perspective and the set of principles as defined by the Rio Declaration of Environment and Development – in particular the Precautionary Principle, Principle 15 (UNCED 1992); 2) prevention has already been implemented in the form of current risk assessment methods such as LCA, Cost-Benefit Analysis, etc.; 3) foresight is a dimension that is based on an individual ontology regarding random future events – it represents a historical perspective regarding the

ways in which humans manage their livelihoods (EWALD, GOLLIER, and SADELEER 2001). This is not representative of the problems faced by modern society; 4) precaution represents a dimension of prudence that requires a collective form of discourse for supporting decisions and seeks to address the uncertainties that face humanity (JONAS 1985; KOURILSKY and VINEY 2000; EWALD, CALLON, LASCOUMES and BARTHE 2001; GOLLIER and SADELEER 2001; HARREMOËS 2003; RAFFENSPERGER 2004); and 5) the precautionary principle has not yet been implemented in design practice. This research is seeking to understand how this may be achieved.

The two specific objectives to help achieve this are: 1) understanding how the precautionary principle may be incorporated into the design process, but more specifically, a collaborative, inclusive design process; and 2) understanding how controversies emerging from the dialogue in such a design process are revelatory of the social implications of the design project, and therefore can help reveal social indicators that may be used in the design process. These objectives are meant to enrich the theory related to design project methodologies.

The Research Question and Hypothesis

This research posits the arguments that: 1) the precautionary principle is a fundamental principle of sustainable development (UNCED 1992); 2) design activity (architectural, landscape, industrial, etc.) can contribute to sustainable development through the exploration, creation and assessment of alternative solutions to current problematic living systems using an evaluation framework of prudence (CUCUZZELLA 2007); 3) current evaluation methods (such as risk assessment, life cycle analysis, etc.) are based on preventive approaches and present limits when seeking a global vision in a context of sustainable design (LASCOUMES 1996; TICKNER, RAFFENSPERGER and MYERS 1998; RAFFENSPERGER and TICKNER 1999; STIRLING 1999; KOURILSKY and VINEY 2000; BYERS 2001; GOLLIER and SADELEER 2001; EWALD, DOBSON et al. 2004; RAVETZ 2004; VAN GRIETHUYSEN 2004; GODARD 2005; VAN DER SLUIJS 2007); and 4) a prudent framework for the evaluation and conceptualization of sustainable solutions can help overcome some of these limitations.

One of the obstacles for the implementation of a precautionary approach to sustainable design (as a complement to current preventive methods) is that there is an aversion to addressing fundamental uncertainty in an integrative manner in the evaluation and innovation stages of design (DUPUY 2002). This is evident in that the modus operandi for sustainable design is using statistical predictable (linear) methods of evaluation where innovation is based on optimizing results. However, the uncertainty inherent in the integration of the three pillars of sustainable development must be seriously considered during evaluation and innovation.

There, the hypothesis is that a complex vision can provide a new paradigmatic framework that will provide a more global perspective of the issues regarding sustainable design based on a theoretical framework of prudence.

The main research question is this: how can a theoretical framework based on prudence enable designers (stakeholders) to contribute to sustainable development by overcoming some of the limitations based on current modes of evaluation and innovation?

Conclusion

The focus of this research is to understand the evaluation process and methods that could be used by the design team in a context of sustainable development. In addition, as the methods to be adopted for evaluation would also have an impact on the process of innovation (GUBA and LINCOLN 1989), the nature and degree of the innovation in a context of sustainability is also to be studied.

A framework that includes prevention, precaution and foresight is a promising framework for evaluation in the context of sustainable design (CUCUZZELLA 2007). The precautionary principle can contribute to sustainable development (UNCED 1992) through its broader temporal and spatial perspective, and add to the current preventive approach of evaluation and innovation (CALLON, LASCOUMES and BARTHE 2001). The precautionary principle represents an alternative approach to risk assessment for defining action. This method adopts an approach to risk reduction

based on a constructivist understanding of concerns, issues and claims, all of which are comprised of uncertainty, doubt and suspicion. Therefore, controversy is explicitly dealt with in design projects that adopt a precautionary approach. In addition, an approach to evaluation based on the precautionary principle addresses the core issues of sustainable development since it does not only look for technocratic solutions, but also social, cultural, economic ones etc., therefore considering the complexity of the situation.

References

ADAM, BARBARA. "Minding Futures: An Exploration of Responsibility for Long-Term Future," in *Working Paper Series* 67. School of Social Sciences, Cardiff University. 2004.

ARENDT, H. *The Human Condition.* Chicago: University of Chicago Press, 1958.

BINDÉ, JÉRÔME. "Toward an Ethics of the Future." *Public Culture* 12, no. 1 (2000): 51–72.

BOUTINET, J. P. *Anthropologie du projet.* 1st edition, Quadrige ed. Paris: Presses Universitaires de France, 2005.

BYERS, STEPHEN. "Applying the Precautionary Principle." *Science and Public Affairs.* 2001.

CALLON, M., P. LASCOUMES, and Y. BARTHE. *Agir dans un monde incertain: Essai sur la démocratie technique.* Paris: Le Seuil, 2001.

CHECKLAND, PETER. *Systems Thinking, Systems Practice: Includes a 30-Year Retrospective.* Chichester: John Wiley & Sons, 1999.

COOPER, TIM. "Product Development Implications of Sustainable Consumption." *Design Journal* 3, no. 2 (2000): 46–57.

CUCUZZELLA, CARMELA. "From Eco-Design to Sustainable Design: A Contribution of the Precautionary Principle." *Mémoire de Maîtrise en Aménagement.* Université de Montréal, Montreal: 2007.

CUCUZZELLA, CARMELA. "The Limits of Current Evaluation Methods in a Context of Sustainable Design: Prudence as a New Framework," in *Proceedings of IDMME – Virtual Concept Beijing.* China: Verlag Springer, 2009.

CUCUZZELLA, CARMELA, and PIERRE DE CONINCK. "In Pursuit of Sustainable Consumption: The Limits of Adopting a Strategy of Efficiency," in *The 8th International Conference on EcoBalance*. Tokyo, Japan, 2008.

CUCUZZELLA, CARMELA, and PIERRE DE CONINCK. "The Precautionary Principle as a Framework for Sustainable Design: Attempts to Counter the Rebound Effects of Production and Consumption," in *First International Conference on Economic De-growth for Ecological Sustainability and Social Equity*. Paris, 2008.

DE NOBLET, JOCELYN. "Extension du domaine de la forme," in *Colloque de Cerisy, Prospective d'un siècle à l'autre (III), Les nouvelles raisons du savoir: vers une prospective de la connaissance,* edited by T. GAUDIN and A. HATCHUEL: éditions de l'aube. 2002.

DOBSON, CONOR, GRAHAM KNOWLES, CLAUDE-ANDRÉ LACHANCE, MIRIAM LEVITT, BARBARA MCELGUNN, PAUL MULDOON, KEN OGILVIE, HUGH PORTEOUS, JUDY SHAW, and CYNTHIA WRIGHT. *Applying Precaution in Environmental Decision-Making in Canada,* edited by NEW DIRECTIONS GROUP PRECAUTION PROJECT TEAM. 2004.

DROZ, Y., and J.-C. LAVIGNE. *Éthique et développement durable.* Paris: Editions Karthala et Institut universitaire d' études du développement (IUED). 2006.

DUPUY, J.-P. *Pour un catastrophisme éclairé. Quand l'impossible est certain.* Paris: Seuil, 2002.

DYLLICK, THOMAS, and KAI HOCKERTS. "Beyond the Business Case for Corporate Sustainability." *Business Strategy and the Environment* 11 (2002): 130–141.

ELLUL, J. *La technique ou l'enjeu du siècle.* New edition, Économica, 1990 ed., Paris: Armand Colin, 1954.

ELLUL, J. *Le bluff technologique.* Paris: Hachette, 1987.

EWALD, FRANÇOIS. "Philosophie de la Précaution." *L'année sociologique* 46, no. 2 (1996): 383–412.

EWALD, FRANÇOIS, CHRISTIAN GOLLIER, and NICOLAS DE SADELEER. *Le Principe de précaution.* Paris: PUF/Que sais-je, 2001.

GODARD, O. "The Precautionary Principle, Between Social Norms and Economic Constructs." *Laboratoire d'Économétrie de l'Ecole Polytechnique,*

EDF - Ecole Polytechnique, Paris: Cahier no. 2050–020, 2005.

GUBA, EGON G., and YVONNA S. LINCOLN. *Fourth Generation Evaluation.* Newbury Park, CA: Sage Publications, Inc. 1989.

HARREMOËS, P. "Ethical Aspects of Scientific Incertitude in Environmental Analysis and Decision Making." *Journal of Cleaner Production* 11, no. 7 (2003): 705–712.

HAWKEN, P., A. LOVINS, and L. H. LOVINS. *Natural Capitalism: Creating the Next Industrial Revolution.* UK: Back Bay Books, 2000.

HERTWICH, EDGAR G. "Consumption and the Rebound Effect: An Industrial Ecology Perspective." *Journal of Industrial Ecology* 9, no. 1–2 (2005): 85–98.

JACKSON, TIM. "Consuming Paradise? Unsustainable Consumption in Cultural and Social-Psychological Context." Paper read at *Driving Forces of and Barriers to Sustainable Consumption, Proceedings of an International Workshop.* Leeds: March 5–6, 2004.

JACKSON, TIM. "Live Better by Consuming Less? Is There a "Double Dividend" in Sustainable Consumption?" *Journal of Industrial Ecology* 9, no. 1–2 (2005):19–36.

JONAS, H. *The Imperative of Responsibility: In Search of an Ethics for the Technological Age.* Translated by H. JONAS and with the collaboration of D. HERR. Chicago: University of Chicago Press, 1985.

KOURILSKY, PHILLIPE, and GENEVIÈVE VINEY. *Le Principe de précaution: Rapport au Premier ministre.* Paris: Éditions Odile Jacob, La Documentation française, 2000.

La technique ou l'enjeu du siècle. Paris: Économica, 1990. Original edition: Armand Colin, 1954.

LADRIÈRE, J. *L'éthique dans l'univers de la rationalité:* Catalyses, Artel – Fides, 1997.

LASCOUMES, P. "La précaution comme anticipation des risques résiduels et hybridation de la responsabilité." *L'année sociologique* 46, no. 2 (1996): 359–382.

LATOUCHE, SERGE. *Le pari de la décroissance.* Paris: Fayard, 2006.

MARCHAND, A., and S. WALKER. "Product development and responsible consumption: designing alternatives for sustainable lifestyles." *Journal of Cleaner Production* doi:10.1016/j.jclepro.2007.08.012 (2007).

MCDONOUGH, WILLIAM, and MICHAEL BRAUNGART. *Cradle to Cradle: Remaking the way we make things.* New York: North Point Press, 2002.

MCDONOUGH, WILLIAM, and PARTNERS. "The Hannover Principles: Design for Sustainability." In *EXPO 2000, The World's Fair.* Hannover, Germany, 1992.

MORIN, EDGAR. *La Méthode 6, Éthique.* Paris: Éditions du Seuil, 2004.

MYERS, NANCY J., and CAROLYN RAFFENSPERGER, eds. *Precautionary Tools for Reshaping Environmental Policy.* Cambridge, Mass.: MIT Press, 2005.

OECD, ORGANIZATION FOR ECONOMIC CO-OPERATION AND DEVELOPMENT. "Policy Brief – Biofuels for Transport: Policies and Possibilities," in *OECD Observer* (2007).

PRINCEN, T. *The Logic of Sufficiency.* Cambridge, Mass.: MIT Press, 2005.

PRINCEN, T. "Principles for Sustainability: From Cooperation and Efficiency to Sufficiency." *Global Environmental Politics* 3, no. 1 (2003): 33–50.

RAFFENSPERGER, C., and J. TICKNER, eds. *Protecting Public Health and the Environment: Implementing the Precautionary Principle.* Washington, DC: Island Press, 1999.

RAFFENSPERGER, CAROLYN. "Precautionary Precepts: The Power and Potential of the Precautionary Principle." *Multinational Monitor* 25, no. 9 (2004).

RAVETZ, JERRY. "The Post-Normal Science of Precaution." *Futures* 36, no. 3 (2004): 347–357.

REES, WILLIAM E. "Globalization and Sustainability: Conflict or Convergence?" *Bulletin of Science, Technology and Society* 22, no. 4 (2002): 249–268.

REISCH, L. A., and G. SCHERHORN. "Sustainable Consumption." *The Current State of Economic Science* 2 (1999): 657–690.

ROBINS, N., and B. DE LEEUW. "Rewiring Global Consumption: Strategies for Transformation," in *Sustainable Solutions: Developing Products and Services for the Future,* edited by M. CHARTER and U. TISCHNER. Sheffield, UK: Greenleaf Publishing Limited, 2001.

SCHAEFER, A., and A. CRANE. "Addressing Sustainability and Consumption." *Journal of Macromarketing* 25, no. 1 (2005): 76–92.

STIRLING, ANDREW. *On Science and Precaution In the Management of Techno-logical Risk.* Seville: European Commission – JRC Institute Prospective Technological Studies, 1999.

STRAHEL, WALTER, R. "Sufficiency Strategies for a Sustainable and Competitive Economy: Reversed and Inversed Incentives." *IEEE* (2001): 583–589.

TICKNER, J., and K. GEISER. "The Precautionary Principle Stimulus for Solutions and Alternative based Environmental Policy." *Environmental Impact Assessment Review* 24 (2004): 801–824.

TICKNER, J., C. RAFFENSPERGER, and NANCY MYERS. *The Precautionary Principle in Action: A Handbook,* First edition: Science and Environmental Health Network, 1998.

UNCED. "Rio Declaration on Environment and Development," in *United Nations Conference on Environment and Development.* Rio de Janeiro, 1992.

UNEP/WUPPERTAL. "Creating Solutions for Sustainable Consumption and Production," in UNEP *Production and Consumption Branch:* UNEP/Wuppertal Institute Collaborating Centre on SCP, 2007.

VAN DER RYN, S., and S. COWAN. *Ecological Design, 10th Anniversary Edition.* Washington: Island Press, 2007.

VAN DER SLUIJS, JEROEN P. "Uncertainty and Precaution in Environ-mental Management: Insights from the UPEM Conference." *Environmental Modelling & Software* 22, no. 5 (2007): 590–598.

VAN GRIETHUYSEN, PASCAL. "Le principe de précaution: quelques éléments de base," in *Les Cahiers Du Ribios:* Réseau universitaire inter-national de Genève, 2004.

WHITESIDE, K. H. *Precautionary Politics: Principle and Practice in Confronting Envi-ronmental Risk.* Cambridge, Mass.: The MIT Press, 2006.

YASUKO, SUGA. "Designing the Morality of Consumption: 'Chamber of Horrors' at the Museum of Ornamental Art, 1852–53." *Design Issues* 20, no. 4 (2004): 43–56.

ABSTRACT+
COMMENTS

Hypothesizing about
Design from the
Perspective of
Visual Rhetoric

Annina Schneller

The still emerging field of Visual Rhetoric considers design from a rhetorical perspective. In my paper, I will argue that there is not just one way of applying rhetoric to the field of design; rhetoric itself is a vast and heterogeneous field with different viewpoints, each offering a variety of new questions and hypotheses for design research. In the following, I will pinpoint three main rhetorical perspectives on design and I will present some of the hypotheses, questions and problems arising from each of them.[1] Moreover, I will try to show how these views are interconnected and thereby help to establish a systematic basis for visual rhetorical theories.

01—To make such a distinction is valuable. How about making distinctions between the rhetorical perspective and other perspectives such as cognitive,

management, systems, philosophical, etc.? At the moment, I am not clear about the advantages of adopting Visual Rhetoric for design. 02—Do you believe that design is a particular case of the visual field? And is visual the most important aspect of design? If we move beyond the visual, will rhetoric still have relevance for design? Perhaps the third perspective that you discuss at the end of the paper goes beyond the visual.

Adopting a rhetorical perspective towards the visual field, or at design in particular,[2] can be (and has been) done in quite different ways. Since the 1960s, when GUI BONSIEPE started to use rhetorical terminology for visual phenomena, there have been diverse, mostly unconnected and not systematically laid-out attempts to connect rhetoric to design theory (or visual culture in general). The different viewpoints not only differ on the specific terms and aspects of traditional verbal rhetoric they apply to the design area, but also on how, fundamentally, design itself is posited as an inherently rhetorical process. Moving from the first to the third perspective presented here, you will find this idea of design as rhetoric gaining in strength. I do not want to argue that the authors cited strictly adhere to one of the three perspectives, but that the perspectives should be carefully kept apart, as they entail different hypotheses about the connection between design and rhetoric.

1.

The first rhetorical perspective I want to discuss focuses on the results of design, mostly on classical products of graphic design such as posters and ads with a clear visual message, but also, in a wider sense of rhetoric and argumentation, on product design. Such a perspective simply ascribes to these products certain features borrowed from classical rhetoric. As GUI BONSIEPE (1965) or HANNO EHSES (1986) do, we can look for rhetorical figures such as the metaphor, metonymy, hyperbole, etc., realized not (only) verbally but on a visual level as well. Suggesting the forest by showing a leaf could be described as a synecdoche or metonymy; signifying the king by featuring a lion would count as a visual metaphor. Alternatively, as RICHARD BUCHANAN suggested with his idea of "design argument" (1985), one could focus on the three rhetorical dimensions *pathos*, *ethos* and *logos* and assign them to different pieces of design (or to different aspects of one piece of design). Some features of design act on an emotional level *(pathos)*, others draw on our moral convictions or values *(ethos)*, others again try to influence us by providing information, rational arguments or mere functionality *(logos)*. Analogously, one could pick out any other interesting term from rhetorical vocabulary and transfer it to design. Some of

these terms focus more on the production, while others more on the results of speech, e.g. the *partes orationis*, the steps involved in producing a discourse and delivering it or the *officia oratoris*, the traditional tasks or duties of a speaker (pleasing, teaching and moving) (HEINEN 2008). Due to space restrictions, I leave it to the reader to think of ways of transferring these concepts from speech to design.

However interesting the aforementioned accounts might be, they have one major problem: they take the analogy between the verbal and visual dimension for granted. These accounts use existing rhetorical vocabulary and apply it to visual phenomena, without even asking whether this can be done and how exactly. In what sense do pictures carry a message? Is it advisable to use the term "argument" in connection with images or even bookshelves or coffee machines? And if we do so, what do we mean by these terms? Adopting such a perspective seems to be a decent start, but it does not constitute a critical point of view, since it leaves crucial points unexamined, even unmentioned. The hypothesis implicit in such a view is that design functions and therefore can be treated in the same way as the subject of rhetoric: spoken language. From a more critical perspective, this is a hypothesis that would need careful consideration. What is more, mere terminological borrowing does not inform about the deeper connection between design and rhetoric. Does talking of visual metaphors, etc. imply an understanding of design as rhetorical art? Or is it just a nice metaphor, a useful way of naming characteristics of design objects and production? The lack of explicitness in the mentioned accounts makes it difficult to answer these questions. Such accounts may provide food for thought but leave us unclear about the theoretical implications of the views they advocate. They might easily provide many plausible examples of different rhetorical figures and effects in (graphic) design, but cannot serve as a theoretical or systematical basis for visual rhetoric, since they barely shed light on the specific visual or visual/verbal idiosyncrasies. Someone who makes an attempt to clarify the concept and argue for the possibility of

visual "arguments" is J. ANTHONY BLAIR (2004). He explains that pictures can be arguments in the sense of persuading (not forcing) someone to adopt a view or to do something by presenting a reason for this belief or action, and he defends his view against the charge that visuals are vague and bear no strictly propositional content (as opposed to verbal arguments). Getting deeper into such issues leads to a more informed and more informative perspective, which will be addressed in the following section.

2.

Another, more critical way of looking at design from a rhetorical perspective would be to transfer certain *essential* principles of rhetorical theory to design. Such a perspective does not just borrow terms from rhetoric to talk about design, but assumes that certain fundamental mechanisms of rhetoric are also at work in the design process. It implies that, at least in certain basic respects, design has to be seen *as* rhetoric. Such a view must be, and automatically is, far more explicit on where exactly the similarity between using verbal language and designing a visual object is supposed to be found.

The most general and most often promoted idea surely is that of rhetoric as the art of *persuasion*. The fundamental rhetorical characteristic of persuasiveness is taken to be a basic principle in design, too. Just as the rhetorical act is characterized as the attempt to persuade someone with speech, the design act is defined as the attempt to persuade an audience with visual means.[3]

03—What do you think of the book "The Semantic Turn" by Klaus Krippendorf? His main thesis, in brief, suggests to involve all

ANNINA SCHNELLER — ABSTRACT

stakeholders in the process of producing "compelling proposals." Do you think Krippendorf offers a more sophisticated account of "persuasion?"

Such a general characterization can be found in most texts of visual rhetoric (e.g. BONSIEPE 1965; BUCHANAN 1985; EHSES 1986; BLAIR 2004). Not all authors give an exact definition of persuasion, but they at least make some effort to do so. In general, to persuade means to invoke certain decisions, opinions, emotions or actions in a public. To point out the persuasiveness of design means to focus on the influence of designers, respectively, on the intended effects design has on a public; to stress the persuasive aspect of design is to consider design as a *means* of pleasing, teaching, informing, etc. an audience (BUCHANAN 1985). One point of contention is the question of whether this influence must be free of coercion, i.e. whether the intended public must be in some way free to adopt or reject the promoted view (BONSIEPE 1965; BLAIR 2004). Is mere manipulation or causal influence part of the persuasive effects and therefore of rhetoric? My view is that rhetoric, just like design, is about the intentional production of rational *and* causal (e.g. affective, emotional) responses in an audience. Therefore, the term "persuasion" should be used to mean both sorts of effects. However, I would avoid talk of "arguments" or "argumentation" in connection with direct, causal modes of influence. These terms, in my understanding, clearly suggest that reason plays a central role in the persuasion process (which is why BUCHANAN's talk of "design argument" presents a problem). Another problem of defining rhetoric and design by persuasion is that "persuasion" usually means a rather strong mode of influencing people. But, as it seems, not all speech and not all forms of design want or need to have such a strong impact on their public. Timetables, signposts and official bulletins, for instance, obviously want to help people find their way, but they clearly avoid a blatant, obtrusive look. My suggestion here would again be to use "persuasion" in a rather broad sense so that any form of intended influence on a public would count as a persuasive effect. Merely informing someone would then also count as persuading him, since even an information design object, e.g. a timetable, is designed in view of optimally fulfilling its informative purpose for an audience.

A second, more specific way to take on a perspective that transfers essential features from rhetoric to design would be to see the idea of *deviation* as fundamental. The General Rhetoric of the Belgian semioticians *Groupe µ* (DUBOIS *et al.* 1974) defined rhetoric as the art of deviation from the baseline (*degree zero*) of speech, or from the normal way of putting things. Accordingly, design could be characterized as the process of adding something special at the right point, of breaking a rule in order to catch people's attention, or of running counter to people's expectations in order to surprise or even shock spectators. The focus here is on what makes skillful design, as well as on the concept of a norm or rule as underlying every act of design. However, it seems too narrow a position to take only design or speech that deviates from the norm to be a form of rhetoric (see criticism by KINROSS 1985). Depending on the context and intended effect of a design, following the familiar design rules and therefore choosing the simplest and most obvious form might be the way to design the most persuasive solution available. Fulfilling the expectations of the public can be a perfectly rhetorical act. In design areas such as information design, this will often prove to be the best strategy. What gives design a rhetorical dimension in this sense is not necessarily deviation, but the fact that the designer executes her design with regard to a certain end. The skill desmonstrated when applying, playing with, or breaking the design rules in order to create the intended effect would then

04—For some reason, the discussion of norms and rules reminds me of Donald Schön's study of design process in 1980s. Are you familiar with his works? 05—Is this not a truism?

be what makes a good or bad designer. A modified view would then not so much stress the deviation aspect of rhetoric, but the purposeful and systematic handling of design norms or rules.[4] Such a view of design as rhetoric is closely connected to the persuasion view, since the overall purpose of all possible design intentions could be summarized as that of persuasion.

A third central rhetorical principle applicable to design is that of the *decorum* or *aptum*, which requires appropriateness of the used means, contents and forms in relation to the respective context (i.e. subject, audience, place, time) (see HEINEN 2008). This overall rhetorical principle could be seen as the link between design as persuasion and design as guided by the rule book (or it could act as a second order design rule):
— Design always tries to influence or persuade its audience.
— Every piece of design follows or breaks a rule.[5]
— In order to attain the aim of persuading an audience, the designer must follow the *aptum/decorum*, i.e. she must choose the appropriate means. Depending on the context, she must therefore follow or break certain design rules.

Compared to the hypotheses in the first perspective, the ones from the second are more comprehensive and instructive, as they explicitly state the ways in which design is supposed to be rhetorical. Not only do they allow for integrating the rhetorical elements mentioned in the first part; they also explain why and on what conditions they occur. The use of a visual metaphor such as the lion on a theater poster for "King Lear,"

for example, could be explained as rule-breaking with a view to using the appropriate means of persuasion: the design rule of maximal directness ("Show things as they are") is broken in order to gain the attention and interest of a rather sophisticated audience.

3.

The third perspective that relates rhetoric to design goes one step further than the last one. It takes the interplay of theory and practice present in verbal rhetoric to be an inherent principle of design (JOOST and SCHEUERMANN 2006, 2008). While a speaker writes and gives speeches in practice, he will draw on the theory of rhetoric in order to improve his skills. In particular, the speaker will analyze his speeches and those given by others, so as to find out what features made them work or fail. This feedback loop leading from practice to theory and back into practice again can be used to describe design, too. The designer is supposed to create her work on the basis of former analysis and to feed her completed work (and the work of others) back into the loop in order to analyze it and learn from it. In the process of creating and analyzing design, the designer will find out certain rules of effect; rules that can be applied in her further work, rules that will be copied by others and rules that will finally be broken as new ones emerge. When times and fashion change, the design rules and role models will change, but the feedback loop between theory and practice will go on and on.

The third, holistic perspective is able to locate and systematically build on the ideas from the second and first perspectives. It can, for example, explain a lot about design rules: that rules can be written down and

245

taught in design theory, whilst they are mainly created in practice, as soon as a certain way of designing things is repeated and reliably proven to have a certain effect on the intended public. It also allows for the possibility that rules can be followed (or broken) by the designer without her necessarily being aware of this fact. As a practitioner, she must not necessarily be, but can become, aware of the theoretical aspects of her creative process. Making the underlying rules explicit is part of analysis, or theory, while applying them is part of practice. The main hypothesis found in the last perspective runs as follows: Design is a process of creating, analyzing, learning, adapting and recreating, whereby design rules are generated and (implicitly, tacitly or consciously) acquired and applied.[6]

In this short survey of three possible rhetorical perspectives on design, it was of course impossible to make the ideas of persuasion, rule handling, appropriateness and the theory/practice loop sufficiently clear. Nevertheless, I think that the presented rhetorical hypotheses have confronted us with promising, (more or less) plausible, simple and yet fruitful characterizations of design. We also got a glimpse of how the different essential rhetorical features can be interconnected. Last but not least, the threefold distinction and the corresponding levels of considering design *as* rhetoric have hopefully shed some light upon the study of Visual Rhetoric.[7]

06—This reminds me again of the many studies on the design process, and perhaps the learning process by Kolb. Wolfgang Jonas has developed a generic design process model which seems to include the process described here. If applying rhetoric to design ends up having the same conclusion as other perspectives, what does rhetoric do to design? **07**—Are you developing a fourth perspective?

FINAL PAPER

——

Hypothesizing about Design from the Perspective of Visual Rhetoric

Annina Schneller

The still emerging field of Visual Rhetoric considers design from a rhetorical perspective. In my paper, I will argue that there is not just one way of applying rhetoric to design; rhetoric itself is a vast and heterogeneous field with different viewpoints, each offering a variety of new questions and hypotheses for design research. In the following, I will pinpoint three main rhetorical perspectives on design and present some of the hypotheses, questions and problems arising from each of them.

Moreover, I will try to show how these views are interconnected and thereby help to establish a systematic basis for visual rhetorical theories. Especially the second and third view might offer valuable design theoretical insights, some of which could complement or even outclass the established cognitive, philosophical, management or system theoretical perspectives. To compare and contrast these views is a task for further research.

With the proliferation of and growing theoretical attention paid to visual media (photography, cinema, TV, video and internet) during the 20th century, there has also been a revival of the old art of rhetoric, though in the somewhat new guise of a rhetoric of visual, rather than spoken, communication. Design is a favored object of such visual rhetorical study, as it works largely on a visual level (though not exclusively, as acoustic, haptic and other modes of effect should not be forgotten; in fact, the perspectives offered here, while usually attributed to Visual Rhetoric, are not necessarily restricted to the visual mode). Looking at design from a rhetorical perspective can be (and has been) done in quite different ways. Since the 1960s, when GUI BONSIEPE started to use rhetorical terminology for products of graphic design, there have been diverse, mostly unconnected and not systematically laid-out attempts to connect rhetoric to design theory (or visual culture in general). The different viewpoints not only differ on the specific terms and aspects of traditional verbal rhetoric they apply in the design area, but also in the extent to which design itself is posited as an inherently rhetorical process. Moving from the first to the third perspective presented here, you will find this idea of design as rhetoric gaining in strength. I do not want to argue that the authors cited strictly adhere to one of the three perspectives, but that the perspectives should be carefully kept apart, as they specify different hypotheses about the connection between design and rhetoric.

1.

The first rhetorical perspective I wish to discuss focuses on the results of design – mostly on classical products of graphic design such as posters

and ads with a clear visual message, but also, in a wider sense of rhetoric and argument, on product design. Such a perspective simply ascribes to these products certain features borrowed from classical rhetoric. Following GUI BONSIEPE (1965) or HANNO EHSES (1986), we can look for rhetorical figures such as the metaphor, metonymy, hyperbole, etc. realized on a visual level. Suggesting the forest by showing a leaf could be described as a synecdoche or metonymy; signifying the king by featuring a lion would count as a visual metaphor. Alternatively, as RICHARD BUCHANAN proposes with his idea of "design argument" (1985), one could focus on the three rhetorical dimensions of *pathos, ethos* and *logos* and assign them to different works of design (or to different aspects of one piece of design): some features of design act on an emotional level *(pathos)*, others draw on our moral convictions or values *(ethos)*, and others try to influence us by providing information, rational arguments or mere functionality *(logos)*. Analogously, one could pick out any other interesting term from rhetorical vocabulary and transfer it to design. Some of these focus more on the production, others more on the results of speech: e.g. the *partes orationis,* the steps involved in producing and delivering a discourse, versus the *officia oratoris,* the traditional tasks or duties of a speaker (pleasing, teaching and moving) (HEINEN 2008). Due to space restrictions, I leave it to the reader to think of ways of transferring these concepts from speech to design.

However interesting the aforementioned accounts might be, they have one major problem: they take the analogy between the verbal and visual dimension for granted. These accounts use existing rhetorical vocabulary and apply it to visual phenomena without even asking whether and how exactly this can be done. In what sense do pictures carry a message? Is it advisable to use the term "argument" in connection with images or even bookshelves or coffee machines? And if we do so, what do we mean by these terms? Taking on such a perspective seems to be a decent start, but it does not constitute a critical point of view, since it leaves crucial issues to be addressed. The hypothesis implicit in such a view is that design functions and therefore can be treated in the same ways as the subject of rhetoric: spoken language. From a more critical

perspective, this is a hypothesis that would need careful consideration. What is more, mere terminological borrowing does not reveal anything about the deeper connection between design and rhetoric. Does talk of visual metaphors, etc. imply an understanding of design as rhetorical art? Or is it itself just a handy metaphor, a useful way of naming characteristics of design objects and production? The ambiguity in the mentioned accounts makes it difficult to answer these questions. Such accounts may be thought-provoking, but they leave us in the dark about the theoretical implications of their promoted views. They may provide many plausible examples of different rhetorical figures and effects in (graphic) design, but cannot serve as a theoretical or systematic basis for Visual Rhetoric, since they hardly shed any light on specific visual or visual/verbal idiosyncrasies. One person who makes an attempt to clarify the concept and advocate the possibility of visual "arguments" is J. ANTHONY BLAIR (2004). He explains that pictures can be arguments in the sense of persuading (not forcing) someone to adopt a view or to do something by presenting a reason for this belief or action, and he defends his view against the charge that visuals are vague and bear no strictly propositional content (as opposed to verbal arguments). Getting deeper into such issues leads to a more informed and more informative perspective, which will be addressed in the following section.

2.

Another, more critical way of looking at design from a rhetorical perspective would be to transfer certain *essential* principles of rhetorical theory to design. Such a perspective does not just borrow terms from rhetoric to talk about design, but assumes that certain fundamental mechanisms of rhetoric are also at work in the design process. It implies that, at least in certain basic respects, design has to be seen *as* rhetoric. Such a view must be far more explicit on where exactly the similarities between using verbal language and designing a visual object are supposed to be found.

The most general and most often promoted idea here rests on a view of rhetoric as the art of *persuasion:* the fundamental rhetorical characteristic of persuasiveness is taken to be a basic principle that also governs

design. Just as the rhetorical act is characterized as the attempt to persuade someone with speech, the design act is defined as the attempt to persuade an audience with visual means. Such a general characterization can be found in most texts of Visual Rhetoric (e.g. BONSIEPE 1965; BUCHANAN 1985; EHSES 1986; BLAIR 2004; KRIPPENDORFF 2006). Not all authors give an exact definition of persuasion, but they at least make some effort to do so: in general, to persuade means to invoke certain decisions, opinions, emotions or actions in a public. Accordingly, to point out the persuasiveness of design means to focus on the way that designers influence the intended effects design has on its public; to stress the persuasive aspect of design is to consider design as a *means* to pleasing, teaching, informing an audience (see BUCHANAN 1985). One bone of contention is the question of whether this influence must be free of coercion, i.e. whether the intended public must be in some way free to adopt or reject the promoted view. Are mere manipulation or causal influence part of the persuasive effects and therefore of rhetoric? Whereas BONSIEPE (1965) and BLAIR (2004) argue for freedom, KLAUS KRIPPENDORFF'S (2006) notion of designs as "compelling proposals" is actually indecisive as to whether design is strictly speaking compelling or whether it merely has the character of a proposal (which suggests that the targeted stakeholders would be free to accept it or not). My view is that rhetoric, just like design, is about the intentional production of rational *and* causal (e.g. affective, emotional) effects in an audience. Therefore, the term "persuasion" should be used to mean both sorts of effects. However, I would avoid talk of "arguments" or "argument" in connection with direct, causal modes of influence. These terms, in my understanding, clearly suggest that reason plays a central role in the persuasion process (which is why BUCHANAN's talk of "design argument" presents a problem). Another problem of defining rhetoric and design in terms of persuasion is that "persuasion" usually means a rather strong way of influencing people. But, as it seems, not all speech and not all forms of design want or need to have such a strong impact on their public. Timetables, signposts, and official bulletins, for instance, are obviously intended to help people find their way, but they clearly avoid a

blatant, obtrusive appearance. My suggestion here would again be to use "persuasion" in a rather broad sense, so that any form of intended influence on a public would count as a persuasive effect. Merely informing someone would then also count as persuading them, since even an information design object, e.g. a timetable, is designed with a view to optimally fulfilling its informative purpose for an audience.

A second, more specific way to adopt a perspective that transfers essential features from rhetoric to design would be to see the idea of *deviation* as fundamental. The General Rhetoric of the Belgian semioticians *Groupe µ* (see DUBOIS *et al.* 1974) defined rhetoric as the art of deviation from the baseline (*degree zero*) of speech, or from the normal way of putting things. Accordingly, design could be characterized as a process of adding something special at the right point, of breaking a rule in order to catch people's attention, or of running counter to people's expectations in order to surprise or even shock spectators. The focus here lies rather on what constitutes skillful design, and on the concept of a norm or rule that is supposed to be underlying every act of design. However, it seems too narrow a position to take only design or speech that deviates from the norm to be a form of rhetoric (see KINROSS 1985). Depending on the context and intended effect of a design, following familiar design rules and therefore choosing the simplest and most obvious form might be the way to design the most persuasive solution available. Wholly fulfilling the expectations of the public can be a perfectly rhetorical act. In design areas such as information design, this will in fact often prove to be the best strategy. What gives design a rhetorical dimension on such an understanding is not necessarily deviation, but the fact that the designer executes her design with regard to a certain end. The skill demonstrated during application of, play with, or breach of the design rules in order to create the intended effect would then be what makes a good or bad designer. A modified view would thus not so much stress the deviational aspect of rhetoric, but the purposeful and systematic handling of design norms or rules. Such a view of design as rhetoric is closely connected to the persuasion view, since the overall purpose of all possible design intentions could be summarized as that of persuasion.

A third central rhetorical principle applicable to design is that of *decorum* or *aptum,* which requires appropriateness of the used means, contents and forms in relation to the respective context (i.e. subject, audience, place, time) (HEINEN 2008). This overall rhetorical principle could be seen as the link between design as persuasion and design as using the rulebook (or it could act as a second-order design rule):

— Design always tries to influence or persuade its audience.

— Every piece of design follows or breaks a rule.

— In order to attain the aim of persuading an audience, the designer must follow the *aptum/decorum,* i.e. she must choose the appropriate means. Depending on the context, she must therefore follow or break certain design rules.

Compared to the hypotheses from the first perspective, those from the second are more comprehensive and instructive, as they make clear in what sense design is supposed to be rhetorical. They not only advocate the integration of the rhetorical elements mentioned in the first part, but also explain why and on what conditions they occur. The use of a visual metaphor such as the lion on a theater poster for "King Lear," for example, could be explained as rule breaking with a view to using the appropriate means of persuasion: the design rule of maximum directness ("Show things as they are") is broken in order to gain the attention and interest of a rather sophisticated audience.

3.

The third perspective that relates rhetoric to design goes one step further than the second one. It assumes the interplay of theory and practice present in verbal rhetoric to be an inherent principle of design (see JOOST and SCHEUERMANN 2006, 2008). While a speaker writes and gives his speech in practice, he will draw on the theory of rhetoric in order to improve his skills. In particular, the speaker will analyze his speeches and those given by others so as to find out what features made them work or fail. This feedback loop leading from practice to theory and back into practice again can be used to describe design, too. The designer is supposed to create her work on the basis of former analysis and to feed

her completed work (and the work of others) back into the loop in order to analyze it and learn from it. In the process of doing and analyzing design, the designer will find out certain rules of effect: rules that can be applied in her further work, rules that will be copied by others and rules that will finally be broken as new ones emerge. When times and fashions change, the design rules and role models will change, but the loop between theory and practice will remain operative.

This third, holistic perspective is able to take up and systematically integrate the ideas from the second and first perspectives. It can, for example, explain a lot about design rules: that rules can be written down and taught in design theory, whilst they are mainly created in practice, as soon as a certain way of designing things is repeated and reliably proven to have a certain effect on the intended public. It also allows for the possibility that rules can be followed (or broken) by the designer without her necessarily being aware of this fact. As a practitioner, she need not necessarily reflect on the theoretical aspects of her doing, but may do so – an idea that echoes (though with a twist) DONALD SCHÖN's thoughts on the "reflective practitioner" (1983). Making the underlying rules explicit is part of analysis, or theory, while applying them is part of practice. The main hypothesis found in the last perspective runs as follows: Design is a process of creating, analyzing, learning, adapting and recreating, whereby design rules are generated and (implicitly, tacitly or consciously) acquired and applied. Such a view has similarities with DAVID KOLB's theory of experiential learning and the learning spiral (1984) or WOLFGANG JONAS' generic design process model of analysis, projection and synthesis (1996). However, I must leave it for another essay to explore any such connections or contentions further.

In this short survey of three possible rhetorical perspectives on design, it has of course been impossible to make the ideas of persuasion, rule handling, appropriateness and the theory/practice loop sufficiently clear. Especially the use and implications of the suggested visual rhetorical hypotheses for existing design theories require more detailed examination. Nevertheless, I think that the ideas presented here have confronted us with promising, (more or less) plausible, simple and yet fruitful character-

izations of design. We also got a glimpse of how the different essential rhetorical features might be interconnected. Last but not least, the three-fold distinction and the corresponding grades of considering design as rhetoric have hopefully shed some light upon the study of Visual Rhetoric.

References

BLAIR, J. ANTHONY. "The Rhetoric of Visual Arguments," in *Defining Visual Rhetorics,* edited by CHARLES A. HILL and MARGUERITE HELMERS. Mahwah, N.J.: 2004.

BONSIEPE, GUI. "Visual/Verbal Rhetoric." Ulm 14/15/16 (1965): 23–40.

BUCHANAN, RICHARD. "Declaration by Design: Rhetoric, Argument, and Demonstration in Design Practice." *Design Issues* 2, no. 1 (1985): 4–22.

DUBOIS, JACQUES *et al. Allgemeine Rhetorik.* München, 1974.

EHSES, HANNO. "Design and Rhetoric: An Analysis of Theatre Posters." *Design Papers* 4 (1986): 1–36.

HEINEN, ULRICH. "Bildrhetorik der frühen Neuzeit – Gestaltungstheorie der Antike: Paradigmen zur Vermittlung von Theorie und Praxis im Design," in *Design als Rhetorik: Grundlagen, Positionen, Fallstudien,* edited by GESCHE JOOST and ARNE SCHEUERMANN. Basel: 2008.

JONAS, WOLFGANG. "Systems Thinking in Industrial Design." *Proceedings of System Dynamics.* Cambridge, Mass.: 1996, 241–244.

JOOST, GESCHE and ARNE SCHEUERMANN. "Design as Rhetoric. Basic Principles for Design Research." In *Drawing New Territories,* edited by *Swiss Design Network.* Zürich: 2006.

JOOST, GESCHE and ARNE SCHEUERMANN, eds. *Design als Rhetorik: Grundlagen, Positionen, Fallstudien.* Basel: 2008.

KINROSS, ROBIN. "The Rhetoric of Neutrality." *Design Issues* 2, no. 2 (1985): 18–30.

KOLB, DAVID A. *Experiential Learning: Experience as the Source of Learning and Development.* Upper Saddle River, N.J.: 1984.

KRIPPENDORFF, KLAUS. *The Semantic Turn: A New Foundation for Design.* Boca Raton: 2006.

SCHÖN, DONALD A. *The Reflective Practitioner: How Professionals Think in Action.* London: 1983.

ABSTRACT+
COMMENTS

How to Choose Methods for Researching Design Methods: The Impact of Narrative Scenarios on Design Processes and Products

Christian Wölfel

Summary

There is a long tradition of doing research on design methods and methodology (see e.g. CROSS 1984; BÜRDEK 2005). Due to changing demands for products, changing technology and organizational constraints on design processes, design methods continue to underlie persistent development (see e.g. CLARKSON and ECKERT 2005).[1]

During decades of research on design methods, no overall agreement about a consistent research methodology has been reached. In accordance with the richness of design research, there are different research approaches to the investigation of design methods (see e.g. conferences and other events of the *Design Research Society* and *The Design Society*). These research methods must be discussed within a PhD thesis concerning design methods. Since research methods are more or less means of working, they should be selected rather pragmatically.

Within this paper, a distinct example of research on design methods will be used to discuss criteria for the selection of appropriate research methods within a PhD work. Starting with a rough description of the research problem, the development of certain design methods will be presented in order to derive a research

question from them. The second part of the paper will emphasize the core of this contribution, namely the possibilities of conducting scientific research about design methods correlating with concrete hypotheses.[2] This should be the main topic of the discussion at the *Questions & Hypotheses* Conference concerning this paper.

Developing design methods

It is largely undisputed that knowledge plays a central role in product development. There is, however, no agreement about which kinds of knowledge are relevant for the disciplines involved. Industrial Designers seem to require a special kind of knowledge at the beginning of a design process. This has been observed when analyzing industrial design projects completed by novice design students whose industrial design education comes after an engineering curriculum. Observation shows that some students have difficulties acquiring knowledge at the start of the design process. We assume that these are problems of activation rather than inherent problems, as the major source of knowledge in the design process is the designer himself (e.g. GOEL 1995; LAWSON 2004, 2006). He must, however, be able to activate and use this source. Awareness about this problem leads us to consider facilitating methods, looking for design methods which support the acquisition of the "right" knowledge for the industrial design process. In order to develop methods for this purpose, we have defined criteria which help to distinguish industrial design knowledge from other types of knowledge (in the process of interdisciplinary product development and in particular from engineering knowledge).[3] We examined prescriptive object knowledge (VAN AKEN 2005), which is needed at the start of the industrial design process, and determined the following criteria:

— It is not known at the very beginning of the design process (see JONAS 2004; HACKER and SACHSE 2006). The whole design process is a process of knowledge acquisition. It is completed when the process is complete, when the design knowledge then lies in the design result.

01—This is so, despite the decline of design methodology research as characterized by Bonsiepe (2009). 02—One issue that arose in the discussion was the need for a clear distinction between research methods, design methods and methods for researching design methods. In some cases this can not easily be done. 03—This is an important part of the theoretical framework for further research.

— It must be acquired from
 — prior (and experiential) knowledge (see SCHÖN 1983; HACKER and SACHSE 2006; LAWSON 2004; DIXON and O'REILLY 2002).
 — Episodic and factual knowledge (see UHLMANN and SCHULZE 2007, 2008; VISSER 1995)
 — Socio-cultural and everyday knowledge (see LAWSON 2004; VISSER 2006; STRICKFADEN 2006)
— It is implicit and tacit (NONAKA and TAKEUCHI 1995; RUST 2004)
— It is objective, subjective and emotional (PRESS and COOPER 2003; BUDD et al. 2003; UHLMANN 2005).

We then used these criteria among others (regarding e.g. organizational matters) to examine methods of knowledge acquisition in order to develop a tool which enables novice designers to acquire a "starters kit" of object design knowledge. From the huge variety of methods available for product development and design (see LINDEMANN 2007) and knowledge management (REINMANN and MANDL 2004), we chose storytelling (THIER 2006) and scenario-based methods (RINGLAND 2006), combined and modified for our purposes.[4] The tool is centred around is a set of narrative scenarios (see e.g. GASSNER and STEINMÜLLER 2006) based on the relationship between prototypical target-group members and the objects to be designed. The tool also consists of basic brainstorming and writing techniques for the development and verbal and visual mood allegories for the analysis of the narrative scenarios.

This tool and its single methods have been seen before in one form or another in product development as well as industrial design education and practice. However, the analysis of the problem described above finally led to the adaption and combination of these methods, resulting in the specific tool which helps novice designers to acquire the "right" knowledge. We successfully incorporated this tool into our education program and into industrial design workshops for engineers. However, we do not yet know whether the novices only feel better (more contended, confident, etc.) or whether they have indeed improved their knowledge acquisition or even their design processes and design results.

Investigating design methods

The feelings of designers, for instance their self-confidence throughout the process, may be one reason to advocate the application of certain design methods. Thus, if our purpose is to steadily develop and improve design processes, we must investigate which design methods affect designers and processes more deeply, and how they do that.

The opportunities to investigate design methods are diverse, which leads to the unavoidable necessity of narrowing down the choices. There are many questions that would be interesting to answer, but within a PhD thesis, only a rather small section can be accomplished, as there is just one person that must do the work within a limited time frame. There is thus the need for precise criteria to select the right opportunity and the right research methods for the investigation on design methods.[5]

04—These methods are widely considered as being appropriate for the acquisition of knowledge comprising most of the characteristics described above. 05—The presentation at the conference concerned the content of the

original abstract. In addition to that, further thoughts on general ways of selecting appropriate research methods

There are three main fields from which such criteria can be derived:

— The research problem and research questions, as far as these have been formulated

— Guidelines on research methods,[6] unfortunately not available from one source for design research[7]

— Organizational boundaries such as time frame, number of available test persons, etc.

Within the presentation at the *Questions & Hypotheses* Conference I elaborate on these three topics with concrete criteria concerning the research project described above.[8]

for the investigation of design methods have been implemented. These thoughts are explained in the final chapter of the full paper in this book. The aim of the author was to discuss strategies for selecting research methods to use in the investigation of design methods in general at the conference, rather than talking about the particular research problem stated in the abstract. 06—In the conference presentation, the author named research methodologies of engineering design and psychology. The use of these two scientific disciplines is related to the institutional background and research involvement of the author. However, if a design researcher is going to look for appropriate research

methods from other disciplines, s/he must be aware of the nature of the research problem. The research problem as stated above is more or less an educational problem. Following that, educational research methods must be considered. **07**—In any case most research methods are borrowed from other disciplines, whether applied to design or research problems. **08**—Thus I also do so in the full paper in this book.

FINAL PAPER

—

Narrative Scenarios in Industrial Design Processes: Selecting Opportunities for the Investigation of Design Methods

Christian Wölfel

Abstract

There is a long tradition of conducting research on design methods and methodology reaching back more than fifty years (see CROSS 1984; BÜRDEK 2005). Despite the fact that methodological research in design seems to be declining (BONSIEPE 2007) due to changing demands for products, changing technology and organizational constraints on design processes, design methods continue to underpin persistent development (see CLARKSON and ECKERT 2005).

During decades of research on design methods, no overall agreement about a consistent research methodology has been reached. In accordance with the richness of design research, there are various research approaches available for use during the investigation of design methods. The differences result from different traditions, paradigms and constraints from different research institutions, disciplines and national contexts. Current design research ranges from philosophical interpretation to experimental validation. Within a PhD thesis concerning design methods, these different research approaches and related investigative methods must be discussed. Research methods are nothing more and nothing less than a means of researching within the limited frame. Thus, they should be selected carefully but also efficiently.

The aim of the conference submission was to discuss criteria for the selection of appropriate research methods for PhD thesis. For this purpose, a distinct example of research on design methods has been illustrated. Starting with a rough description of the original research problem, the development of certain design methods will be discussed in order to derive a research question. The second part of the paper will emphasize one example of scientific research on design methods and the selection of appropriate methods for empirical investigation on design methods.

Research context

That knowledge plays a central role in product development is largely undisputed. There is, however, no agreement about which kinds of knowledge are relevant to the disciplines involved. Industrial Designers seem to require a special kind of knowledge at the beginning of a design process. This has been observed by analyzing industrial design projects completed by novice design students whose industrial design education is preceded by an engineering curriculum. Observation shows that some students have difficulties acquiring knowledge at the start of the design process. As a result, many students struggle with the creation of industrial design concepts. We assume that these are problems of knowledge activation rather than problems of lacking knowledge, as the major source of knowledge used in the design process is the designer himself

(GOEL 1995; LAWSON 2004, 2006). A (novice) designer must, however, be able to activate and use this knowledge source. Awareness of this problem leads us to consider facilitating methods, looking for design methods which support the acquisition of the "right" knowledge for the industrial design process.

Theoretical framework for further investigation

In order to develop methods for this purpose, we defined criteria which help to distinguish industrial design knowledge from other knowledge, in particular from engineering knowledge. We were looking at prescriptive object knowledge (VAN AKEN 2005), which is needed at the start of the industrial design process (WÖLFEL and PRESCHER 2008; WÖLFEL 2008). We decided on the following criteria:

— The problem is not known at the very beginning of the design process (see JONAS 2004; HACKER and SACHSE 2006). The whole design process is a process of knowledge acquisition. It is completed when the process has been finished, when the design knowledge then lies in the design result.

— It must be acquired from:

> — Prior (and experiential) knowledge (see SCHÖN 1983; DIXON and O'REILLY 2002; LAWSON 2004; HACKER and SACHSE 2006)
>
> — Episodic and factual knowledge (VISSER 1995; UHLMANN and SCHULZE 2007, 2008)
>
> — Socio-cultural and everyday knowledge (LAWSON 2004; STRICK-FADEN 2006; VISSER 2006)

— It is implicit and tacit (NONAKA and TAKEUCHI 1995; RUST 2004)

— It is objective, subjective and emotional (PRESS and COOPER 2003; UHLMANN 2005; SCHIFFERSTEIN and HEKKERT 2008)

However, these concepts not only match industrial design knowledge, but also knowledge in general. Referring to the research context described above, the differences from engineering knowledge must still be outlined. Ignoring psychological research on engineering design, for instance most theoretical and educational frameworks of engineering design (e.g. PAHL *et al.* 2007) do not consider experiential, episodic, socio-cultural, everyday, subjective and emotional knowledge.

We then used these concepts among others (regarding e.g. organizational matters) to examine methods of knowledge acquisition in order to develop a tool which would help novice designers acquire a "starter's kit" of object design knowledge. From the huge variety of methods available for product development and design (see HUGENTOBLER et al. 2004; LINDEMANN 2007; CHOW and JONAS 2009) and knowledge management (REINMANN and MANDL 2004), we chose storytelling (THIER 2006) and scenario-based methods (RINGLAND 2006), as these are widely considered as appropriate ways to improve knowledge acquisition which involves most of the characteristics described above. In other words, these methods can be used to acquire experiential, tacit, episodic, socio-cultural, subjective and emotional knowledge. We then combined and modified the methods for our purposes. The resulting tool is a set of narrative scenarios (see GASSNER and STEINMÜLLER 2006) based on the relationship between prototypical target-group members – Personas (see COOPER 2004; COOPER et al. 2007) – and the objects to be designed. The tool also consists of basic conventional brainstorming and writing techniques for the development of the narrative scenarios, as well as verbal and visual mood allegories for its analysis. The students create three members of the chosen target-groups including names, biographies, feelings, etc. Based on this, they create user stories, which describe an average day of the persona including their contact with the objects that are being designed. Finally, mood images and tags are extracted from the stories, serving as a basis for the development of industrial design concepts.

This tool and its methods have been seen before in one or another form in product development as well as industrial design education and practice (see the references given above). However, the analysis of the problem described above finally led to these methods being adapted and combined, resulting in the specific tool which helps novice designers acquire the "right" knowledge in a systematic way. We successfully incorporated this tool in our education program and into industrial design workshops for engineers and novice designers. However, at this point we do not know whether the novices just feel better

(more contended, confident, etc.) or whether they have indeed improve their knowledge acquisition or even their design processes and design results.

Choosing appropriate research methods for empirical investigation

The feelings of designers, for instance their self-confidence throughout the design process, may be one reason to advocate the application of certain design methods. But if our purpose is to steadily develop and improve design processes, we must continue to investigate whether design methods affect designers and processes, and if so, then how. One rather general research question is: What impact does the narrative scenarios tool have on design processes and products in our industrial design education program?

The opportunities to investigate design methods are diverse, which leads to the unavoidable necessity of narrowing down the choices. There are many questions that would be interesting to answer, but within a PhD thesis, only a rather small section can be accomplished, as there is just one person that must do the work within a limited time frame.

Compendiums and handbooks on research methods are unfortunately not available from one source for design research. Considering the diversity of design research and design in general, this is not surprising. There are, however, compendiums on research methodology from other research disciplines, which can be applied to design research in various cases. The research problem described in this paper is fundamentally an educational one. The PhD research consists of the development of a theoretical framework as well as the development and evaluation of design methods. The empirical investigation is about evaluating design methods within education. According to this, evaluation methods from pedagogy and educational psychology will be considered. To give one example, the handbook "Research and Evaluation in Education and Psychology" (MERTENS 2005) offers advice on selecting appropriate investigation strategies and methods. However, such

advice can rarely be put into design contexts without being revised. Recently, a revised handbook for engineering design research has been published by BLESSING & CHAKRABARTI (2009). One goal of the book is to give assistance to PhD researchers. Despite the focus on engineering design, a large part of the advice given in this handbook can also be applied to industrial design research.

Usually, the methods of investigation that are advocated in research handbooks can not be applied in PhD research settings. **Organizational boundaries** such as research project partners, time frames or the number of available test persons heavily influence the choice of investigation methods. At our faculty, there are only about 50 industrial design students. The narrative scenarios tool is now part of the first educational industrial design project, which is done by about 10 students each year. Furthermore, we complete industrial workshops involving this tool with about 30 engineering students at two universities each year. These students can be considered as test persons insofar as they are treated fairly during the investigations. The rather small number of test persons narrows down the choice of methods for any kind of investigation on the impact of the narrative scenarios tool described above. Thus, the study will incorporate qualitative research methods to complement quantitative methods. Such mixed method research settings have gained more support alongside theoretical background in the recent years (see MAYRING *et al.* 2007).

The research problem and related general questions have been described above. Depending on the research aim, particular research questions and hypotheses must be formulated. The application of the narrative scenarios tool aims to achieve an improvement of the novice student's design processes and results. In order to determine if such an improvement occurs, measurable criteria must be selected.

Formative evaluation is easily carried out by investigating relevant criteria like personal motivation, self-confidence, etc. by standardized questionnaires. However, better arguments for further application of the narrative scenarios tool can be derived from summative evaluation, i.e. the measurement of any improved outcome.

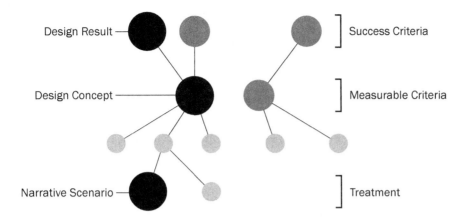

Figure 1: Application of the Network of Influencing Factors according to the model of BLESSING *&* CHAKRABARTI *(1999) to the general research question*

Given that it is almost impossible to measure the quality of industrial design results, one approach would be to apply expert assessments, which are common in psychological research, on engineering design. In recent studies, however, we have found that this approach does not provide valid results when applied to industrial design in our settings (PRESCHER 2008; WÖLFEL and PRESCHER 2008). The main problem is the need for correlation between different expert assessors, which is hard to get since aesthetic judgments always incorporate subjective and emotional values in addition to other knowledge and depend on personal experience and background of the assessor. One way to overcome these issues could be a very high number of test persons and assessors, which could be integrated into research through online surveys as has been done recently by various design researchers. However, online surveys are hard to control and the results must be interpreted with care.

Furthermore, there are many uncontrollable variables relating to the narrative scenarios tool and the design results, considering that the design projects that were investigated cover more than just a few hours. Thus, other criteria must be found. Clarifying the Network of Influencing Factors according to BLESSING & CHAKRABARTI (1999, 2009) exposes connections between success and measurable criteria. In our case, the correlation between design concepts and design results has

been described by ULRICH & EPPINGER (2003) and KRZYWINSKI (2009), among others. Thus, measuring the criteria of design concepts can be appropriate (see *Figure 1*). Such criteria can be formal, like length of time taken for development and number of concepts, or summative, like completeness of the concepts according to certain categories.

The application of the Network of Influencing Factors model helps narrow down the choice of research opportunities and thus the choice of methods used to investigate the impact of the narrative scenarios tool. A more specific research question is this: Does the narrative scenarios tool improve the completeness of design concepts in first educational design projects?

Some results

The investigation has been carried out as a ex-post-facto study under field conditions. Long term projects of two industrial design student groups have been analyzed by observation, standardized questionnaires and qualitative content analysis of the design results and documentations written by the novice students (see KRIPPENDORFF 2004; MAYRING and GLÄSER-ZIKUDA 2005). One student group *(n=10)* was guided through the development and analysis of narrative user scenarios as described in the third chapter of this paper, while the other group *(n=13)* was not; they served as a control group. The control group did apply the narrative scenarios tool in a second project.

While motivation, self-confidence, consciousness and other subjective criteria were examined, the focus was on the acquired knowledge and compiled industrial design concepts. Design concepts are concentrated descriptions of the aim of the design process, "determining the identity and character of the object" to be designed (KRZYWINSKI *et al.* 2009). Design concepts are mainly based on the knowledge acquired in the first phase of the design process. We analyzed the completeness of the design concepts by locating content about organization, technology and user experiencing. As would be expected given the engineering background of the students, organizational and technical aspects were found in most cases, whereas the design concepts often lacked aspects of user

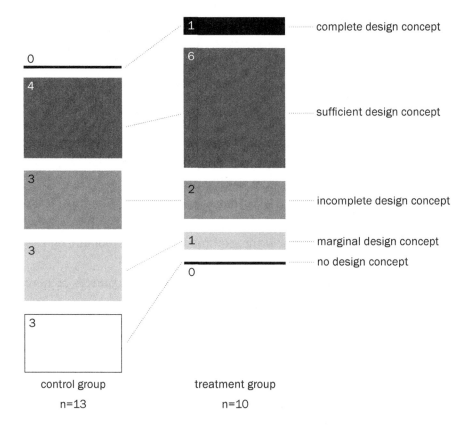

1 complete design concept

6 sufficient design concept

4

3

2 incomplete design concept

3

1 marginal design concept

0 no design concept

3

control group
n=13

treatment group
n=10

Figure 2: comparison of the completeness of design concepts in treatment and control group

experience, especially in the control group. Despite the limited number of test persons, the differences in terms of acquired knowledge are statistically significant (t-test, technical aspects: $p < 0.01$, aspects of user experiencing: $p < 0.01$). The impact of the development and analysis of narrative scenarios on the completeness of the industrial design concepts is graphically illustrated in *Figure 2*. However, statistical significance could not be proven (median test, $p = 0.29$). This means that there is no evidence that the differences are not merely caused by coincidence. Interestingly, the correlation between the knowledge acquired regarding user experience and the completeness of the design concepts is statistically significant (SPEARMAN's rank correlation coefficient, $p = 0.038$).

Conclusion and outlook

The narrative scenarios tool is now well integrated and accepted in our education program. The preliminary results of the study justify applying it not only in education, but also in professional settings where designers and non-designers work in teams.

There is growing interest in user-centered design methods in various disciplines involved in product development. This opens up new opportunities for investigations on such design methods. However, the tool must be refined. Further development will involve comparing it to similar user-centered design methods as well as integrating additional supporting methods in order to achieve better comprehension and guidance, since until now the explanation for the tool during the workshops is not satisfying.

The example shown in this paper illustrates one example of how research methods for the investigation of (new) design methods can be chosen by the systematic criteria. If such selection is part of PhD research, further support is always necessary. This is even more so if universal compendiums are not available. The selection of methods for investigation on design methods depends on the situation and interest of the researcher among other conditions. In conclusion, it can be said that many criteria for the selection of appropriate research methods can be derived from the research problem and research question (as far as formulated), from organizational boundaries and from relevant compendiums or manuals. However, there remains a demand for a compendium of methods for the investigation of design methods. Such a compendium might be rather general and unspecific but it could guide the researcher and refer to further, more specific compendiums.

References

BLESSING, L. T. M., and A. CHAKRABARTI. *A Design Research Methodology.* London, Berlin, Heidelberg, New York, Barcelona, Hong Kong, Milan, Paris, Santa Clara, Singapore, Tokyo: Springer, 1999.

BLESSING, L. T. M., and A. CHAKRABARTI. *DRM, A Design Research Methodology.* Dortrecht, Heidelberg, London, New York: Springer, 2009.

BONSIEPE, G. "The Uneasy Relationship Between Design and Design Research," in *Design Research Now: Essays and Selected Projects,* edited by R. MICHEL. Basel: Birkhäuser, 2007.

BUDD, J., R. TAYLOR, R. WAKKARY, and D. EVERDEN. "From Industrial Design to Experience Design: Searching for New Common Ground," in *ICSID 2nd Education Conference. Critical Motivations and New Dimensions,* edited by IF INTERNATIONAL FORUM DESIGN GMBH. Hannover: iF International Forum Design, 2003.

BÜRDEK, B. E. *Design: History, Theory and Practice of Product Design.* Basel: Birkhäuser, 2005.

CHOW, R., and W. JONAS. "Beyond Dualism in Methodology: An Integrative Design Research Medium 'MAPS' and some Reflections," in *Undisciplined!: Proceedings of the Design Research Society Conference 2008,* edited by D. DURLING, C. RUST, L.-L. CHEN, P. ASHTON, and K. FRIEDMAN. Sheffield: Sheffield Hallam University, 2009.

CLARKSON, J., and ECKERT, C., eds. *Design Process Improvement: A Review of Current Practice.* London: Springer, 2005.

COOPER, A. *The Inmates Are Running the Asylum.* Sams, 2004.

COOPER, A., R. REIMANN, and D. CRONIN. *About Face 3: The Essentials of Interaction Design.* Indianapolis: Wiley, 2007.

CROSS, N., ed. *Developments in Design Methodology.* Chichester: Wiley, 1984.

DIXON, P., and T. O'REILLY. "Appearance, Form, and the Retrieval of Prior Knowledge," in *Design and the Social Sciences. Making Connections,* edited by J. FRASCARA. London: Taylor & Francis, 2002.

GASSNER, R., and STEINMÜLLER, K. "Narrative normative Szenarien in der Praxis," in *Szenariotechnik: Vom Umgang mit der Zukunft,* edited by F. E. P. WILMS. Bern: Haupt, 2006.

GOEL, V. "Sketches of Thought." *A Bradford Book.* Cambridge, Mass.: MIT Press, 1995.

HACKER, W., and P. SACHSE. "Entwurfstätigkeiten und ihre psychologischen Unterstützungsmöglichkeiten," in *Wirtschafts-, Organisations- und Arbeitspsychologie,* edited by U. KONRADT, B. ZIMOLONG, and DEUTSCHE GESELLSCHAFT FÜR PSYCHOLOGIE. Ingenieurpsychologie 2. Göttingen: Hogrefe, 2006.

HUGENTOBLER, H. K., W. JONAS, and D. RAHE. "Designing a Methods Platform for Design and Design Research," in *Futureground: Design Research Society International Conference 2004*. Melbourne: Monash University, 2004.

JONAS, W. "Mind the Gap!: On Knowing and Not-Knowing in Design." 2004. *www.thebasicparadox.de* (accessed October 12, 2007).

KRIPPENDORFF, K. *Content Analysis: An Introduction to Its Methodology*. Thousand Oaks: Sage, 2004.

KRZYWINSKI, J. "Design Concept Development in Transportation Design," in *Undisciplined!: Proceedings of the Design Research Society Conference 2008*, edited by D. DURLING, C. RUST, L.-L. CHEN, P. ASHTON, and K. FRIEDMAN. Sheffield: Sheffield Hallam University, 2009.

KRZYWINSKI, J., C. WÖLFEL, and F. DRECHSEL. "Experience Concept as a Tool for Fuzzy Front-End in *Engineering* Design." ICED'09 International Conference on Engineering Design 2009, Stanford.

LAWSON, B. *What Designers Know*. Oxford: Elsevier Architectural Press, 2004.

LAWSON, B. *How Designers Think: The Design Process Demystified*. Oxford: Elsevier Architectural Press, 2006.

LINDEMANN, U. "Methodische Entwicklung technischer Produkte: Methoden flexibel und situationsgerecht anwenden." 2nd ed. VDI. Berlin: Springer, 2007.

MAYRING, P., and M. GLÄSER-ZIKUDA, eds. *Die Praxis der qualitativen Inhaltsanalyse*. Weinheim: Beltz, 2005.

MAYRING, P., G. L. HUBER, and L. M. GÜRTLER, eds. *Mixed Methodology in Psychological Research*. Rotterdam, Taipeh: Sense Publishers, 2007.

MERTENS, D. M. *Research and Evaluation in Education and Psychology: Integrating Diversity with Quantitative, Qualitative, and Mixed Methods*. 2nd ed. Thousand Oaks, CA: Sage Publications, Inc., 2005.

NONAKA, I., and H. TAKEUCHI. *The Knowledge-Creating Company: How Japanese Companies Create the Dynamics of Innovation*. New York: Oxford Univ. Press, 1995.

PAHL, G., W. BEITZ, L. BLESSING, J. FELDHUSEN, K.-H. GROTE, and K. WALLACE, eds. *Engineering Design: A Systematic Approach*. 3rd ed. London: Springer-Verlag London Limited, 2007.

PRESCHER, C. "Training von Umgang mit Wissen im Designprozess: Zur Beurteilung von Entwurfsergebnissen," in *Industriedesign und Ingenieurwissenschaften: Technisches Design in Forschung, Lehre und Praxis,* edited by N. HENTSCH, G. KRANKE, and C. WÖLFEL. Dresden: TUDpress, 2008.

PRESS, M., and R. COOPER. *The Design Experience: The Role of Design and Designers in the Twenty-First Century.* Aldershot: Ashgate, 2003.

REINMANN, G., and H. MANDL, eds. *Psychologie des Wissensmanagements: Perspektiven, Theorien und Methoden.* Göttingen: Hogrefe, 2004.

RINGLAND, G. *Scenario Planning: Managing for the Future.* 2nd ed. Chichester: Wiley, 2006.

RUST, C. "Design Enquiry: Tacit Knowledge and Invention in Science." *Design Issues* 20, no. 4 (2004): 76–85.

SCHIFFERSTEIN, H. N. J., P. HEKKERT, eds. *Product experience.* Amsterdam: Elsevier, 2008.

SCHÖN, D. A. *The Reflective Practitioner: How Professionals Think in Action.* New York: Basic Books, 1983.

STRICKFADEN, M. *(In)tangibles: Sociocultural References in the Design Process Milieu.* Doctoral Thesis, Napier University. Edinburgh: Napier University, 2006.

THIER, K. "Storytelling: Eine narrative Managementmethode." *Arbeits- und organisationspsychologische Techniken.* Heidelberg: Springer Medizin, 2006.

ULRICH, K. T., and S. D. EPPINGER. *Product Design and Development.* 3rd ed., Internet ed.. Boston: McGraw-Hill, 2003.

UHLMANN, J. *Die Vorgehensplanung Designprozess für Objekte der Technik: Mit Erläuterungen am Entwurf eines Ultraleichtflugzeuges.* Dresden: TUDpress, 2005.

UHLMANN, J., and E.-E. SCHULZE. "Evaluation of Design Knowledge: Empirical Studies and Application of the Results in Product Design Education," in *ConnectED International Conference on Design Education 2007.* Sydney: 2007.

UHLMANN, J., and E.-E. SCHULZE. "Investigations into the Data Basis of Design Knowledge in Industrial Design Engineering," in *Proceedings of the DESIGN 2008. 10th International Design Conference,* edited by

D. MARJANOVIĆ, M. ŠTORGA, N. PAVKOVIĆ, and N. BOJČETIĆ. Dubrovnik: University of Zagreb, 2008.

VAN AKEN, and J. ERNST. "Valid Knowledge for the Professional Design of Large and Complex Design Processes." *Design Studies* 26, no. 4 (2005): 379–404.

VISSER, W. "Use of Episodic Knowledge and Information in Design Problem Solving." *Design Studies* 16, no. 2 (1995): 171–187.

VISSER, W. *The Cognitive Artifacts of Designing.* Mahwah, New Jersey: Lawrence Erlbraum Associates, 2006.

WÖLFEL, C. "How Industrial Design Knowledge Differs from Engineering Design Knowledge," in *New Perspectives in Design Education* 1 (2008): 222–227, edited by A. CLARKE, M. EVATT, P. HOGHART, J. LLOVERAS, and L. PONS. Barcelona: Institution of Engineering Designers; The Design Society, 2008.

WÖLFEL, C., and C. PRESCHER. "A Definition of Design Knowledge and its Application to two Empirical Studies," in Swiss Design Network (Ed.): *Focused – Current Design Research Projects and Methods. Swiss Design Network Symposium Berne 2008.* Genève: Swiss Design Network, 2008.

SPECIAL
ARTICLES

Alain Findeli

Searching For Design Research Questions: Some Conceptual Clarifications

1. Mode, purpose, subject-matter and structure of the paper

The dominant tone of this paper is speculative and didactic. Speculative, since it does not rely on recent empirical research or field work; didactic in order to be in tune with the general framework of this conference and its presumed audience. As a result, the style has remained in some respects that of an oral presentation. As to the purpose of the paper, it

stems from the observed reactions to some previous published works on the same topic, namely design research methodology and education.[1] Some of the key concepts coined in these works seem to lack clarity, with the consequence that the resulting epistemological and methodological models suffer from misunderstanding and misinterpretation. For this reason, I considered that it would not be superfluous to re-frame these concepts and try to increase their intelligibility and, consequently, their usefulness in actual research situations.

The title of the paper directly mirrors the theme of our conference. In effect, this keynote lecture has been configured like a design proposal, i.e. as a hopefully adequate answer to a design brief; the brief in this case being the *Call for Papers,* more specifically its "Why" section. From this section, I mainly retained the aim of being student-centered and the wish to promote "rigor in conceptualizing," especially in "formulating research questions," since "it is questions and ideas that give meanings and values to meticulously executed research."

The structure of the paper into two main parts is contained in its main title. First we will focus on the concept of *design research,* with the promise (made in Bern) that there will be no direct or explicit reference to FRAYLING's categories. The issue of what a *research question* is or should be will then be addressed, so that the following general questions may be answered: 1) Are design research questions very different from other discipline's research questions? and 2) Is design research such a special case of research? In the conclusion, a general operational model of Project-Grounded Research in design will be presented.

1 Reference is made here to the following publications: A. FINDELI. "Die projektgeleitete Forschung: eine Methode der Designforschung," in *Erstes Designforschungssymposium,* edited by R. MICHEL. Zurich: SwissDesignNetwork, 2005, 40–51; A. FINDELI, and R. BOUSBACI. "L'éclipse de l'objet dans les théories du projet en design." *The Design Journal* 8, no. 3 (2005): 35–49. (with a long English abstract); A. FINDELI, and A. COSTE. "De la recherche-création à la recherche-projet: un cadre théorique et méthodologique pour la recherche architecturale." *Lieux Communs* 10 (2007): 139–161; A. FINDELI, D. BROUILLET, S. MARTIN, CH. MOINEAU, and R. TARRAGO. "Research Through Design and Transdisciplinarity: A Tentative Contribution to the Methodology of Design Research," in *Focused – Current design research projects and methods,* edited by B. MINDER. Bern: SDN, 2008: 67–94.

2. Scope and stance: Another definition of design research

"Oh no, not another endless and useless discourse on the definition of design research!" – such may be the expected reaction to my proposal of redefining the field. This is fair enough, but the reason for such an apparently obstinate initiative is that I believe we, in our design research community, are using a somewhat restricted definition of the term. In other words, although I do agree with the members of the Board of International Research in Design that "it is no longer sufficient to merely indulge in either general or specific meta-discussions on methodologies or even on the fundamental question as to whether design is at all qualified to undertake research,"[2] I also warn that, bearing with the metaphor of the pudding used by the authors, it is hazardous to look for a proof in the pudding by eating it if it is the wrong pudding that is being served. My remark is meant as a reminder that epistemological vigilance (e.g. to make sure we have the right pudding) is indeed always to the point, as it is – or should be – the rule in other areas of research.

Now why do I find it necessary to open this issue once again? Why am I not satisfied (I actually am) with the acknowledgment that "what is needed now is the publication of relevant *results* from design research,"[3] or, to take another recent example, with the current state of the art of design research as reported in a book like *Design Research Now?*[4] The reason, as will be argued shortly, is that we in the design research community have built our collective design research enterprise on a misunderstanding. The statement of intentions and intellectual program of those we consider, with full right, the pioneers of design research, were so convincingly spelled out that we have followed them ever since in full trust, with an enthusiastic and almost uncontested unanimity.

Let me be more precise. There seems to be a common agreement, in our community, around BRUCE ARCHER's definition of design research and NIGEL CROSS' search for a rigorous and compelling definition of his

2 BIRD, "Transition and Experience as Perspectives of Design Research." Foreword to U. BRANDES, S. STICH, and M. WENDER. *Design by Use.* Basel: Birkhäuser, 2009: 4.
3 *Ibid.,* my emphasis.

4 R. MICHEL, ed. *Design Research Now.* Basel: Birkhäuser, 2007. For a review of this title, read D. DURLING in *Design Studies* 30 (2009): 111–112.

famous "designerly way(s) of knowing." As reported by GUI BONSIEPE and many others in 1980 at the "Design: Science: Method" conference, BRUCE ARCHER mentioned in his talk the following definition: "Design Research is a systematic search for and acquisition of knowledge related to design and design activity."[5] The scientific validity of such a general statement can be checked by replacing "design" with any other discipline, for instance: "Economic research is a systematic search for and acquisition of knowledge related to economics and economic activity." If there is anything problematic with this definition, it lies with the definition of design one adopts. In this context, design is understood as the activity performed by designers.

The same holds, apparently, for NIGEL CROSS' "Designerly way(s) of knowing." Looking closer at this central concept, one finds out, first, that CROSS alternatively refers to designerly ways of "knowing," "thinking" or "acting." As far as I know, he never discussed if he referred to the same epistemic idea of "designerly" in all three cases, a task which would be of undeniable interest for the community. Nor does he explain why he alternately uses the plural or the singular. My intent here being mainly epistemological, I will proceed with the designerly way of *thinking* and try to characterize it further. For commodity reasons, I will stick to the singular, a conceptual generalization and risk for which I take all responsibility.

—

5 G. BONSIEPE. "The Uneasy Relationship between Design and Design Research," in *Design Research Now*, Op. cit., edited by R. MICHEL: 2007, 27. In fact, BONSIEPE's report of ARCHER's paper is misquoted and misleading. On p. 31 of the original paper, ARCHER writes that he finds the following definition of design research too narrow (notice the exact quote): "Design Research [with "a capital D and R"] is systematic enquiry into the nature of design activity." He discusses instead two other possible definitions composed of the definitions of Design and design, on one hand, and of research ("with or without capital R"), on the other hand. The first one he finds "impossibly broad": "Design Research is systematic enquiry whose goal is knowledge of, or in, the area of human experience, skill and understanding that reflects man's concern with the enhancement of order, utility, value and meaning in his habitat." He is "still uncomfortable with the vagueness of [the] focus" of the second one, even though it "seems to be a better description of the matter which design researchers are actually investigating": "Design Research is systematic enquiry whose goal is knowledge of, or in, the embodiment of configuration, composition, structure, purpose, value and meaning in man-made things and systems." See B. ARCHER. "A View of the Nature of Design Research," in *Design, science, method, proceedings of the 1980 Design Research Society Conference*, edited by R. JACQUES, and J. POWELL. Guildford: Westbury House, 1981: 30–47.

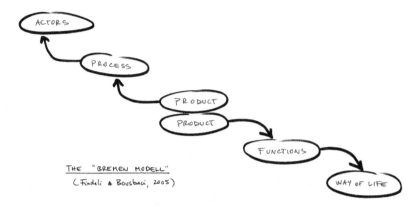

Figure 1: The so-called "Bremen Modell," a model of a general theory of the design project (FINDELI & BOUSBACI 2005)

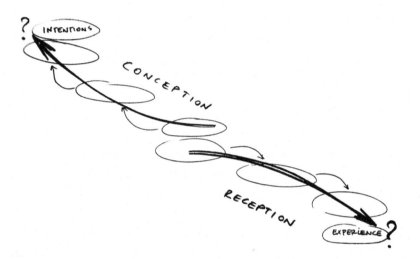

Figure 2: The Bremen Modell with emphasis on the two main moments or constituents of a design project.

Indeed – and this is the important point – what CROSS is interested in is the designerly way of thinking *in design,* i.e. in the specific logics and thought processes that designers adopt, individually or collectively, when doing design. In his view, the purpose of design research is then to observe, model, describe, theorize and/or predict these processes in order, for instance, to show their specificity when compared to thought processes in other situations than design situations.

By no means do I mean thereby that CROSS' intellectual and scientific program is irrelevant. There is plenty of evidence in the published literature and in the design studios that this endeavor has proven fruitful and valid. However, as we have shown in the article where the so-called *Bremen Modell* is introduced and discussed (*Fig. 1*),[6] the "conception" part is only one of the two main moments or constituents of a design project, the "reception" part being the other one (*Fig. 2*). When CROSS uses the term "design," he only refers to the "conception" side, whereas we consider that a model of the design act is incomplete if we do not address what happens to the project's output once it starts its life in the social world. In this regard, the opening up of the generic model of the design project to the user space is indeed one way of extending the scope of design research. As is witnessed by current research, such opening has proven fruitful.

What I contend, however, is that the scope of design research and of the designerly way of thinking can be extended much wider still, beyond the mere framework of design situations. I am interested in investigating the potential of a designerly way of thinking in research in general (not only *in design*), in the same way one might be interested in characterizing sociological, chemical, ethnological or other disciplines' ways of thinking in research, i.e. when striving to know or understand the world. This amounts to considering design as a discipline on its own, capable of delivering valid and trustworthy knowledge about a part of the world considered as its specific field of knowledge. In such a framework, our epistemological inquiry sets the task of determining what the characteristics, the potential, and the blind spots of our designerly way of looking at the world are and what the originality of the corresponding knowledge is. Thus our central question becomes: Does a designerly approach allow design researchers to increase or enrich the intelligibility of the world (or part of it) more or better than other disciplines?

6 A. FINDELI, and R. BOUSBACI. "L'éclipse de l'objet dans les théories du projet en design." *The Design Journal*, Op. cit. A long English abstract summing up the core argument is presented in the introduction of the article.

Now that our task has been set as clearly as possible, we must address the following two sets of questions, corresponding respectively to the *scope* and the *stance* of design research:

1) What is the proper subject-matter of design research? What part of the world may design research claim as being of its concern? To the knowledge and understanding of what phenomena is design research equipped to contribute?

2) How does design behold the world? Do design researchers observe, describe and interpret the world very differently from, for instance, ethnography, demography, economics or engineering researchers? More precisely still: Suppose design researchers are interested in the same phenomenon as the above disciplines (which may often be the case, especially in interdisciplinary research); in which way does their intellectual culture and their "designerly" approach color the phenomenon? Does this "coloring" constitute a hindrance or an asset? Conversely, to which aspects of the phenomenon will design researchers remain blind due to their designerly ways of thinking?

There are enough questions here to fill in a whole PhD project, so I will confine my answers to the essential at the risk of skipping some important and necessary justifications.

2.1 The scope or field of design research

It is generally accepted that the end or purpose of design is to improve or at least maintain the "habitability" of the world in all its dimensions: physical/material, psychological/cognitive/emotional, spiritual/cultural/symbolic. The terminology may vary according to authors, but the idea remains more or less the same.[7] Habitability is best defined

7 The concept of "habitability" was, to my knowledge, first used in the early 1980's by the Italians (BRANZI, MANZINI). Its origin is sometimes attributed to a famous text by HEIDEGGER, *Bauen Wohnen Denken*. HERBERT SIMON's terminology ("To transform a situation into a preferred one") is also quite popular within our community. One could also mention MANZINI's most recent proposal that design should contribute to "enable people to live as they like, while moving toward sustainability." Indeed, within such wide frameworks, more local purposes of design activity may be identified. Examples of such lists may be found in BONSIEPE *(see footnote 5)* or A. FINDELI. "De l'esthétique industrielle à l'éthique: les métamorphoses du design." *Informel* 3, no. 2 (Summer 1990): 72.

in systemic terms: it refers to the interface, interactions and transactions between individual or collective "inhabitants" of the world (i.e. all of us human beings) and the world in which we live (i.e. our natural and artificial environments, which includes the biocosm, technocosm, sociocosm and semiocosm). The discipline that studies these systemic relationships is *human ecology:* "Ecology is the science of relationships between living organisms and their environments. Human ecology is about relationships between people and their environment [...] [It] is useful to think of human-environment interaction as interaction between the human social system and the rest of the ecosystem. The *social system* is everything about people, their *population* and the psychology and social organization that shape´their behaviour."[8] Following such general definitions, who would deny that human ecology constitutes a core knowledge field for design?

The above conclusion brings us back to one of our previous questions: What distinguishes ecologists' and designers' claim that their central field of knowledge is the "relationships between people and their environment?" If there is no difference, then we should conclude that design research is or should be the same as research in human ecology. If there is a difference, then what is it?

In my view, the difference lies in two aspects. The first is anthropological (in the philosophical sense) and would deserve a longer discussion. Due to its rooting in biology, human ecology has a tendency to adopt a contextualist, determinist view of the human being; in this sense, human ecology is but an extension of animal ethology. For the purpose of design, the field of human ecology should be extended to the cultural and spiritual dimensions of human experience, and as a consequence of the human-environment interactions, yet without neglecting the other dimensions. This is why I prefer to speak of a *general* human ecology. Keeping this important reservation in mind and using

8 The definition is taken from a standard textbook: G. MARTEN. *Human Ecology,* London & Sterling, Earthscan, 2001 (emphases in original text). Such a systemic model has first been used to describe what I considered to be the Urmodell (in its Goethean phenomenological sense) of design activity. A. FINDELI. "Design, les enjeux éthiques," in *Sciences de la conception: perspectives théoriques et méthodologiques,* edited by R. PROST. Paris: L'Harmattan, 1995: 247–73.

BRUCE ARCHER's original phrasing as a template, we may redefine design research in the following terms:

> Design research is a systematic search for and acquisition of knowledge related to general human ecology.

The second aspect is epistemological. Design researchers' view of human ecology differs from ecologists' in what can be called their stance, i.e. in the way they look at the human-environment interactions. This important distinction will allow us to complete the above definition.

2.2 The stance or epistemological bent of design research

The aim of human ecologists is to construct a theory of human-environment interactions; their stance is descriptive and mainly analytical. Conversely, the aim of designers is to modify human-environment interactions and to transform them into preferred ones. Their stance is prescriptive and diagnostic. Indeed, design researchers, being also trained as designers – a fundamental prerequisite – are endowed with the intellectual culture of design; they not only look at what is going on in the world (descriptive stance), they look for what is going wrong in the world (diagnostic stance) in order, hopefully, to improve the situation. In other words, human ecologists consider the world as an object (of inquiry), whereas design researchers consider it as a project (of design). Their epistemological stance may thus be characterized as *projective.*

The validity of the ecologists' descriptive/analytical stance derives from the grounding of their models, methods, and conceptual frameworks in their mother science, biology, the scientificity of which no longer needs to be assessed and asserted. But what is the scientific validity of the normative, diagnostic, prescriptive and projective position of design researchers, a stance which requires their subjective involvement? Are we not confronted here with one of the capital sins of scientific inquiry: lack of objectivity? What is indeed the value of a protocol which implies value judgments and includes the possibility that two different researchers will not yield the same conclusion?

Fortunately enough for design researchers, such epistemological scruples are no longer prevalent in the scientific community. Recent developments in human and social sciences have dealt extensively with the issue of objectivity as a possible and desirable horizon in research. The interpretive or hermeneutic turn has shown that objectivity is not a relevant and fruitful criterion for research in those disciplines, and that rigorous inquiry is nevertheless possible without diving into extreme relativism or skepticism. On the other hand, the pragmatist epistemological tradition – where the involvement of the researcher is also required – may also be invoked to propose a robust epistemological framework for design research, not to mention action research (renamed "project-grounded research" in design research) as one of its incarnations in methodological applications.

As a consequence, with the warranty of careful and constant epistemological scrutiny, we may consider that a designerly way of looking at human-environment interactions, i.e. at human experience in terms of general human ecology, is not only a valid but also a valuable epistemological stance. In such conditions, design research has the potential of delivering original and relevant knowledge around the world, according to the following completed definition:

> Design research is a systematic search for and acquisition of knowledge related to general human ecology considered from a designerly way of thinking, i.e. a project-oriented perspective.[9]

9 It is quite important to notice that the project-oriented perspective is not only required in the "conception" constituent of design activity (CROSS' program), but also in its "reception" constituent. It follows that users are not to be considered as mere "receptors" of the output of the design project (product, service, etc.), but as endowed with a project, namely the project of inhabiting the world in a meaningful, comfortable, functional, aesthetic, sustainable, etc. way. The terms "reception" (borrowed from art history and theory) and "users" are somewhat misleading in this respect. In his own way, BERNARD STIEGLER makes a relentless and radical critique of the service economy and its concept of the user. See his website: *www.arsindustrialis.org*.

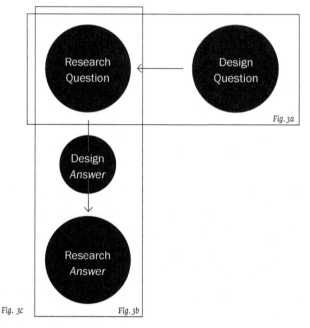

Figure 3a, b, c: Operational and methodological model of a PhD design research.

3. Conclusion: Searching for research questions

If one adopts our redefinition of design research, the issue of the research question becomes more straightforward. For this purpose, the central distinction that needs to be made is between a *research question* and a *design question*. Our final model *(Fig. 3c)* will make this distinction clear by showing how, in a doctoral research situation, these two questions relate to each other.

A simple logical approach may already shed some light on this distinction. One may ask, for instance, if design questions constitute a subset of research questions or vice-versa, if research questions are a subset of design questions.[10] Or one may ask if research questions might

10 RANULPH GLANVILLE has addressed this problem as wittily as usual in various papers. His standpoint is that research situations are a special case of design situations.
GLANVILLE, R. "Why Design Research?" in *Design/Method/Science*, edited by JACQUES, R. and POWELL, J. Westbury House, Guildford, 1981.
GLANVILLE, R. "Variety in Design," *Systems Research* 11, no. 3 (1994).
GLANVILLE, R. "Researching Design and Designing Research," *Design Issues* 13, no. 2 (1999):80–91

be deduced from design questions (my viewpoint, with a reservation on "deduced") or vice-versa (my viewpoint also, with the same reservation). It may be wiser to ask oneself what the relationships between both realms of questioning are, in other words how different such questions "sound" or "taste, " epistemologically and phenomenologically speaking of course. A quicker way to grasp the distinction is to look at how different the *answers* are to these questions. One notices, for instance, that design answers are presented in glossy design magazines with plenty of pictures and in sometimes very chic downtown galleries, whereas research answers are found in academic journals with as few pictures as possible in the typical grey literature and in – sometimes as trendy – academic conferences. More seriously, one could also compare the criteria used to evaluate both types of answers, an exercise that has been carried out quite extensively lately within our research community. At any rate, the distinction needs to be made in order not to confound or reduce a (design) research project with or to a design project.

A steady observation reveals that PhD candidates in design usually tackle their subject matter in the form of a design question. The latter usually originates either from some dissatisfaction in their professional practice, or from the wish to deepen one aspect that has puzzled them in their professional education. This reflex is quite normal, but the next and important step that needs to be made then is to *transform their design question into a research question*. I posit that this is always possible since every design question raises, at least potentially, many more fundamental issues related to human experience in the world or, following our terminology, related to general human ecology. However, it is wrong and unfair to request from PhD candidates that they manage this transformation by themselves; this is the task, indeed the duty, of their supervisors, since in general, the intellectual and disciplinary knowledge and culture acquired by the candidates in their previous education and/or professional experience do not equip them with the necessary competence to switch from the realm of design questions to the realm of research questions. Only research experience and scholarship can provide the necessary intellectual mastery.

As hinted at above, the progression from a design question to a research question is not automatic or deductive. It is a matter of construction, of design. There are usually many potential research questions hidden in a design question, for the simple reason that design deals with the most banal of all phenomena: daily human experience. Who, except designers, is interested in such a prosaic and ordinary subject matter? For their inquiries, human and social sciences have a tendency to choose situations of exceptional and non-ordinary character: chess playing, social deviance, psychological distress, crime, economic crises, exotic cultural practices, etc. The daily life of ordinary humans has only recently raised some interest within academic circles (e.g. consumer studies, ethnography of contemporary societies, history of the present, popular culture, etc.). But this apparent banality of daily human experience conceals a rich complexity, well known by designers who are working in experience, service, or social design. Indeed, every daily human activity (work, going to school, taking a vacation, being at the hospital, going shopping, being retired, etc.) is an entanglement of various interrelated dimensions and values (economic, social, psychological, cultural, geographical, historical, technological, semiotic, etc.), with each dimension being due a systematic inquiry and interpretation. The often proclaimed interdisciplinarity of design and design research and the inherent complexity of design situations is precisely a consequence of that.

An ideal design research question would thus be one that uncovers and emphasizes the complex interdisciplinarity of the specific anthropological experience that is at stake in a design question. In systemic, human ecology terms, we may consider each experience as the consequence of the interaction of two multi-layered systems: the human (individual or collective) and his/her context or environment. A simple combinatory calculation shows that the scope of this complexity is out of reach of the usual conditions in which a PhD must be carried out." A choice has therefore to be made within all the possible research questions, an operation that requires a set of criteria. These are mainly circumstantial and situation-specific: academic setting (a large university with a vast choice of departments and disciplines or an isolated design

institution), personal experience of PhD candidate, scholarship of the supervisor, surrounding research teams and laboratories, expectations of non-academic research partners (private or public), and of course personal inclination and intellectual project of the candidate (and supervisor). These criteria need to be matched with the management constraints of the PhD research project: time, cost, availability of resources, nature of field work, etc. In short, the "search" problem of our title is not so much for the candidate to find a research question at all (there are way too many!), but to make sure to settle for a *good* research question.

Let us take a concrete example from this conference. In a previous presentation, a PhD candidate in architecture with obviously many years of professional experience explained to us that, in social co-housing projects, one of the main obstacles to the realization of the architectural project is mistrust arising between partners and stakeholders. He presented the problem as a very practical architectural question, which has been answered (or not, in the case of failure) diversely according to the singular situations. The presentation was very convincingly supported by slides and documented case studies by the speaker. Considering the wish of this architect to embark upon a PhD project, a possible starting recommendation could be to consider "trust" as his central concept of inquiry. The research question would then need to be worked out appropriately with the designerly (or architectural, in this case) way of thinking in mind. Concretely, this means that the idea is not to question what the concept of trust is or entails in general (a philosophical inquiry), or what mental processes are activated in a situation of trust (a cognitive psychological inquiry),

11 Only considering a threefold anthropological model (physical, psychological and spiritual dimensions of the individual human being) and the previous fourfold partition of the environment (biosphere, technosphere, socio-political sphere, cultural/semiosphere), we are already in the presence of twelve possible binary relationships to investigate, each one being in principle the specific domain of a scientific discipline. The complexity increases when ternary relationships are considered, since the subsystems are not independent from each other. A possible model may be found in *Human Ecology* Op. cit., 2. HERBERT SIMON's somewhat behaviorist model has become an icon in our community. For an even more sophisticated systemic-anthropological approach, see D. BODACK. "Wie beurteile ich Architektur- und Designqualität?" *Mensch+Architektur* 41 (April 2003): 2–15 (with English translation in appendix).

or how the brain reacts to simulations of trust and mistrust (a neuro-biological approach), or else what architectural historians and theoreticians have written on the concept of trust (provided they have), etc. Although all these aspects are indeed important and should ideally be addressed in the research, a more targeted (i.e. designerly) way of approaching the phenomenon could be with the following question: "Which facet of the general phenomenon of trust does an inquiry reveal that is actively engaged in an architectural project?" In other words, we take it for granted that the project-grounded approach to the phenomenon of trust will contribute to the knowledge already provided by other disciplines that have studied the phenomenon of trust (law, ethics, religious studies, social psychology, anthropology, etc.). The title of the dissertation could thus read: "The contribution of architecture (or design) to a theory of trust."

The general model of this approach is what I have called Project-Grounded Research in design, elsewhere usually called research through design. It derives from the pragmatist maxim (the "gospel of design research"): "If thou wantest to understand a phenomenon, put it into project."[12] The overall model is illustrated in *Figure 3c,* and the instructions read as follows:

Fig. 3a: First ask your supervisor to help you transform the design question into a research question. Then, remembering your PhD methodology seminar, conceive a research strategy corresponding to this question in order to reach a satisfactory research answer.

Fig. 3b: Select a research method where the designerly way of thinking is central to the research process to make sure you are in a design (i.e. not sociology, economics or engineering, etc.) research situation. For this purpose, use the design project as your research field as recommended in Project-Grounded Research.

And good luck !

12 See our "Research through Design and Transdisciplinarity." Op. cit.

Afterword

Due to a technical bug, the video recording of the presentation could not be saved, so that we lost access to the questions from the audience and their tentative answers. I tried to integrate into the text whatever my memory has stored from the discussion period.

There were many more questions than I could answer in the given time frame, among them some by CLIVE DILNOT. He took the trouble to write them down on a piece of paper that he very kindly handed to me to meditate over. I thought it would be interesting to reproduce them here. I hope CLIVE will not mind.

1) How do we cope with *uncertainty* in relation to research which is so grounded on certainty? Can research cope with what is uncertain?

2) Is "research" the real focus here, or knowledge, or, even better, understanding?

3) Do we translate the design question into a research question or into a question about what understanding / knowledge we "need" to know? So is the first translation "design question" to "knowledge / understanding" question, then to research question?

4) There is then the question of *translation*. How do we translate the design question into the knowledge / understanding question and then into a series of research hypotheses / questions / methods?

5) This question of translation opens up the genuine problem of the radical incommensurability of artifacts and realm of knowledge / research. Big question here is the adequacy, or rather inadequacy, of language in respect of the areas that design wishes to understand.

6) Final point is the ultimate contribution of the PhD to … what exactly? What is a PhD really trying to help us comprehend?

The next day, we spent a couple of hours together trying to answer these questions. It would take another paper to document this conversation here, and I wish that we had brought a tape recorder! Inevitably, we raised another bunch of fundamental questions, among them the fact that we lack an adequate aesthetics in design. What a good topic for a future design conference!

Keith Russell

On Ducts and Design

For the ancient philosophers, the everyday world was the location of their thinking, much as it is for design. Things are found in the world; things are made in the world. For the ancients, it was a serious question to be asked: Can this thing be bent? If it can, then it has the property of being intensional, that is, it can sustain straining, or stretching, or bending. We might make a bow, an arrow, or a staff: each would require a different intensionality.

When the mind is bent towards an object of its attention, this thinking is said to be intentional. That is, such thoughts illustrate that the mind can be bent to such a relationship. If our minds could not be bent towards things, and if things did not bend our attention, then we would be disconnected and locked in mere self-thinking. We are bent towards the world as the world is bent towards us. In HEIDEGGER's terms, we outstand and the world approaches us.

Things are ductible if they can be drawn or extruded; some materials are ductile and others are not. The same applies to thoughts. Some can be drawn from observations, some from speculations and some from the ether of the imagination. Such drawings have, over time, acquired argumentative, and, in some cases, logical authority. We readily embrace de-duction, we tentatively accept in-duction, we dismiss re-duction and we scramble to compensate for our wayward thinking by claiming the complexity of ab-duction.

For design, there are other kinds of duction that need to be introduced into the methodologies of research. For example, con-duction, pro-duction, sub-duction, and e-duction. After all, we can have bouncing concrete!

But, before we get to the fun of bouncing concrete, we need to take in a little history. It has been ten years since the PhD Design Conference in Ohio. CLIVE DILNOT, one of the Ohio conference presenters, has recently been moved to complain about the collapse of seriousness in the field of design research. For DILNOT:

> "The task is not to force design into the straight jacket of a clichéd model of technical reason (design methods: passim) but to do exactly the opposite, to 'rescue' design for thought by thinking design and in the process expanding the models of what we know as reason.
>
> In this process there is no secure foundation. There are laws – which is why, beyond the superficial, there is no possibility of experiment in design (only the proposition). Thought has to essay itself 'into' design somewhat as an explorer encountering an unknown territory. One is discovering possibilities of reasoning in action, one is not simply extracting from design that which

seems identical to reason as we know it. The interest of the project is not in building false foundations but charting and articulating new morphologies of acting, deciding, proposing, making, apprehending. One is, in this process, 'experimentally' pushing beyond the given – for the given, we know, is inadequate to comprehend this territory (otherwise we would already grasp it, but we do not).

Ten years ago the movement to try to think seriously about doctoral work in design began by asking these sorts of questions. It has often seemed, over the last few years, that it has declined into a merely institutional debate characterized, especially at conferences, by the avoidance of serious questioning. But the field cannot escape these questions. Design gets taken seriously as an academic field when it thinks in relation to knowledge as a whole and thinks what is the contribution it potentially makes to knowledge. The answer is simple (though the 'getting there' is not). Design potentially makes a contribution to knowledge by articulating design – that which by definition knowledge (i.e. 'university knowledge') does not know. Central to this is the articulation of the reasonings (one has to put this term in plural no matter its grammatical barbarity) that design contains, utilizes, draws upon and exemplifies – reasonings, to repeat, that go beyond the merely technical" (DILNOT 2008).

In raising the issue of ducts in design, are we "articulating new morphologies?" Are we "experimentally" pushing beyond the given? Is bouncing concrete going beyond or merely extending the already explained? These are serious issues deserving of our full attention, yet in some sense we cannot devote our full attention to these issues while we are faced with the confounding logic of new knowledge: just how can we articulate the reasoning of design without re-articulating the reasoning of "university knowledge?"

Here the method of critique might come to our aid. When we offer a critique we are not aiming to exhaustively cover an area of existing knowledge, nor are we aiming to keep our logic pure. In a critique we can be partial, fragmentary and flagrantly faulty. Our efforts, in a critique, are purposed towards a new outcome, a kind of manifesto

(what is at hand). Our purposes are pragmatic and temporary: a rope bridge is enough if it gets us across the river of ignorance to the further bank of clarity. And, after we are across, we can fake our discoveries (see RUSSELL 2001, 2002).

How so fake? Any story told, after the event, is a fake, a made-up one. But, in the case of a method-fake, a fake that describes a journey taken, the fake is purposed for the retelling rather than for the factual account of what happened. DESCARTES' meditation is just such a fake which places the reader, in the way of the problem of certainty, not through a logical account, but through a narrative reshaping of the thought experiment that led Descartes to his moment of clarity. Reviewing DESCARTES in this way offers us a sample of just what can be done when we dislodge philosophy from its university reasoning.

Ducts have a purpose beyond their accepted domains. While we all may feel well acquainted with the reasonings behind the deductive method, we disguise the fundamental process. All men are mortal. SOCRATES is a man. SOCRATES is mortal. However, when the government deducts money from our wages for taxes, we don't see this as an instance of reasoning. Rather, we see it as an action, an event, a real world fact. Equally, when we look at materials in terms of their properties and we assign the quality "ductile," we see this quality existing in terms of reality; we could actually draw this material in some manufacturing process. If we give back this quality of "being able to be drawn from" to deductions, then we are able to see that the quality exists in the proposition, or thought and not in some abstract table of reasoning. That is, we are able to simply think, "what can I draw from this?" without some irritable school master demanding, "is this deduction or induction?"

In passing, we might note that while de-duction would seem to be an exhausted category for design, in-duction has a possible appeal to design beyond the form of loose reasoning generally described as inductive. In the case of electricity, we talk about induction as a process of jumping or leaping such that electrons have the ability to jump around. Proximity is then a characteristic of inductive reasoning that might be

extended in the case of design to articulate or formalize creative ways of thinking such as are typical of the haiku and the metaphoric ratiocinations of poetry.

In his study of human reasoning, c. s. peirce came to the conclusion that what we mostly do when we set out to reason is a kind of mixture of induction and deduction that he describes as abduction. Simply put, we usually have far too much information that we then reduce through speculation to some kind of working hypothesis that we then test out on our information. After our testing we redetermine our working hypothesis by abducting our initial hypothesis and so it goes on in iteration after iteration until we are exhausted and/or our information seems to be well fitted inside our reasoning.

This abductive approach seems well suited to many aspects of many academic fields, including literature. In the study of texts, multiple critical readings lead to a more articulated account that seems better able to account for the contents. In the case of design, abduction has often been argued as the most useful way of looking at what goes on in the design process. And, in many ways, abduction is a useful tool that allows design to free itself of paradoxes that do not lead to design outcomes. At some point measurements need to be made, materials need to be specified and production needs to begin.

So, now we have another duct: pro-duction. While we commonly see a product as the outcome of a process, we need to shift our focus from the fixed outcome (the nut and bolt) and the process (the machinery and materials) to look at the temporal aspects. Key to a pro-duct is the element of time. Design is not only haunted by outcomes (products), but also by the arriving at outcomes (production). In a court case, witnesses are produced over time to prove a case. Products are produced over time indicating the success of the design endeavor or reasoning. That is, a key aspect of design reasoning is this feature of pro-duction. Design may well be a science of the artificial, but it is also a science of production; that which cannot be produced is not part of design. Production is then, as a form of reasoning, a limiting logic that is peculiar to design. (This limiting logic of design can also be seen in the structuring of differences

in design, which must be sufficiently robust so as to sustain production and reproduction.)

A less satisfying aspect of ducts and design can be found in the case of sub-duction, better known as se-duction. Part of the attempt to ground design in its own forms of reasoning necessarily involves a psychology of objects. This area of design theory is poorly covered from within design, despite there being a wide range of existing literature. ALESSI has often used the work of DONALD WINNICOTT to account for the playful aspects of things his firm makes, but, the general world of design would rather talk of useful things as if there were a danger in letting on that design was also frequently involved in the more artistic, sensory and psychological aspects of aesthetics:

> "Commenting on Phillipe Starck's designs, he [Alessi] refers to 'impracticability;' these are 'objects that are in a certain sense almost useless when it comes to function, objects where at times the function is secondary to the expressive values of the object, such as sensory values.' He is aware that his products are often purchased in spite of – not because of – their functionality as kettles or pots – bought either as status symbols, which he deplores, or as art objects. … [according to Alessi] 'Winnicott insisted that this playing activity – this transitional activity – is not only typical of the child but continues into their entire adult life. Playing helps the child understand the outside world and participate in its creation'" (WALLER 1996, 75).

Just making stuff has a primitive and child-like magic. Adding to this magic the sensory qualities that can lead to subduction takes design into the field of the affective. While there are many effect logics used in design, affect logics are generally absent except to say such mundane things that as people get excited and have feelings. The attempts by design researchers to scan faces and wire brains are very appealing to clients who would love to think that a blue box will sell more cornflakes. Such research is clumsy at best. And, while seduction is often raised as a moral issue in advertising and branding, the reasoning involved in subduction is not made evident as a quality of design thinking. If the identity of the owner/user of an object or service is treated as a quality

within an affect logic, then design can articulate the reasoning already involved in this aspect of designing.

Subduction, like production, is not generally considered part of the family of reasoning ducts. To add to this list of vagrant forms of reasoning, we can take up e-duction as possibly the most mysterious and useful form of disguised reasoning. Eduction means to draw forward and it has been used, perhaps incorrectly, to indicate what goes on in the process of education. The origins of the word "education" seem to indicate the concept of "bring up" rather than lead forward. But, eduction is the kind of logic that is of use to us here.

In the *Meno*, SOCRATES leads the slave forward in an eductive way. Just as water will follow a line drawn in the dirt, so the slave is drawn forward, presumably by SOCRATES drawing squares and triangles in the dirt with a stick. As the mind of the slave follows the reasoning of what is drawn, so the slave is drawn to new knowledge. This is not quite what happens in the *Meno* (it is more SOCRATES leading Meno forward than leading the slave), but the problem-based logic that SOCRATES outlines is typical of the kind of reasoning we can define as eductive reasoning. It may well be that after this session the slave could then use his grounding in Euclidean geometry to de-duct things not explained or educed by SOCRATES, but at the point of ignorance, the slave is being drawn forward in his knowledge; he is not deriving knowledge in a deductive way.

In the case of design, the form of eductive reasoning is not simply, or directly, that of a master and a student, though all designers do have a history of instruction that provides a model of eduction that describes, if not typifies, their ways of drawing knowledge forward. One might well acknowledge a master as the source of a way of approaching the unknown and such acknowledgment is typical of artists, if not designers. But, what is of more interest here is the subtended arc of designing that allows the designer to reason forward in the absence of final reason. Here we need to look at MERLEAU PONTY's ideas of embodied knowledge:

"The life of consciousness – cognitive life, the life of desire or perceptual life – is subtended by an 'intentional arc' which projects round about us our past, our future, our human setting, our physical, ideological and moral situation, or rather which results from our being situated in all these respects. It is this intentional arc which brings about the unity of the senses, of intelligence, of sensibility and motility" (1962, 136).

The "unity of the senses, of intelligence, of sensibility and motility" are key aspects of all human reasoning involving the unknown. We are able to draw ourselves forward because we are always, already, articulating a subtended arc. We are able to reason in advance and forward because we are always in proximity of what we don't know that we know. It may be that eduction, as a practice of self-reasoning, is typical of artists, designers and all creative thinkers. Indeed, such reasoning is the conceptual floor of the studio, both theoretically and practically (see RUSSELL 2000). In this sense, when talking about eduction we might be successfully adding to the "articulating [of] new morphologies" that DILNOT urges us towards. It may be that designers, if they were able to attend to their eductive processes, could add significantly to our understanding of how humans reason and of how these unacknowledged forms of reasoning can enhance our capacity for articulated thought.

So, who cares about bouncing concrete? It was merely an idea to draw us forward.

References

DILNOT, CLIVE. "Science or Understanding?" <*phd-design@jiscmail.ac.uk*> October 15, 2008.

MERLEAU-PONTY, MAURICE. *Phenomenology of Perception.* Routledge, 1962.

RUSSELL, KEITH. "Poetics and Practice: Studio Theoria." *Working Papers in Art and Design* 1 (ISSN 1466-4917).

The Foundations of Practice-Based Research. University of Hertfordshire, 2000. *http://www.herts.ac.uk/artdes/conex/res2prac/wp/index.htm.*

RUSSELL, KEITH. "Towards a Poetics of Design and Play." *Designing in Context (proceedings of Design Thinking Research Symposium, December 18–20, 2001),* edited by PETER LLYOD, and HENRI CHISTIAANS. The Netherlands: Delft University Press – Science, 2001: 17–30.

RUSSELL, KEITH. "Loops and Fakes and Illusions." *M/C online journal.* August, 2002.

WALLER, CHRISTOPHER. "The Transformer." *Interview with Alberto Alessi,* 21, no. 2 (1996): 72–75.

CONTRIBUTORS

SARAH BELKHAMSA is a graduate of the *Tunis Institute of Fine Arts,* where she received her B.A. in Industrial Design in 2004. In 2006, she earned her Master's degree in Art and Communication, in a joint supervision between the *University of Paris 1 Pantheon Sorbonne,* and the *Advanced Institute of Fine Arts Nabeul* at the *University of Carthage.* Since 2006, she has been a researcher at the *Centre of Research, Images, Cultures & Cognition* (CRICC) at the *Sorbonne University,* where she is currently preparing a PhD in the Arts and Sciences of Art, with a specialty in Design. She also received a scholarship from the French government to continue her research in material culture studies. Her subject is entitled "Semiotic and systemic study of the material culture: the case of design product as a complex sign." Since 2007, she has been an Assistant Professor in Design at the *Faculty of Sciences and Technologies of Design (ESSTED)* in Tunis.

STELLA BOESS has been an Assistant Professor for user research and design for interaction at the *TU Delft* in The Netherlands since 2002. She earned a PhD in design research from *Staffordshire University,* UK in 2003, and she has lived and worked in Rotterdam since 1998. In 1994

she earned a degree in product design from the *Hochschule der Bildeneen Künste Saar* in Germany. Her experience includes product design consultancy, independent concept work and user research for design. Her academic research and educational activities center on the relationship between usage research and the design activity. She is coordinator of a design course for 100 students. Her independent work comprises self-initiated and commissioned projects that investigate notions of product usage.

DAG BOUTSEN is an architect and Head of the *School of Architecture, Sint-Lucas*, Brussels/Ghent. In 2002, he organized the semester-project *!brussels!*. He has organized international workshops *(Joint Meta University* "Int'nal Workshop" 2003 en Workshop IP "Borders & Boundaries I 2004, Workshop Borders & Boundaries II 2005, Workshop World Way of Living Lille-Brussel 2005) and is an expert in inter-department courses and facilitator agencies like *Pyblic, UrBS, etc.*. His PhD research since 2007 has focused on "Trust & trust-based architecture through participatory design" at *Chalmers University*, Göteborg, Sweden and the *Department of Architecture Sint-Lucas*, Brussels, Belgium under the supervision of STEN GROMARK. BOUTSEN also holds the following memberships and accomplishments: IvOK, *The Institute for Research in the Arts of the Association of the Catholic University*. Leuven: Member BIvOK (Governing body Institute for Research in the Arts) 2006–2009. Chairman Commission OPK (Research Platform for/in the Arts) since 2006.

KATHARINA BREDIES was born in Bremen, Germany, where she also studied Integrated Design at the *University of the Arts (Hochschule für Künste)*. Since the beginning of her studies, her interests spanned from illustration and animation to product design, interface design and design theory. She graduated in 2006 with a diploma about the application of system analysis for alternative concepts of electronic patient records. After her graduation, she started to work as a research scientist and doctoral candidate at the newly founded *Design Research Lab*, which is part of *Deutsche Telekom Laboratories* in Berlin. Her research interests are on the relation of

designers and users, and design-in-use. In her dissertation project, she is investigating how strange artifacts can provoke a breakdown in its established use and restore the artifact's "interpretative flexibility."

LISA CRESSWELL is an illustrator and designer. She completed her undergraduate degree in illustration and later went on to complete a Master's of Design at *Duncan of Jordanstone College of Art, University of Dundee*. Her illustration and design work concentrates on contemporary social issues and her work seeks to connect these issues with associated business stakeholders using visual communication. Since graduating in 2006 with a newly established design skill base, she has remained in a working capacity within the *Duncan of Jordanstone College of Art*. She seeks challenges throughout her independent and university work and enjoys deconstructing complexity using visualization.

CARMELA CUCUZZELLA is a PhD candidate in the *Faculty of Aménagement* at the *Université de Montréal*. She works at *L.E.A.P. (Laboratoire d'étude de l'architecture potentielle)* as a research assistant at the *Université de Montréal*, and is a student member of *CIRAIG*. Cucuzzella is a a contributing author to the forthcoming publication (May 2009) produced by *UNEP/ SETAC Life Cycle Initiative*, called "Guidelines for Social Life Cycle Assessment of Products." She obtained her M. App. Sc in Environmental Design (Design and Complexity option) at the *Université de Montréal* in 2007, and also received a Bachelor's in Fine Arts (Design Art option) in 2005 and a Bachelor's in Computer Science (Systems Architecture option) in 1990. Her fields of interest include sustainable design and development, evaluation methods for sustainable design, social approaches to design and ethical and responsible design.

MICHEL DE BLOIS graduated from the *University of Sherbrooke* in Management and completed a Bachelor's Degree in Environmental Design before starting his own practice in furniture and interior design. He quickly expanded his expertise in manufacturing and went into the construction business as a manufacturer/contractor of high end

specialty architectural metals and as a general contractor. He specialized in design management for a variety of institutional and commercial clients. After twenty years in the field he returned to school in order to complete an Msc. A. in Design and Complexity at the *University of Montreal*. He is now pursuing a PhD Aménagement at the same institution. He is affiliated with the *Groupe de Recherche IF* and also acts as a design management consultant for various projects. He teaches project management in industrial design. His research interests focus on "organizing" processes in project behavior and organizational design from a design thinking perspective.

DOAA EL AIDI is an Assistant Lecturer at the *Faculty of Applied Arts, Helwan University,* Cairo, Egypt. She has a Bachelor of Applied Arts Degree in the branch of Interior Design and Furniture, and a Master of Applied Arts Degree with the title "The Ideology of Art Nouveau and Art Deco in Modern Furniture Design" from *Helwan University.* Since 2007, she has been granted a scholarship from the *Egyptian Mission* for post graduate studies in Germany, leading to a PhD. Her PhD research focuses on a new responsible role for the designer in order to support sustainable development in the future.

ALAIN FINDELI is an Honorary Professor at the *School of Industrial Design, Faculté de l'Aménagement, University of Montreal,* where he taught from 1973 to 2006. His current research interests and recent publications address general issues in the theory and practice of design (logics, aesthetics, ethics), and more specifically pedagogical aspects of design research education (PhD). He is also the founder of the research Master's program in "Design & Complexity" (*Univ. of Montreal,* 2001) for which he was the scientific and pedagogical advisor until 2006. He is currently a Full Professor at the *University of Nîmes* in France, where he co-founded *Les Ateliers de la recherche en design,* a French and Francophone design research community. Since 2008 he is also a visiting professor and researcher at the *Universities of Art and Design of Geneva and Basel* in Switzerland, and at the *Sint-Lucas School of Architecture* in Belgium.

MAREIKE GRAF studied Information and Media Design at the *University of Applied Sciences (Hochschule für Gestaltung, HfG) Schwäbisch Gmünd*. Her interest in Digital Media is the tension zone between product design and information design, forcing new scopes of duties. To be able to develop projects within the field of interaction design at the university, she was part of a small group that developed the *medialab* in 2006. Scenario-based Design, a combination of social and technological matters, was the topic of research for her Master's thesis. Amongst others she was freelancing for a media lab with headquarters in Stuttgart. There she worked in cooperation, including with the *Fraunhofer Insitut IAO,* expanding her methodological background. MAREIKE is managing the new course of study "Interaction Design" at the *HfG Schwäbisch Gmünd*. She also teaches "Invention Design," where she develops new products, services or applications with students using new technologies. Here, as well as in design research, her focus is on the role of design as the communicator and connector between technology and "user."

QIN HAN MDes., BEng., is currently undertaking PhD research focusing on Service Design and Design Management. At the same time, she is a Teaching Fellow for the Master of Design program at the *University of Dundee*. QIN worked as an information designer after she graduated with a Master's degree in Design in 2006. Before coming to Britain, she had a BEng in Computer Science and Technology from *Tongji University,* China. Her interdisciplinary experience in teaching, researching and working has given her a unique perspective on the coming generation of designers and their role in the changing world. Her blog *www.designgeneralist.com* records her insights and reflections on both research and teaching.

CARMEN HARTMANN-MENZEL studied integrated design at the *Anhalt University of Applied Sciences (Hochschule Anhalt)* in Dessau and industrial design and sculpture at the *Cleveland Institute of Art* in Cleveland, Ohio. In 2004 she earned a degree in industrial design. From 2004 until 2005 she worked

as an R&D assistant at the *Institute of Integrated Design* in Bremen, with the research topic of design planning and management. Following this she taught design management and visual communication design at *Keimyung University* in Daegu, South Korea for one and a half years, during which time she gave lectures at *Daegu University* and the *Daegu Graphic Design Association*. In 2007, she was a coauthor of the *Asian Study Conference* in Tokyo, Japan about the change of today's Korean lifestyle due to western influences. As a designer she worked in the fields of communication and industrial design for clients like *Silit, Analytik Jena* and the *German Embassy* in Seoul. She has taught corporate design and design management in bachelor and master programs at different universities in Germany and is now working and teaching at the *University of Applied Sciences (Hochschule für Gestaltung) Schwäbisch Gmünd*.

THIERRY LAGRANGE is an engineer and architect. He runs the office *ALT* and is a lecturer at the *Sint-Lucas School of Architecture* in Brussels. As a member of *Ubicumque,* he is co-editor of a series of art-publications, such as *Images/images, Tekst/tekst* and *Cahier.* He is active as a photographer. Both architecture and photography are central elements in his ongoing PhD project at *Sint-Lucas & Catholic University of Leuven (IVOK)*.

LESLEY MCKEE is a PhD research student based at the *University of Dundee,* Scotland. Her research explores the concept of physical and abstract space in urban environments. In particular, Lesley's interests focus on community-led initiatives, which seek to reclaim urban space as a place for people to come together. Her Masters of Design centered on local, community organization and policymaking. In 2007, Lesley was involved in *Design Against Crime,* a project conducted in conjunction with *Tayside Police*. Following an award for funding from the *Arts and Humanities Research Council* to further develop this research, Lesley began doctoral studies in October, 2007. A deeper understanding of the challenges design faces in making the transition beyond conventional consumptive boundaries towards objectives of socio-political transformation has led to new considerations.

DENNIS OSWALD was born in 1978 in Germany. He finished his university studies in 2006 with a diploma in "Communication Design" and a continuative Master's degree from the *University of Applied Science* in Constance, Germany. Dennis combines a practically-oriented and an academic approach to design. He believes in design as a multidisciplinary process for innovation. His master's thesis about "Design Methodology" won the students' prize and builds the starting point for his current project: an online design method archive. Since 2006 Dennis is based in Zürich, Switzerland, where he works as a designer for *Interbrand Zintzmeyer & Lux,* a brand agency for national and international clients.

KEITH RUSSELL – Short biographies are like short bits of string: useless except to tie around your finger and feel comforted on a dark night. The shape we are is much the shape we were! Born in a small Australian country town, in Northern New South Wales, Casino, I am a country kid. To trap eels and go bottling for fish in water grass and small rapids above the falls. Here the local was large and the scale of myth just right for a young mind expanding with little molding beyond simple theology and ornate moral tales. The poetics of mud and sticks and corrugated tin boats sealed with roadside tar taken on days too hot for no shoes. Wandering as cattle might, the river bank where Aboriginal children lived outside the laws of school and work time I learned much of the taste of wilded gooseberries from once were farms and stolen paw paws from the Deputy Principal's yard that abutted a flood tormented rich loam bend where elephant grass and lantana made it easy to hide. This then is an ode of a child. This is the land of the Bundjalung Nation and the Gundy tribe. My own tribe is other. I have a PhD in Literary Aesthetics. I am a Design and Communication philosopher as well as a poet. Currently I teach in the school of Design, Communication and IT at the *University of Newcastle,* Australia.

ANNINA SCHNELLER has been a research assistant in Communication Design at *Bern University of the Arts* since 2007, responsible for the development of the research field "Design and Rhetoric" *(www.hkb.bfh.ch/komm*

design.html?&L=2). She is also a researcher in the DORE *Swiss National Science Foundation* project "Visual Rhetoric in Commercial Graphics." In 2003, she finished her M.A. in Philosophy, Mass Communication Studies and German Literature at the *Universities of Bern and Humboldt* Berlin. From 2005 to 2006 she worked as a research assistant in the *Swiss National Science Foundation* project "Saying & Meaning and the semantics/pragmatics distinction" about H. PAUL GRICE's philosophy of language at the *University of Bern* and was co-founder of the research group *meaning.ch (www.meaning.ch).* She also worked as chief editor of the website *www.kathbern.ch,* was project manager of *Kulturinformatik Bern* and communication assistant at VIPER, the international festival for film, video and new media in Basel.

ZDRAVKO TRIVIC obtained his Bachelor's degree in architecture at the *Faculty of Architecture, University of Belgrade,* Serbia in 2005. He is currently a PhD scholar at the *Department of Architecture, National University of Singapore (NUS).* He researches "Total Healing Environment and Seduction in Contemporary Consumption Spaces" under the supervision of DR. RUZICA BOZOVIC-STAMENOVIC and DR. LIMIN HEE. In 2007 he was a teaching assistant at NUS for modules "Theories and Elements of Urban Design" and "Health and Space." In 2008 he won the *Fit-City Competition* organized by *Oxford Health Alliance,* London and presented his work at the *OxHA Conference* in Sydney *(http://www.fit-city.org).* His work was exhibited at: *Venice Biennale,* Italy (2006); *World Congress of Architecture,* Istanbul, Turkey; *MARCHI,* Moscow, Russia; *Faire of Furniture, Accessories and Decoration,* Belgrade, Serbia – special award (2005).

CHRISTIAN WÖLFEL is a design researcher and an industrial designer based in Dresden, Germany. He studied Industrial Design Engineering at the *Technische Universität Dresden* and was a visiting student at the *Burg Giebichenstein University of Art and Design* in Halle, Germany. His final year project, *CarCoverMachine,* won the *IMB Innovation Award.* Since 2005, he has been a research associate at the *Center for Industrial Design, Technische Universität Dresden.* He is also a lecturer in aesthetic freeform design and an advisor for practice-based design projects. His research interests

include user-centered design processes and methods with a focus on problem-solving and knowledge-handling in early stages of the design process. His PhD research is strongly connected to work and organizational psychology and focuses on the impact of particular methods on design processes and their outcome under field conditions.

FAN XIA Mdes, BA is an experienced international researcher now funded by the *School of Design* to further her PhD studies on the topic of using dynamic visualizing methods to help design companies shape good design teams with members from multiple disciplines. Xia graduated in 2005 with a degree in Environmental Art Design in China. Before being awarded a Master of Design degree at *University of Dundee,* she was a project leader at *Crystal Digital Technology Company* (Beijing 2008 Olympic Games Graphic Design Services Supplier). Her research used Goal-Directed Design Methodology to facilitate design process and management, helping designers to create tractable interactive products to bring users pleasant using experiences.

MITHRA ZAHEDI holds a Master's of Science degree in Educational Technology, preceded by her study of Industrial Design at *École nationale supérieure des arts visuels de La Cambre* in Brussels. She is currently a Visiting Assistant Professor at the *School of Architecture & Design* of the *Lebanese American University.* Prior to this position, she was a Lecturer at the *School of Industrial Design* at the *University of Montreal,* Canada for the past 8 years. She worked as a design consultant in Canada and USA for more than 15 years before working as a researcher and pursuing a PhD. She focused on human-centered product/communication systems and worked with different industries including educational institutions, IT, transportation, and pharmaceutical companies. In her current research, her main interest is in team interaction and support for design activities within multidisciplinary teams. Her research enriches her work and vice versa.

Design Research Network is a platform particularly established to serve design research students and is open for all to participate. Design research students are encouraged to take active and leading roles and senior researchers supportive ones. It is a medium for exploring new forms of discourses, adequate to the social and technological state of the art.

Design Research Network is international in nature but is mindful of cultural differences and encourages diverse local practices.

www.

Design

Research

Network

.org